Fewer, Better Things

Art in the Making (with Julia Bryan-Wilson)
The Invention of Craft
The Craft Reader
Thinking Through Craft

Fewer, Better Things

The Hidden Wisdom of Objects

Glenn Adamson

BLOOMSBURY PUBLISHING
NEW YORK · LONDON · OXFORD · NEW DELHI · SYDNEY

BLOOMSBURY PUBLISHING
Bloomsbury Publishing Inc.
1385 Broadway, New York, NY 10018, USA

BLOOMSBURY, BLOOMSBURY PUBLISHING, and the Diana logo
are trademarks of
Bloomsbury Publishing Plc

First published in the United States 2018

ISBN: HB: 978-1-63286-964-7; eBook: 978-1-63286-966-1

LIBRARY OF CONGRESS CATALOGING–IN–PUBLICATION DATA IS AVAILABLE.

2 4 6 8 10 9 7 5 3 1

Typeset by Westchester Publishing Services
Printed and bound in the U.S.A. by Berryville Graphics Inc., Berryville, Virginia

To find out more about our authors and books visit www.bloomsbury.com and sign up for
our newsletters.

Bloomsbury books may be purchased for business or promotional use. For information on
bulk purchases please contact Macmillan Corporate and Premium Sales Department at
specialmarkets@macmillan.com.

CONTENTS

Fewer, Better Things

Introduction

ENGAGING WITH THE OBJECTS
AROUND US

L IKE MOST AMERICAN CHILDREN, I had a teddy bear when I was young. Two, actually. One was big and floppy, slightly walleyed, with a tight-fitting T-shirt bearing his name in hand-stitched red letters: PHIL. The second, smaller one was my favorite, ranking so highly in my imagination that he did not even have a name. If pressed, I would have referred to him as Bear, but he was more like an alter ego of myself. Compact and surprisingly heavy, with tiny glittering eyes and no garments or other accessories, he was a constant companion and an actor in whatever imaginary narratives I invented. Despite his modest size, he was a big presence in my life.

I owned Phil and Bear before I even knew how to talk, and I interacted with them mostly without words, through touch. Today I look at children three or four years of age and wonder how they will be different, not only from my generation but from all others preceding mine. Most kids still are given stuffed animals by their parents, often in profusion, and in many colors, shapes, and sizes. But what really seems to capture a child's

attention is technology. If you want to see a distracted ten-year-old suddenly achieve total focus, hand them a smartphone or a digital tablet and watch them go down the rabbit hole. They will probably already be well adapted to the device and its possibilities, and able to navigate it as if by ancient instinct. I have heard stories, possibly apocryphal, of kids swiping at the cover of printed magazines in an effort to move the picture on to the next one. Many a behind-the-times parent, using an analog camera loaded with celluloid film, has witnessed their child's baffled disappointment when the picture fails to appear immediately on-screen on the back.

Clearly, children are getting a lot out of technology, and they will continue to get more out of it as they grow older. They will have countless transformative experiences in the infinite and depthless zones of the digital, not only stimulation and entertainment, but also information and awareness. What will they be like when they reach maturity? Quite likely, their breadth of understanding will be vastly superior to my own generation's. Their grasp of the world will be as unlimited as the Internet itself. They will have explored its distant reaches, virtually, from an early age. On the other hand, to the extent that these children clutch a smartphone rather than a teddy bear to their small selves, they may be losing an intimate connection to physical objects, which has nurtured human development for many thousands of years. Commentators have worried semiseriously about the emergence of an entirely new species, the "brittle bodied, hefty headed *Homo Technologicus*," who can surf the web with ease but has trouble throwing a ball.[1] We are running a giant experiment on this generation, without a control group.

Interestingly, young people do seem to realize that they are missing out on something. My brother's family lives in Munich, but last summer they came to see me in New York. During their visit, I noticed that my fifteen-year-old niece, Sophia, had set up a framed photograph of her cat Pepper next to her improvised bed in the living room. She had brought it with her all the way from Germany. I was surprised and asked her why she had bothered. Didn't she have pictures of the cat on her phone? She replied in a way that was as perceptive as it was tongue-twisting: "Yes, but I want a picture of Pepper. And the point of the phone is not to show a picture of Pepper, while the point of the picture of Pepper *is* to be a picture of Pepper."

Sophia had cleverly noticed an important fact about traditional (that is, nondigital) objects. Because they are unable to transform themselves at the level of content, they must answer to our needs without the benefit of adaptability. A physical artifact has to have, as Sophia put it, "a point." A framed photo, like a pot or a pen or a table, must serve its purpose, just as it is, without apps or upgrades. In the digital era, this irreducible thingness may seem like a drawback. But let's not forget that it is also an enduring human value. A well-made object is informed by thousands of years of accumulated experiment and know-how. Whenever we make or use an everyday tangible thing, or even when we contemplate one seriously, we commune with this pool of human understanding.

A smartphone may help its user to navigate an unfamiliar city perfectly well, and goodness knows it can hold a lot of cat pictures. But it was probably manufactured a world away from its user, with great negative impact on the environment and on workers' lives. It can also diminish our awareness of our

immediate surroundings, as when we follow Google Maps like a mouse in a maze, facedown, rather than looking at the streets around us. It's when we don't engage with our material environment in a focused manner that we truly lose our way. As a culture we are in danger of falling out of touch, not only with objects, but with the intelligence they embody: the empathy that is bound up in tangible things.

I am speaking here of *material intelligence*: a deep understanding of the material world around us, an ability to read that material environment, and the know-how required to give it new form. This skill set was once nearly universal in the human population, but it has gradually shifted to specialists. Meanwhile, materials themselves have proliferated, becoming more numerous and complicated thanks to scientific research. As a result of these tendencies toward specialization and complexity, even as our literacy in other areas (like visual codes and interactive technology) has increased, our collective material intelligence has steadily plummeted. We are all born with this faculty. It is instinctive—it's why a child loves his teddy bear. But like any inherent capacity, it can flourish or fade depending on how it is nurtured.

There are many different facets of materiality, many ways we can engage with physical objects. We may or may not notice them, or know what to make of them, but the objects are there all the same, awaiting our understanding. Here's a good example of what I mean. My grandfather Arthur grew up in Coffeyville, Kansas. When his sister Gail was thirteen years old, she was hired to mind the neighbors' 160-acre farm for a few days while they were away. When she returned a week

later with four dollars' wages, an impressive sum for a girl her age, her parents asked how it had been. She said fine, but there had been one problem. The hog had died. It was August, and under the summer sun a bunch of farm dogs had chased the two-hundred-pound pig until it expired in the heat. This was in the days before landlines came to rural Kansas, much less smartphones, so she couldn't call for help.

Here's how my grandfather told the story:

What to do? There was the family's winter meat supply useless on the ground and getting ready to spoil. So my sister did the only thing she could. She got out the butcher's knife and butchered the pig. She kindled a fire in the kitchen cookstove. She skinned the hog and cut it into pot-sized chunks. She cooked it on the woodstove in the hot kitchen. She washed and sterilized twenty mason jars. She cut up and packed the meat in the jars. She cooked the meat jars in the pressure cooker. She flipped down the latches on the jars. She let the jars cool and moved them to the cyclone cellar. Then she washed up and went to bed.

This was a thirteen-year-old! What is amazing is that this skill set was more or less expected of girls her age (though impressive enough, I guess, that my grandfather remembered the tale many years later). The difference between my great-aunt Gail and today's children has something to do with a rise in squeamishness, but it is mainly a decline in material intelligence. She grew up on a midwestern farm in the midst of the Great Depression. Although the family was impoverished, they had

a deep connection to the material world. Homesteaders like them would have been intimately familiar not only with raw meat and mason jars, but with many different types of timber, stone, clay, straw, metals, and innumerable other materials, and many different processes for working with them. If they needed to build a fence, they wouldn't go to Home Depot— they would cut down a tree and split it into posts. Every day they fed and milked cows. After the cows were slaughtered or died, their hides furnished shoe leather for the family.

There's no going back to the old days, nor should we necessarily want to. I doubt Aunt Gail was especially glad to have had the chance to butcher that pig, and my grandfather remembered that when he went out to the freezing cold milking shed early in the morning, he would mutter to himself, "I sure as hell don't want to be a farmer when I grow up." But he had something important going for him. Like most people of his generation, he was sensitively attuned to the material landscape around him. And this, in turn, provided a strong sense of social cohesion. In Coffeyville there was a feeling of shared enterprise, a commonly held set of skills and experiences. People may not have agreed about everything, but they faced similar day-to-day challenges. They worked and lived within an established cycle of harvests, of booms and busts. Whether they liked it or not, they were all in it together.

Now, being literate in the materiality of a dust bowl farm is one thing. Doing the same in our technologically sophisticated times is much more difficult. One doesn't have to be nostalgic to notice what we're missing: In an average New York City apartment building, you can easily live for years just ten feet

above another family's heads and never once see them. A contemporary office is typically constructed from wipe-clean plastics, wipe-clean fabrics, and wipe-clean laminated composites, all of which are created in industrial settings in locations that are unknown and probably far distant. Our material environment is not only less accessible and more complex than it ever has been, but its origins are also remote from us, in every sense.

It's true that a farm family of the 1930s had to depend on their material intelligence for survival, while today's city dwellers and office workers can get away with ignoring their physical environment and still make a fine living. Maybe this feels like a sort of progress. But basic necessity is only one side of our relationship to materials. There are others, too: pleasure, discovery, inventiveness, and, particularly important, responsibility. Our relationship to materials determines much about the way we live on earth. Many people think of themselves as being committed to sustainability, but they focus on a relatively limited set of issues: what type of fish they order at a restaurant, how many airplane trips they take, whether they turn the lights off when they aren't in a room. As important as some of those issues are, they pale compared to the impact of the objects we shape and live with. One of the most significant aspects of material intelligence is that it can help us to make better choices about how we live on the planet.

So while it makes sense to be "pro-object," that doesn't have to mean being in favor of *any* object. Having an overabundance of things is sadly out of keeping with our real human needs. Most things being made today are not worth the precious

resources of material, effort, and space we have devoted to them. This does not mean that we should abandon objects and look elsewhere for our future, though—or that we should attempt to reduce or even eliminate our dependency on the physical. On the contrary, the reason that we have too many unsatisfying objects in our lives is that we don't care enough about any single one of them.

William Morris, the great craft reformer of the late nineteenth century, was one of the earliest writers to espouse environmentalism, over a century ago. "Surely there is no square mile of earth's inhabitable surface that is not beautiful in its own way," he wrote, "if we men will only abstain from willfully destroying that beauty."[2] He also famously asked his contemporaries to "have nothing in your house that you do not know to be useful, or believe to be beautiful." This sentiment still rings true today, particularly if we add the idea that objects should be *meaningful*. Let's not think of things as ends in themselves, props to put on the mantelpiece. Rather, let's consider them as points of contact between people. Every object represents a potential social connection. By better understanding the tangible things in our lives, we better understand our fellow humans.

Morris, like many design reformers of the past, thought that each object had an inherent value, that true judges of quality could see for themselves whether it was any good. From this perspective, things are bound by logical rules, based on function, systems of ornament, and appropriate use of materials. Today, we might look at things a bit differently: An object can only be good *for someone*. Its "goodness" is not essential to it,

but rather arises through the relationships that it brings into being. Thus the real test of an object's worth lies not in its efficiency, novelty, or even beauty (which, in any case, is in the eye of the beholder), but in whether it gives us a sense of our shared humanity. It is hardly ever wrong to value an object. The problem lies in not valuing things enough.

A single thing may carry hundreds of stories about the people who made it or who have lived with it. The challenge is to read those stories. Accordingly, this book paints a full, kaleidoscopic picture of material experience. Making things, using them, and learning about them—all these ways of interacting with objects connect. We make things out of materials. Then we use them, in ways that bring us into intimate contact with their qualities. These objects in use both prompt and aid our search for knowledge; we learn from the material landscape around us, and that, in turn, informs how we make things. And so the cycle starts again. All along the way, there are opportunities for human empathy. Makers and users can equally appreciate the warmth of wood, the cool hardness of metal, the pliability of rubber. Just as a skilled maker will anticipate a user's needs, a really attentive user will be able to imagine the way something was made. The material object serves as a bridge between these two perspectives.

One of the most fascinating aspects of the material landscape is the way everything in it is interwoven, in ways that are just as profound and subtle as the "networked" realm of the digital. When we overemphasize the promise of the digital information economy, we not only express an irrational preference for the new over the old, we also miss the physical know-how that

binds our society together. The cultural habit of marginalizing this kind of expertise has deep historical roots and has always been related to class condescension. I believe that by challenging this legacy and building respect for material intelligence across our culture, we can form a bridge that emphasizes shared experience: a greater awareness of the things we hold in common.

Chapter 1

LIFE ON PUMPKIN CREEK

M Y GRANDFATHER ARTHUR SPENT his childhood on Pumpkin Creek Farm, in Coffeyville, Kansas. His upbringing there imbued him with tremendous material intelligence. When Arthur was a teenager, he applied for a job at the local garage. He was told to go out back, strip a tractor down to its parts, clean it, and reassemble it. He did so over the course of an afternoon and was hired on the spot. Arthur could plow a field. He could mend a shirt. He could make ice cream from scratch, a valuable skill on a hot day in the country, especially given that the closest store that sold any was seven miles off. The Pumpkin Creek method involved packing ice into a gunnysack and crushing it with the flat of an ax; placing the ice around a drum, in which was a mix of fresh milk, eggs, sugar, and strawberries; rotating the drum with a hand crank; and eating the results quickly, as there was no refrigerator.

Nostalgia for the "good old days" is in many ways misplaced—my grandfather would have been the first to say so. Life on Pumpkin Creek was not easy for Arthur, his

three sisters, or his little brother. Arthur was born in 1919, so his teenage years coincided exactly with the Great Depression, which hit midwestern rural states particularly hard. Even in the best of times, farmwork is demanding labor, requiring long hours in all kinds of weather. The Depression compounded these demands and helped to drive many away from that life, Arthur included. As soon as he graduated from high school, he left. (As he put it, he "never did a real day's work since.")

Arthur hopped on a Harley-Davidson motorcycle and rode it all the way to Los Angeles, where he enrolled at the University of Southern California. Four years later he graduated with a degree in mechanical engineering. By that time World War II was on, and Arthur went to work for General Electric for sixty-five dollars a week, initially designing control systems for aircraft-mounted guns. He was so capable that he soon was promoted to be—literally—a rocket scientist. I have a notebook he kept in those years. Written out in pen and ink with elaborate diagrams of electrical and airflow systems, it is periodically annotated by another engineer's comment, "read and understood by me," signed, and dated—important documentation in case the company wanted to apply for a patent later on.

Indeed, Arthur was constantly inventing. He eventually went on to be one of the country's leading jet engine designers, helping to develop the experimental XV-5A VTOL, one of the first-ever vertical-takeoff aircraft, and many commercial engines. If you have ever flown in a DC-10 plane, you can thank my grandfather for helping you arrive safely.

Maybe something was missing, though, because while he was still working at General Electric my grandfather took up the hobby of wood carving. He'd whittled a bit in his youth, fashioning little sculptures from a stick using a knife, but now he got serious. His basement in a Cincinnati suburb gradually filled up with hand tools, power equipment, and stacks of timber. I remember going there as a child and watching him carve. It was a magical experience, seeing a sculpture emerge out of a block, one chisel cut after another. The woods themselves were wonderful to learn about: dark, heavy walnut; light-as-air balsa; and Arthur's favorite, Osage orange, which, as its name implies, when freshly sawn has the bright color and sharp scent of a citrus fruit.

My grandfather was proud of his accomplishments both at work and home, and even had a business card printed up:

ARTHUR P ADAMSON

JET ENGINES AND WOOD CARVINGS

MADE TO ORDER

He was a great influence on me in many ways, above all because of his skill at making things. I never aspired to an equivalent level of craft skill or engineering prowess, but watching my grandfather when I was a kid instilled me with tremendous respect for both kinds of knowledge, and also perhaps helped me to see that they were just two aspects of the same thing. No doubt my grandfather's example also had much to do with my eventual career choice, writing about craft and working in museums. On one occasion, I curated an exhibition

at the Milwaukee Art Museum about an industrial designer named Brooks Stevens. That may not be a household name, but he was well known in that part of the country for his work with Miller Brewing, Allen-Bradley machine tools, and many other manufacturers. Among the many other objects Stevens had styled in his career was a bright orange 1938 Allis-Chalmers tractor with a streamlined chassis. I'd never seen Arthur so proud of me, his grandson, as when he saw it in the gallery.

Chapter 2

A FEW WORDS ON CRAFT

CRAFT HAS A MIXED REPUTATION. Many makers (my grandfather was certainly one of them) identify strongly as tradespeople who take professional pride in their work, and as amateurs who pour their heart and soul into what they are doing. Others think of craft in less glowing terms, seeing it as traditional, small-scale, trivial, backward-looking, anti-intellectual, or otherwise limited. My sympathies have always been with the former crowd, but there is no doubt that craft's history is bound up in an inferiority complex. It is often seen as inadequate in comparison to powerful industrial processes, or, in more rarefied circles, compared to the conceptual investigations of fine art.[1]

When we casually dismiss craft as a vital factor in our lives, however, we miss out on many satisfactions. We also ignore and implicitly demean the skilled labor—the "blue-collar" work—that goes on in the background of many human endeavors. When many people hear the word "craft," they think of humble, decorative things: pots, baskets, or macramé plant hangers. But if we consider "craft" in its active form,

treating it as a verb rather than a noun, we immediately realize it is much, much broader than that. People "craft" things as diverse as theatrical set designs, couture gowns, skyscrapers, and automobiles.

Even pots and baskets and plant hangers have a long history behind them and deserve our respect, as do the people who make them. But we shouldn't confuse a few particular mediums like clay, wood, metal, fiber, and glass with the broader notion of craft as a motive force in shaping the world. When we say that someone crafts an object, we mean that they put their whole self into it, body and mind alike, drawing on whatever skills they have acquired over the course of their lives. This is a deeply meaningful human activity, which can be observed not only in suburban garages and hobby shops, but also in factories (where people craft machines and prototypes) and fine art studios (where people craft paintings and sculptures). All these process-based experiences imbue materials with associations that resonate far beyond the act of making itself. As Hugh Aldersey-Williams notes in his excellent book *Periodic Tales*, on the cultural history of the chemical elements: "It is the centuries or millennia of hammering and drawing, casting and polishing that have given many of the metallic elements their meaning. 'Craft' explains why we regard lead as grave, tin as cheap, and silver as radiant with virginal innocence."[2]

One indicator of this pervasive relevance is that, while craft is often opposed to design (which seems a more hands-off affair), if you go back far enough into a good designer's biography you are likely to find a period of intensive involvement in handwork. This can be observed in a wide variety of disciplines. Take,

for example, three of the leading figures in British design of the past twenty years: the stage designer Es Devlin, the architect-engineer Thomas Heatherwick, and the fashion designer Alexander McQueen. Each has stood atop their field, with Devlin getting commissions from the likes of pop stars U2 and Adele, Heatherwick remaking London's iconic red Routemaster bus, and McQueen having been the subject of posthumous retrospective exhibitions in major museums.

Yet, despite their eventual superstardom, all three began by making their ideas by hand and from scratch. Heatherwick was an obsessive model builder as a student, and to this day maintains a fully functioning workshop in his design studio.[3] One of his many extraordinary creations is a bench made by pushing molten aluminum through the world's largest hot extrusion machine. Each bench assumes its unique form as it slithers out and is cut from a continuous flow of metal—heavy industrial equipment used as if it were a handheld tool.

When Devlin designed a play with showers that ran red with blood, the theater's plumbers told her it was an impossible project. According to her father:

> Es went home and got every plumbing manual she could find, she studied them all night, and, next day, she came into the theatre and showed a complete mastery of all these plumbing terms and of what could be done.[4]

As for McQueen, he began his career as an apprentice in the tailoring shops on Savile Row and is reputed to have been the maker of last resort when he was finishing his

first collection—if his staff wasn't able to execute a particular cut, he would stay up all night and do it himself. (Maybe great designers are also distinguished by their insomnia.) As he matured, McQueen continued to be unswervingly dedicated to craftsmanship, commissioning lavish featherwork, wood carving, embroidery, and innumerable other techniques to realize his ideas.[5] The large-scale constructions of Heatherwick, the mass spectacles conceived by Devlin, and McQueen's haute couture all share a common basis in deep craft training and practice.

Chapter 3

THE PAPER CHALLENGE

HAVING SAID ALL THIS, we should also remember that there is more to making, and more to material intelligence, than craft alone. Design writer David Pye suggested in his 1968 book *The Nature and Art of Workmanship* that we should distinguish between the "workmanship of risk" and the "workmanship of certainty." In the former type of making, there is a chance of getting it wrong, so the skill of the worker is important in ensuring the desired result. In the latter, measures have been put in place to guarantee the desired result.

A thought experiment that I call the Paper Challenge can help to make this clearer. Imagine that someone hands you a regular sheet of office paper and asks you to divide it equally in two. What would your options be? If all you care about is speed, you could simply tear the sheet with your bare hands. That will produce an immediate result, but not a very good one, as the two pieces you're left with will be quite different from each other. If you want to achieve more accuracy, you will have to engage to some degree in what Pye calls the "workmanship of certainty." You might, for example, fold the

paper in two, making sure that the facing corners match up. This is a great example of intuitive material intelligence at work: When faced with the Paper Challenge, almost everyone will go ahead and fold the sheet by sheer instinct. Ask them why, and it may take a moment for them to realize that what they've done is to use the paper as a jig (that is, a guide for making something, like a profile used by a turner when making something on a lathe, or a stencil used in laying out a drawing). Handily enough, the paper can be used as a jig against itself, so no other equipment is required. But that's not all that is achieved by folding the paper. The material's fibers are weakened, too, making it more likely to tear along a straight line. This effect can be enhanced by creasing the sheet along the fold, perhaps applying pressure with a fingernail, a very useful tool that we have with us at all times.

If you want to achieve still greater accuracy, you might next turn your attention to the cutting process. Even a crisply folded paper can tear accidentally, leading to an inexact result. You can reduce the odds of this happening by applying further material intelligence to the situation, laying the sheet flat on a table and pulling on each side with equal force. Even then, though, the resulting edge will be softly irregular, as the paper's fibers pull apart according to their own relative lengths and position within the material. If you want to avoid this, you'll need to tool up. You could get yourself a knife, which can slice through the fibers cleanly, and a ruler to guide the cut (another jig). Or a pair of scissors, which are self-guiding (as one blade acts as a jig, or corrective, to the other).

Each of these steps, straightforward as it may seem, shifts you a little bit along the continuum between the workmanship of

risk and the workmanship of certainty. If you want to keep going, you'll have to tool up still further. You could get yourself a paper cutter with a heavy drop blade, which would allow you to cut several sheets at once with great precision. Beyond that, you'll have to mechanize the process, perhaps opening your very own paper mill. So far, you have had to choose between speed and accuracy, but as a mill owner, with your machines up and running, you can have both. Of course the machines will cost quite a bit, and so here, as we come to the end of the Paper Challenge, we encounter the old adage "Fast, good, cheap: You can pick two, but not all three." In project management, this is sometimes called the Iron Triangle. Within a given scope of work, there will always be a competition for resources among cost, schedule, and quality, so all you can do is prioritize.

Speed of execution isn't always a straightforward matter. Making also involves reflection, and this is particularly true when the stakes are high. Indeed, Pye's phrase "the workmanship of risk" is particularly apt when it comes to tasks in which the value of the material is astronomical and a mistake would be correspondingly costly. The writer Doris Lessing beautifully captured this in a short story about a gem cutter:

> To cut a diamond perfectly is an act like a samurai's sword-thrust, or a master archer's centered arrow. When an important diamond is shaped a man may spend a week, or even weeks, studying it, accumulating powers of attention, memory, intuition, till he has reached that moment when he finally knows that a tap, no more, at just *that* point of tension in the stone will split it exactly *so*.[1]

Lessing envisions her gem cutter as applying material intelligence over a long period of study. During this time, the cutter examines the stone in order to determine the best size and shape for the finished diamond. The goal is to maximize the three visual qualities of brilliance (the amount of reflected light), fire (prismatic fracturing of the light into rainbow colors), and scintillation (pinpoint sparkle), all while minimizing waste of the material.

The moment when the stone is first cut is critical, of course, but once that commitment is made the execution will proceed more or less automatically, according to the plan laid out in the maker's head. In fact, the quality of the first strike may only become clear as the cutter reaches the end of the process—a common phenomenon that prompts an oft-heard observation among craftspeople: If you have problems at the end it's probably because of something you did at the beginning. Yet there is an important and underappreciated distinction to be made here. Some processes, like gem faceting, are predetermined. There is a single moment of high risk up front, but the rest of the procedure is relatively straightforward. In other processes, like oil painting, there is the opportunity for the maker to continually change course, so that risk is distributed throughout the whole length of the process.

Other processes lie somewhere between the two extremes of diamond cutting and oil painting. In some types of basketry, for example, the form is determined by the geometry of the first few coils, but the ornament and color can be varied at will through the process and the selection of materials. A particularly wonderful example of such a hybrid structure is seen in the

work of Dorothy Gill Barnes, one of America's greatest basket makers. She is widely known for her work in birch, which involves long preparation prior to the stage of assembly. Now over ninety years old, she lives in Ohio and for many years has been in the habit of cutting simple patterns into the bark of trees that grow near her studio. She then waits months, or years. By the time she is ready to harvest the bark, the natural growth of the tree has made her scratched-in "dendroglyphs" (as she calls them) into complex natural abstractions, which she can then use in her compositions. Barnes's initial intervention into the bark has the same unalterable quality of a gem cutter's, though of course there is significantly longer delay before the job is finished. But because she works the birch into her baskets freely, she retains a high degree of control right up until the object is complete.

Even within a single discipline, then, there may be quite a lot of variation in the disposition of risk. Take painting, for

example: Much is determined by the binder that holds the pigment. Oil painting is extremely slow to dry and easily manipulated while wet. It can be applied wet-into-wet, building the rich and complex depth of colors seen in Old Master paintings by the likes of Rembrandt. Oil painting is a very demanding medium, but in a sense it is forgiving, and relatively low-risk, because it allows for constant readjustment. (Further variation is made possible through additives; if an artist does not want to wait too long for an underpainting to set, they may use a drying medium or thin the pigment with turpentine.)

Acrylic paint sets much more quickly, and so encourages a more decisive approach. However, if the artist changes their mind, they can completely cover over an initial brushstroke with subsequent layers—hard to do in oil unless one is prepared to wait a long time for the paint to completely dry.

Watercolor is all the way at the "risky" end of the spectrum. It fixes immediately when the brush is touched to the paper, and it is translucent. It muddies when one color is laid over another. Watercolorists only get one chance. It is the material qualities of these different painting mediums that determine much of their visual and emotional potential: the deep glow of oils, the brash definition of acrylic, the sensitive immediacy of watercolor.

And so, while painting is often considered to be the most canonical of fine art disciplines—and is conventionally opposed to craft—it is fundamentally just like any other making process. To do it well requires material intelligence, which begins in preparatory work, such as the stretching and priming of canvas. It also involves tools, which must be optimized to the task. For

example, in a larger work, an artist will likely want to use larger brushes or even different pigments altogether—pastels and watercolors are poorly suited to a monumental image. To be effective, artists must understand and exploit their tools and materials, managing the rhythm of risk in the way that most suits their intentions.

The master wood-carver David Esterly has written eloquently on the role of risk in learning his trade. Wood is an unforgiving medium, more like watercolor than oil paint, in that it only affords one chance. You can't ungouge a surface, and wood will simply break if you push it too far—by cutting a flower's stem too slender, for example. Though it was once among the most highly patronized crafts, sought after for everything from furniture and architecture to ship figureheads and tavern signs, wood carving today is an unusual trade. Even within the craft, Esterly is a rare bird, for he specializes in a precise and intricate style pioneered in the late seventeenth century by the artist Grinling Gibbons—arguably the most talented Englishman ever to pick up a chisel.

In his attempts to revive Gibbons's work and to restore surviving examples of it following fire and other damage, Esterly had no one to teach him. He learned the basic principles of handling his tools straightaway—one hand driving from behind, the other guiding the blade with the fingers, while the heel of the guiding hand rests on the workpiece to ensure stability. But beyond that, he learned everything more or less by experimentation. At a certain point, Esterly says in his wonderful book *The Lost Carving*, "the quality of my errors improved. I learned how to move toward the danger point, then stop short.

And pitch my tent there, because that was the territory where I, too, wanted to operate."[2]

This is another sense in which risk is critically important to making. It marks the boundary of what is possible. There are many things to appreciate in skilled craft, but very often what we notice is the quality that comes from risk: the paper-thinness of that carved leaf; a daringly fragile passage of openwork; the repetition of a single motif over and over, without a single mistake disrupting the pattern. "Early on I discovered a curious thing about carving," Esterly says. "Fifty percent of the effort will achieve ninety percent of the effect . . . [But] if you allow yourself to stop at that ninety percent, then the carving can never succeed, never really succeed. Never raise the hair on the back of anybody's neck. The last ten percent, that final zone of difficulty, is everything."[3]

Trust a carver to understand what it means to work right at the edge. Craft, at its best, provides material evidence of the limits of human capability, often showing that we can accomplish much more than we might have thought. It is, in this respect, deeply optimistic. It serves as a constant reminder of what humans can achieve when we put our mind to something and follow through.

Chapter 4

BEING "HANDS ON"

WHERE DOES CRAFT FIT within Pye's risk–certainty spectrum? You might think it lies at one extreme, with the workmanship of risk, where the result is totally up to the maker's control—no jigs, no machines, no margin for error. In fact, that is hardly ever the case. Esterly places the heel of his hand against the wood, and keeps his tools razor sharp, precisely to limit risk. Similar precautions are the foundation for any skilled process—what origami master would be foolish enough to tear a sheet in half with their bare hands? Even in the very risky procedure of striking a diamond, a gem cutter takes precautions to reduce the possibility of error, such as using cement to set the rough stone firmly in place and hold it steady. The true territory of craft is a happy middle ground, lying somewhere between risk and certainty. This sweet spot is staked out according to the nature of the job and the tools available. This leads to a key point: Material intelligence in making is not just a matter of manual dexterity, but extends to the total productive situation. An understanding of tools and raw materials is valuable all along Pye's spectrum from workmanship to certainty. Try running a paper mill without it.

And yet being "hands on" does afford a level of feedback, a back-and-forth, which more mediated ways of making do not. Craft is a two-way street: As you shape the material, it shapes you right back. You are learning the process the whole time that you are engaged in it. In automated forms of making, this doesn't happen, because the feedback loop is not nearly so tight. You can apply material intelligence to the design and operation of a factory full of machinery, and evaluate the results, perhaps going back to the drawing board from time to time. But there is a significant lag time built in. You can go home and have lunch while the machine cranks away, and to figure out how well you are doing, you might have to send the results off for statistical analysis by your quality-control technician. Craft, by contrast, is immediate. It binds both process and product to the individual maker.

We should also remember that "hands on" is only a figure of speech. Pye observed that there are very few things you can make with only your fingers. (He mentions clay pinch pots and woven baskets, and having considered the question for about twenty years, I have thought of only one other—building a drystone wall.) Nearly every act of making requires a tool of some kind, and these tools act as a conduit between the maker and the material, with information traveling both ways. A good analogy might be a conversation between two people who lack a common language. Discussion is carried out with the help of a translator, who may be more or less adept at facilitating communication. A beginner will deliver the intended sense only in fits and starts, stumbling along. An expert translator is able to produce an uncanny sense of transparency, such that the conversationalists almost forget

that there is a third person mediating between them. Similarly, a tool may be more or less suited to its purpose. When it is well designed and skillfully employed, it provides easy give-and-take, acting as an ideal feedback mechanism. You know the tool is functioning well when you stop being aware of it.

The German philosopher Martin Heidegger offered an interesting example to illustrate this point. When a hammer is in use, say, pounding a nail, you don't really notice it in your hand. All your attention is on the nail. This is a well-chosen example, for hammering is a great example of craft feedback in action. Each time you strike the nail head, you subtly register the accuracy of the blow, and either repeat or adjust the next time, again without quite noticing. But if the shaft of the hammer should break, all your attention goes to it. You are suddenly moved to question it—why did the damn thing break? Heidegger says that in this moment, you are brought in touch with the hammer's "thingness," such that "its being becomes present to us."[1] This in turn opens up a different sort of relation to material, one marked by inquiry rather than use.

The hammer, like any tool, allows for the translation of purpose into effect. In seeking to describe this mediating role (which is compounded when more than one tool is used in combination—for example, when a carver knocks a hammer against the back end of a chisel to apply greater force), we often say that the maker "works into" the material. This aptly captures the experiential dimension of making, a certain quality of immersion, which can be compared to that of an actor onstage. Like a performer playing a role, a skilled maker enters the situation at hand. The more adept the maker is, the more complete that sense of connection is likely to be, because the

frustrations and uncertainties that beset the beginner do not block total involvement in the task. Also like a good actor, who is at once being themselves and their character, the maker's awareness may be split into two levels. They are acutely conscious of the inherent properties of the material—the grain, texture, and hardness of the wood, for example—and also of their own intentions, which may be well matched to the material or may involve a degree of struggle, as when a carver literally works "against the grain."

Similarly, music has overlaps with this experiential and immersive dimension of making. Much as an actor may speak from a script or off the cuff, and a craftsperson may work to a design or not, a musician may either play from a score or improvise. In all three cases, when working to a preset plan, there will always be a distinction between the plan and the result. A script is not an evening at the theater, a design is not a chair, and a written score is not a concert. Every performance of Beethoven's Ninth Symphony is unique, though the notes to be played are exactly the same. In craft, every material rendition of a design will differ, if only minutely. No maker, no matter how skilled, can produce a truly exact copy. There will always be a process of translation from the plan (a blueprint or technical drawing, say) to the handmade result. Mass production, by contrast, is a little like playing music off a CD, the same every time. This is another important application of Pye's distinction between the workmanship of risk and the workmanship of certainty. The further we get along that continuum, the more similar each execution of a given task will be, and the less will the maker's ability be the most important factor in achieving consistency.

Chapter 5

TRICKS OF THE TRADE

PEOPLE OFTEN SPEAK OF THE "MUSCLE MEMORY"
of artisans, athletes, and musicians—the way that a skill
enters the body through repetition. Richard Sennett, in his
widely read 2008 book *The Craftsman*, cited the rule of thumb
that it takes ten thousand hours to become proficient at a craft.
This has become something of a cliché, though it is obviously
not meant to be an exact statistic. (Does it take ten thousand
hours to become a potter? Or ten thousand hours to learn
how to throw at the wheel, another ten thousand to learn to
glaze, and a further ten thousand to learn how to fire a kiln?
Conversely, would it really take ten thousand hours to
become highly skilled at tearing a sheet of office paper in two?)
Yet if the notion is imprecise, it nonetheless does underline the
degree to which craftsmanship develops over time, gradually
maturing into its own reward. As Sennett puts it, "The
substance of the routine may change, metamorphose, improve,
but the emotional payoff is one's experience of doing it again.
There's nothing strange about this experience. We all know
it; it is rhythm."[1]

Sennett is on to something in adopting rhythm, and particularly music, as a useful point of comparison to the experience of making. Like him, though not to the same extent—he studied the cello at Juilliard—I have some hands-on experience here. When I was in my twenties, I lived for a short time in my hometown of Boston. The city has a great traditional Irish music scene, and I became interested in learning to play the uilleann pipes. "Uilleann" means "elbow" in Gaelic, and the name of the instrument refers to the bellows held under the right arm, which are used to fill the bag of air that powers the pipes. The melody is played on a part of the instrument called the chanter, which looks a little like an oboe and has a double reed inside it, which vibrates and sounds the instrument when you push the air through.

I learned hundreds of Irish tunes on the pipes by heart and have often played with other musicians. A wonderful aspect of folk music is that the repertoire is shared across a very large community. Every player knows a different set of tunes, but there is a lot of overlap. Part of the joy is finding the common ground when you sit in with a new group. It's amazing to be able to play with people you've never met before, for hours on end, with no sheet music. Also typical of Irish traditional music, and folk music in general, is the fact that there is no one correct version of a given tune. The basic melody remains recognizable, but each player has a slightly different take on it. Some of this individual variation is invented from scratch, maybe even improvised in performance, but most of it is picked up along the way by listening to other musicians.

I don't play the pipes that much anymore, but even now, when I run through a familiar tune, I have a set of associations

constantly drifting through my mind. I can remember learning an ornamental variation here or there from a fiddle player in Milwaukee or an accordionist in London or another piper in New York City. And when I'm playing a tune that I know particularly well and may have played hundreds of times before, much of the interest comes from weaving these different sources together into a new configuration as I play. It's a version that could only come from me.

Craft is a lot like this. A maker who has scope for individual variation when executing a task will bring a whole lifetime of observation to it. This mental archive is like a library from which items can be called up at will, instantaneously and even subconsciously. Within the library there might be basic techniques taught in formal training sessions, but much more important will be tricks of the trade picked up by watching others at work and ideas gleaned from looking at finished objects. Above all, the material itself will have taught the maker many lessons. The way a tool bites into or slides off a surface, the length of time it takes for a particular type of paint or clay to dry to a desired consistency, the way a fabric cut a certain way will fall across a person's body: All of these insights are built up gradually. We often say this learning happens "by feel," and the compendium of a maker's tricks may indeed hover below the level of active consciousness. Even so, it is absolutely intrinsic to their craft.

Chapter 6

TOOLING UP

THIS GETS US BACK TO TOOLS, for one of the very valuable things about them is the way they act as repositories of accumulated material intelligence. Once you are familiar with a fretsaw, a laser cutter, or a Jacquard loom, you will immediately recognize its effects in a finished piece of work. Furthermore, the more powerful and efficient the tool, the more it tends to determine the result. Drawings made with a computer-driven plotter more strongly reflect a predetermined aesthetic than drawings made with a pencil, not because one is digital and the other analog, but simply because the computer handles so much more of the process than the pencil does. Every tool, though, no matter how simple, has a distinctive "handwriting." If you haven't seen the tool in use or are simply unaware of making processes in general, as many people today are, you will literally be blind to this aspect of the material environment, as illiterate in matters of furniture and fabric as someone who can't read English would be if handed a copy of the *New York Times*.

This is a lot to miss out on. If a certain tool has been in use for a long time, there may be the knowledge of generations,

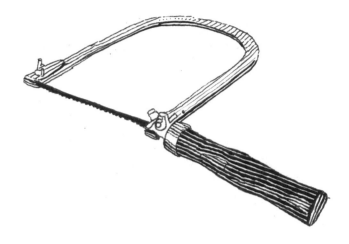

even centuries, embedded in it. Consider the humble fretsaw. We had one in the basement when I was growing up: a thin cutting blade, held in a C-shaped frame with a handle. Little did I know that this tool was invented in Renaissance Europe, initially in order to cut the gears and other workings for clocks. Or that its use was brought to a high state of perfection by the Parisian cabinetmaker André Charles Boulle, who provided furniture to the court of Louis XIV. His signature decorative treatment was marquetry made of various woods, horn, metal, tortoiseshell, and other materials, all of which were cut with a fretsaw. So influential was his work that the tool itself acquired his name. In France and Germany, it is known as a Boulle (or Buhl) saw to this day.

To understand how much material intelligence is packed into the slender fretsaw, let's consider how Boulle and his artisanal workforce would have made a marquetry panel out of thin sheets of wood and brass. When finished, the result looks like a solid wood panel with brass inlaid into it. Actually

this is deceptive, for it is really like a jigsaw puzzle in which the two materials (a thin sheet of brass and a wood veneer) have been cut in reverse image to one another. To achieve this, rather than cutting each material separately, the artisan stacks them together in a packet and cuts through both at once, ensuring an exact match. This approach has another advantage, too: By swapping the little jigsaw pieces, one can create two versions of the same panel design, brass-on-wood and wood-on-brass (known in French as *partie* and *contrepartie*). The cutting must be done at an angle, because otherwise, you'll be able to see the "kerf," that is, the material lost in the cut itself, which will be the same thickness as the saw blade. With an angled cut, the layers can be placed snugly alongside one another, hiding the kerf and creating the impression of an intact sheet.

The fretsaw can do all this because of its combination of strength and maneuverability. The thin, flexible blade makes it possible to cut very tight curves into wood, plastic, or metal, while the deep C shape of the frame allows the user to pivot around the sides of the workpiece. The cleverest part is that the blade is removable. A heavier or lighter gauge of blade can be swapped in, depending on the material to be cut and hence the strength required. Just as important, the user can work from the center of a sheet of material rather than its edge, as the blade can be detached, poked through a drilled hole, and reattached to the frame prior to cutting. Like most tools, the hand fretsaw has inspired other, more complex variations, again over the course of centuries. Already by Boulle's time the fretsaw had been developed into the scroll saw, named for the decorative

scrollwork it was often used to make. A scroll saw also has a removable cutting blade, but it is mounted in a heavy iron stand to provide stability and strength. A foot pedal drives the cutting action. Modern scroll saws have been further improved through electrical power, variable cutting speed, and a cutting table that can be precisely angled.

These days, the scroll saw is being given a run for its money by laser cutters. In theory you could use one "by hand" (maneuvering the workpiece under the laser), but in practice they are always digitally driven. When following a vector drawing, the laser cutter works very quickly, with great accuracy and absolute repeatability—a great example of Pye's workmanship of certainty. I recently visited an industrial fabrication shop in Brooklyn that has one of the world's largest laser cutters in operation. As a demonstration of its power and speed, the technicians took a square sheet of steel, about ten centimeters on a side and a millimeter thick, placed it on the cutting bed, and zapped a hundred perfectly round holes into it in a perfect grid pattern. The programming took less than a minute, and the cutting process, which was fun to watch (extremely loud, lots of sparks), took maybe four or five seconds. Achieving the same result with a hand fretsaw, even if you could cut through the steel, would take many hours and could never be so accurate.

If you are making only one piece and the pattern you want to follow is fairly complex, a scroll saw may still be the way to go, as you don't need to take the time to set up the machine. But if you are making many versions of the same pattern and need each one to be exactly the same, a laser is much more

efficient. On the face of it, this powerful technology seems very different to that of Boulle's saw, and a big step forward in terms of material intelligence. But the conceptual basis of the tool is the same. After all these years, the goal is still to execute free-form cuts on a flat sheet. The laser burns right through the material, so it can be used to begin a cut in the middle of the workpiece, just like a fretsaw with a removable blade. It seems odd that such a high-tech piece of industrial equipment could have its historical roots in extravagantly decorated cabinets made for the Sun King, but that is nonetheless the case.

Similar stories can be told about many other tools. If you want to see the effects of material intelligence accumulated over time, take a good long look at a weaving loom. Nifty as a fretsaw is, it cannot compare to the complexity of such a machine, which interweaves warp and weft threads into textile. The point is often made by textile specialists that the loom was the direct historical predecessor of the computer. This is true in two senses: first, in that the earliest computer designer, the British mechanical engineer Charles Babbage, employed the same kind of punch cards in his so-called Analytical Engine as those that were used to program Jacquard looms; and second, in the more general sense that a loom, like a computer, is a machine for storing and executing very complex patterns, expressed in binary (on/off). Like any tool, but to a very advanced degree, a programmable loom is a repository for human know-how.

To understand the way a loom works, it is helpful to have graph paper on hand, or at least to imagine a sheet of it. The

pattern for a plain weave will look like a regular checkerboard. Each horizontal line of the graph paper denotes one "pick," that is, the passage of the weft thread horizontally across the loom. Each vertical line reflects a warp thread, held in tension on the loom. Squares left white on the graph paper denote the warp threads which are to travel under the wefts, and which are not picked up during the weaving process. Squares filled in black denote threads that do get lifted during the weaving; each warp is held in a little loop attached to a wire, called a heddle. In a plain weave, every other warp thread is lifted as the weft thread is pulled across. For the next pick, alternate warps are picked up—hence the checkerboard pattern. Do this over and over again and you have a simple fabric.

To design more complex textiles you need more graph paper. If you are content to weave in only one color, you can simply vary from the checkerboard to a different pattern. For example, you might have the weft passing over multiple warp threads— three white squares in a row—rather than simply going over-under-over-under. This is aptly called a "float" and produces a smooth effect. A fabric made with a consistent pattern of floats is described as a satin weave, so that gives you an idea of the tactile result. More complexity can be achieved by introducing multiple colors or multiple types of fiber, each of which gets the equivalent of its own sheet of graph paper pattern in the design process. As you may appreciate, the possibility for complication becomes enormous rather quickly.

This is why the Jacquard loom, named for its French inventor, Joseph Marie Jacquard, and publicly unveiled in 1801,

was so important. He devised a means for storing the pattern of each pick (again, that's each single passage of the weft thread through the textile) into a series of punch cards, chained together and fed automatically into the loom. This system completely revolutionized the textile industry. The most ancient forms of weaving had been done on standing frames or so-called "backstrap looms," in which the warp threads were anchored by the weaver's body. As she leaned back, the threads were put under tension, and she could insert a shuttle holding the thread first this way then that. This system can be used to make beautiful, though narrow, textiles—only as wide as the weaver's body. The complexity is limited to what the weaver can accomplish by hand, picking up threads one or a few at a time, and also limited to what the weaver can either plan and remember, or improvise.

By contrast, the industrial looms that preceded Jacquard's innovation were able to "remember" twenty-four or so different patterns, any of which could be applied to a given pick. This permitted great variation but nothing compared to what Jacquard achieved. His introduction of the punch cards meant that every single pick of a textile could be unique, no repetition required. Setting up such a loom required intensive labor. Many Jacquard looms were only ever "programmed" with a stack of cards once and used to make the same textile over and over again. But once it was operating, such a machine permitted weavers to make fabrics of unprecedented complexity, even pictorial weavings that rival handmade tapestries in their level of detail. The skill and knowledge of making were invested up front in the machine and in the design.

In an interesting case of coming full circle, today's looms are themselves computerized, powered by the very technology they helped to inspire. Rather than punch cards, they typically employ automated pegging systems that trigger movement in the heddles holding the warp threads. This situation begins to approximate our earlier example of cutting paper in a mill, rather than with a pair of scissors. We are far along the spectrum toward Pye's workmanship of certainty. Likely the machines are used to produce large batches of fabric, possibly measured in miles, not yards. Diversity in the result may still creep in due to variation in the threads—the color of a particular dye lot, for example. But in industrial weaving we have left the domain of direct craftsmanship behind. This doesn't mean that material intelligence is any less important, however—as you might well reflect if you were about to hit the start button on a machine that can produce miles of cloth without stopping.

This is exactly what Scott Bodenner, a textile designer based in New York City, contemplates when creating one of his custom fabrics. Though he usually works in smaller batches (measured in yardage, not mileage), Bodenner has been motivated by ecological concerns since his student days at the Rhode Island School of Design. He had originally hoped to study architecture but discovered that his attraction to materials and structure was better suited to textiles. ("Hay bales and earthships," he says, laughing, "were not exactly flying with the architecture professors.")[1] Today, he works with a range of different fiber types, focusing mainly on interior furnishing fabrics. Like most weavers, he loves the textures of his materials:

the irregular slubbing of linen, the fine gloss of silk, the warmth of wool.

But Bodenner's most distinctive fabrics involve unusual fiber materials. Many of these are recycled. He often uses offcuts from American cotton mills or Italian luxury silk factories, the kinds that make neckties for the likes of Gucci and Prada. Weaving these materials salvaged from the "waste stream" of the textile industry raises logistical challenges, but he actually prefers such reused fibers because of the richness of the palette. Instead of one uniform red, he can combine many different tints into a color of unbelievable sumptuousness. For this to work, he must secure a reliable source of high-quality recyclable material. It's not good enough to find a boxful of beautiful unused threads, because once they are used up the fabric will have to be discontinued. He has become a connoisseur of textile factory waste.

At the more experimental end of Bodenner's practice is a fabric called Mix Tape, which he makes using salvaged 1970s and '80s cassettes—a generation's lost music, rendered in curtain form. He has also created a spectacular glow-in-the-dark furnishing fabric, which combines a fine Italian linen with a thinly slit plastic film that is translucent in the light but can absorb energy and release it in the dark. By day, it is already beautiful and delicate. By night it makes you feel like you are in a particularly luxurious cabin on the USS *Enterprise*. This is an extreme example of one of Bodenner's key design goals: to make fabrics that have a personality, a life of their own, and coexist interactively wherever they are used. Whether he achieves this with light effects (he has also used reflective and

even holographic materials), or through more conventional means like variable dyeing and weave structure, he always wants to "give you something you can engage in, invest in."

If you met Bodenner, he would probably strike you as the quintessence of a craftsman—and not just because he sports a rather magnificent beard. Apart from one occasional assistant, he works entirely by himself. He keeps a loom in his dining room. Yet the real secret of his success is that he understands industry. He is always thinking about the constraints of the various mills he works with, whether they are in North Carolina, Germany, or Italy. These are, in effect, his tools, and he has to know their capabilities intimately. As Bodenner puts it, these parameters serve as the "exoskeleton" for his designs. Once he has drawn out the pattern for a specific fabric, usually by hand on graph paper, he enters it into what he calls "loom language," a computer program that speaks directly to the mill's equipment. Typically he will first create a "blanket" with a series of minor variations on the design—each of which shows up as a narrow band, perhaps only four wefts' worth—so that he can evaluate the effect. While he can imagine what a fabric will look like just from looking at its design pattern, more or less, there are always surprises. Bodenner delights in this unpredictability, what he calls the "mystery of the loom." His work is a testimony to the fact that analog and digital know-how can literally be interwoven to achieve a terrific result.

I wondered, when talking to Bodenner, whether the subtle qualities of his designs are really appreciated by the people who encounter them. Once upon a time, textiles were the most concentrated form of wealth that most people were likely to

encounter. Embroidered bed hangings made from Indian cotton, or dresses fashioned from imported Chinese silk, might well be the most expensive items in an aristocratic home. Fabric was so precious that it was handed down again and again, not only from parents to children but also down the social ladder, from gentry to servants. Each successive owner would recut the cloth to fit a new purpose. Such habits survived until relatively recently in the United States. A famous example is found in the quilts made by women in Gee's Bend, Alabama, who took the worn-out denim work clothes used by their families out in the fields and composed them into asymmetrical compositions of great complexity and beauty.

As with so much of our material environment, textiles have become much cheaper, and our attention to them has diminished, too. Most contemporary Americans would see the beauty in a Gee's Bend quilt (I hope), but how many would recognize that it is made of hard-wearing twill cotton? How many even know what twill is?[2] Or the differences between the main natural fibers—cotton, silk, linen, and wool—to say nothing of various synthetics? How readily can people appreciate the carefully conceived and executed fabrics that a textile designer like Bodenner makes? He has an interesting response to this question: "I think people do like good materials. But we're in a time when the constraints of production and the scaling up that our industries require don't leave much room for fineness, or actually that much interest, in the fabric." When price competition drives down the cost of upholstery fabric to seven dollars per yard, it doesn't allow someone like Bodenner much room to operate. This race to the bottom has left most

people without much experience of good cloth, such as people a century or two ago would certainly have had. "We have left a more careful consideration of materials behind, for price and production speed," he says. "However, I think we miss it. I think people want it back—they just don't have it."

Chapter 7

LEARNING BY DOING

ERE'S A THOUGHT EXPERIMENT: Imagine that the skill of playing the violin had died out long ago and been forgotten, and you stumbled across a Stradivarius in an attic. Assuming you even recognized it as a musical instrument, how would you go about learning to play it? This question was suggested to me by Chris Pellettieri, a stone carver who lives and works in New York City. His guess is that most people would rapidly become discouraged, decide it was completely impossible, and throw the Stradivarius away.

Pellettieri has good reason to think about the prospect of vanishing skills. It is easy to overplay the degree to which many crafts are endangered or dying out, and there is no doubt that a "last one standing" syndrome is at work in many cases. The final living exponent of a particular tradition has a remarkable, and marketable, romanticism attached to it. Leaving such nostalgia aside, however, history does indeed give us countless opportunities to reflect on the unanticipated losses brought about by technology. We should understand the obsolescence of any skilled trade to be a decline in the sum total of human

experience. Pellettieri offered me a valuable perspective on this point, as the practitioner of a millennia-old craft. "We developed our brains through tool use, and understanding of materials—what to use for a rope to catch food, how to build a shelter. I think it's what defines humans, material intelligence."[1]

Accordingly, Pellettieri finds it sad that, when faced with any sort of work that needs doing, our culture immediately tends to ask: "How can we make a machine that can do this?" In contrast to an emphasis on the short-term benefits of mechanization— faster, cheaper, no training required—he takes the long view. The current drift away from material engagement is "just a trend," he says, "but a trend that's out of control. It's as if beavers were phasing out their lodges, no longer using their tails to pat down the mud. We're not doing what our brains and bodies were developed to do."

Stone carving is a case in point. Artisans who specialize in this craft make their colleagues who work in wood, like my grandfather or David Esterly, look positively mainstream. Pellettieri is one of the few really masterful practitioners of the medium left in the United States. He was for some time the head carver at the Cathedral Church of St. John the Divine in New York City and was kept busy repairing the ornament of this beautiful neo-Gothic building. But then his shop at the church was closed (the land was sold to a developer, who wanted to build a condominium on it). Since then, between jobs, he has made much of his living by teaching others— making him a font of wisdom when it comes to the trade.

Like any material, stone is fully legible only once you understand something of its nature. A working knowledge of

geology is helpful. Stone comes in three basic types: stratified, igneous, and metamorphic. Stratified varieties, like limestone and sandstone, form gradually over centuries under pressure. When worked by a carver, a stratified stone tends to flake along the direction of its built-up layers. Igneous rock, like granite, is formed quickly by volcanic activity; it has the features of a liquid quickly cooled and may have veins of impurity flowing through it. Metamorphic rocks, like marble and slate, are the result of transformation brought on by heat and are often fine and crystalline.

That may all sound helpful, but there is a big difference between reading about stones and picking up a hammer and chisel. I was lucky enough to get a lesson in carving by Pellettieri. We worked in limestone, his favorite material because it looks best when tool marks are left evident on its surface. While other materials require polishing to bring out their translucency and color, polished limestone looks boring, like concrete. In this sense, it encourages the skilled carver to demonstrate their technique. Limestone is also relatively soft to work, unlike granite, which is so hard that it cannot be chipped away. Rather, one must "pulverize it," as Pellettieri says, knocking the chisel into the stone at a nearly ninety-degree angle.

Pellettieri has a wonderful metaphor he uses when teaching, which pertains to the first three tools that he gives to a student. "Think of the stone that you are starting with as your starting point, and the vision of what you want to carve as your destination," he says. "The tools are the vehicles that are going to take you there." First comes the punch, also known as a

point, which is just a square steel rod sharpened at its end. He compares this tool to an airplane, because it takes you the farthest distance in the shortest time, by breaking off the biggest pieces. But just like an airplane, it's also the least precise. "You can't land at your destination and then walk right into your hotel and sit on the couch." Using the punch in my inexpert way, I could understand what he was saying. Big chips and chunks flew from the stone willy-nilly. I was removing a lot of material, quickly but unpredictably.

Once I finished with the punch, Pellettieri said, "Okay. You've made it ninety percent of the way there, but you still need to get transportation from the airport." He handed me the next tool, the claw, which he likened to an automobile. It is a flat bar of steel with small teeth cut into its end, intended for rough finishing work. Sure enough, when I switched to the claw I found that I could control my cuts much more accurately, leaving clear grooves wherever I tapped the tool into the surface. Soon it was time for the final tool, the flat chisel, which removes only small sand-sized particles from the limestone. The flat chisel is ideal for doing precise detail—the linear flourishes in inscriptions, hair on a sculpted head—and also for finishing smooth surfaces on the work. But it goes slowly. This is like walking, Pellettieri said: "It gets you right where you want to go."

Of course, there are many more stone carving tools than the three I used in my initial lesson. On the other hand, sculptures can be beautifully carved even with one tool; Michelangelo's famous slave sculptures in the Louvre were made mostly using a punch, a fact that astounds me now that I've used one. It was

not so much the full tool kit that I was learning from Pellettieri, but rather the basic framework in which future learning could happen. This points to the importance of metaphor and concept in acquiring material intelligence. Too often, learning a craft is caricatured as simple imitation: "Do as I do, not as I say." But any good teacher will outline principles as the student goes along.

Notice that Pellettieri's ingenious vehicular analogy would also work well for other skills, too, like painting: a big brush for the broad strokes of the form (that's the airplane), a medium brush for building up volume (the car), and a fine brush for the detail work (going on foot). Each of these aspects of a picture offers its own enjoyment for the viewer, though this may take some time to appreciate. Many people who have not spent a lot of time looking at paintings tend to focus on the overall composition, the story told by the artist. But as the critic Wayne Koestenbaum notes, "Sometimes it's important not to stand back from a painting. Sometimes it's important not to take in the big picture."[2] There is much pleasure to be had in the intricacies, the way that a certain brushstroke lands on the canvas, perhaps mixing with others already laid down, perhaps standing proud from that surface.

Koestenbaum's observation is worth remembering when thinking about craft, for most types of making involve many small, discrete actions. Together they accumulate into the form. Success comes from the coordination of these micro-events, the way they cohere either through repetition or meaningful variation. This is also how one learns a skill. Think back to Pellettieri's thought experiment, that of someone finding a

priceless violin when they have never seen one before. Absent any indication about how to approach it, it will remain stubbornly inert. But give a beginner even a few tips, and they can start scratching out a tune, modeling their playing on the teacher's.

It is important that the gap not be too immense—there needs to be some satisfaction along the way. Pellettieri laughed when he told me about his first attempts to draw, which were directly inspired by Norman Rockwell. "That was a terrible choice," he recalled, "because he paints so photo-realistically. It just discouraged me." So long as the next goal is in reach, though, and the overall framework continues to be comprehensible, the student should be able to keep learning. Their hands will be guided by the principles they are gradually coming to understand, and those principles will gradually become clearer through the tactile reality of execution. It's another trip on the two-way street of making.

Chapter 8

PROTOTYPING

IN PELLETTIERI'S WORK AS A CARVER, material intelligence is applied in a very direct way. While he may well have a notion of what he wants to create before he begins—perhaps even a measured drawing—he finds the form primarily through the act of making. This is craft in its most straightforward aspect, with a tight feedback loop between intention and result. Whether striking a chisel into limestone, raising silver sheet with a hammer, or blowing glass on the end of a pipe, the artisan is up close and personal with their product. But many making processes are not like this. They are indirect, in the sense that they involve tooling up. Often, there is a dynamic relationship between the tool originally used to conceive a product (like the loom in Scott Bodenner's apartment) and the tool that will eventually be used to produce it (like the big computerized loom in a North Carolina mill). Typically, such multiple-stage forms of making involve some form of prototyping— that is, making one object as a precedent for another. These models have a huge impact on the way the world around us

comes to be, though it may take a certain amount of sleuthing to see how.

A good example is automotive industry design. In the 1930s, with the end of the reign of the Model T Ford ("you can have any color as long as it's black," as they used to say), aesthetics became a more competitive factor in car manufacture, and companies established large offices staffed by full-time stylists. Some were specialist renderers, who used airbrushes (handheld tools hooked up to compressors, which emit a fine spray of atomized paint or ink) in combination with pencils and fine pens to create curvaceous and subtly shaded drawings. These sketches were then used as the basis of models, first at one-quarter scale and then actual size, in unfired clay. The advantage of using this material was that the shape could be finely adjusted, each line being shaved down or built up just so. Because of the difficulty and labor involved, the modeler would sometimes make only one half of the vehicle, as if it had been split down the middle from the hood ornament to the back license plate. By putting a mirror against the flat side, it was possible to create the illusion of a whole symmetrical car. Once the body shape was finalized, the clay model was carefully measured and transferred to blueprints, which were used to make the tooling to manufacture the actual cars.

This design repertoire of airbrush and modeled clay had an important role in inspiring the streamlined aesthetic of midcentury cars. Both mediums were ideal for making smooth, gentle curves. In the 1960s, however, there was a shift. Instead of airbrushes, auto stylists in Detroit began to use blunt, felt-tipped markers, which had been popularized in the previous

decade (Americans will be familiar with the brand name "Magic Marker," which was invented in 1953). This drawing tool, which works by wicking water-soluble ink out of an internal repository, is faster and requires less skill to use than an airbrush, but it is much less subtle.

Around the same time as designers adopted felt-tipped markers, they also began using colored tape to rough out the profile of a vehicle at full scale. These two design mediums together contributed to a new look in automobiles, with hard edges and boxy volumes, familiar to us from the "muscle cars" of the era. Shifts in three-dimensional modeling processes also had an important effect on the finished product. Though the industry continued to rely on unfired clay to make large models, now the designers visually articulated them with the same sort of tape they used as a sketching medium. According to a master model maker at Ford Motor Company, "Tape gives us a defined line that is like a carpenter laying a level line on a building. So when the designers put tape on the model, there is no question what their intent is."[1] The differences between a streamlined 1937 Pontiac and a choppy 1967 Ford Mustang speak directly of the tools used in envisioning the cars.

Today, in almost all automotive factories, digital design processes have displaced sketching by hand and clay modeling. Watch the vehicles roll past you on a highway next time you are in traffic: The cars look more or less the same, and their compound curves both look and feel like they were born on a screen. Brooks Stevens, the industrial designer, indignantly called it "the bland-izement of the American automobile." There are a few holdouts, mostly in the upper echelons of the

industry. Ferrari, for one, still uses the old way, and even has its clay models painted by hand in order to achieve astonishing verisimilitude. Only the parts of the vehicle that need designing are actually modeled, so sometimes the prototypes are bizarre combinations of mass-produced metal parts and handmade clay elements. The craft-intensive methods that Ferrari uses are essential to realizing the distinctive, aerodynamic shapes of their cars.

I once had the chance to incorporate such a hybrid object into an exhibition. It was 2003, I was living in Milwaukee, and Harley-Davidson was celebrating its one hundredth anniversary. The event was quite an experience—hundreds of thousands of motorcycles converged on the city. The streets seemed to rumble from the engine vibration. (My grandfather Arthur, then eighty-four years old, also came to town and charmed the bikers he met with tales of riding his '38 Harley from Kansas to California.) As part of the festivities, the company collaborated with the Milwaukee Art Museum to

create an exhibition called *Rolling Sculptures*, which I helped to curate. The star exhibit was a 1996 prototype for a bike called the V-Rod. This full-sized model had "real" elements, such as the wheels, engine, handlebars, and rearview mirrors. To indicate the shape of the bodywork, which had been initially established digitally, it also had clay elements refined by hand sculpting. In a striking instance of material translation, the elements on the V-Rod model that were shaped by hand in clay corresponded to parts that would be hydroformed in aluminum when the bike was manufactured.

Hydroforming is a replacement technology for stamping, a basic industrial process in which a flat sheet of metal is pounded into a die with a hammer, at very high power.[2] Aluminum is a challenging metal to stamp. Though strong and light in weight, it is not as ductile as steel—that is, it doesn't stretch well—so it is not suitable for pressing into a complex or tight curve. Hydroforming is a big improvement. Instead of the single impact of metal against metal against metal that happens in die stamping, it works by exerting hydraulic force against the sheet. The material is coaxed gradually into the die with pressurized water. With this technique, shapes can be realized that would be impossible through conventional stamping. The Harley V-Rod attests to the advantages of this process, and also to the fact that clay was the perfect medium in which to work out the undulating contours achievable through hydroforming. The motorcycle may have been designed on a computer screen, but it was manufactured using both low-tech and high-tech material intelligence.

Chapter 9

ONE THING FOR ANOTHER

PROTOTYPING IS JUST ONE OF MANY SORTS of making in which one material takes the place of another. This is a common situation for craftspeople, and one that doubly tests their material intelligence, because the maker needs to understand both materials intimately. While there are many examples of such switching around, all of them interesting, the most demanding and intriguing kinds are those that are actually intended to misrepresent. I don't mean the momentary trickery of trompe l'oeil ("fool the eye" in French), but cases where makers truly intend to deceive, as in the case of a forgery. A good fake may be ethically indefensible, but there is little doubt that it represents an extreme instance of craft excellence. Trompe l'oeil only needs to look the part for a moment, long enough to give a viewer pause, a pleasurable diversion. A fake, by contrast, must be deceptive all the way down, as it were, even under close inspection.

Making an exact copy, deceptively or not, is such a demanding task that it could serve as a good objective test of craftsmanship. Even the act of making a symmetrical object is such a test of

skill, because it requires the maker to copy their own work—to produce two sides that are the same. Psychologists have speculated on why we seem to prefer symmetry in our objects, suggesting that perhaps it's because the human body and face are more or less symmetrical, and we like objects that look like us.[1] That may be, but an equally compelling argument is that symmetry acts as a natural proof of workmanship. It allows us to immediately assess the quality of anything made by hand.

Imagine that you were faced with thirty painters and had to decide who was the best of them. There are many criteria you could use to arrive at such a judgment, involving various types of skill (dexterity of mark making, expressive control and range, scientific understanding of the medium). But if you were trying to assess only the painters' objective level of craftsmanship, a good test would be to ask each one to make a duplicate of an existing painting, and see whose came closest. This is exactly what fakers learn how to do, of course, and the best of them amass incredible know-how about techniques and materials along the way.

Making a persuasive copy of a Renaissance panel painting, for example, will require extensive understanding of timber and its historical usage, the grinding and preparation of pigments, the way paint shrinks and cracks over time, and many other areas of specialist technical expertise, not to mention innumerable stylistic and iconographical issues. It's a good reminder that craft skill does not necessarily equate to moral virtue. The theorist of workmanship David Pye made a similar observation, noting drily that good craftsmanship has "doubtless been practiced effectively by people of the utmost depravity."[2]

Be that as it may, fakes and the charlatans who make them seem to exert a powerful hold on the imagination. Notorious forgers have inspired numerous films, among them the wonderfully strange *F for Fake* by Orson Welles, a portrait of Elmyr de Hory, who made an excellent living knocking off Picasso and other modern masters. The more recent documentary *Art and Craft* details the exploits of Mark Landis, who made no money from his copies, but nonetheless successfully defrauded numerous American museums by giving the works in the guise of a generous donor. Among my own favorite examples of the faker's art is a counterfeit Botticelli called the *Madonna of the Veil*, made by the Italian forger Umberto Giunti. Acquired by the Courtauld Gallery in 1930 as a masterpiece by the Renaissance artist, it was sniffed out by the art historian Kenneth Clark, reportedly because he noticed that the pencil-eyebrowed Virgin Mary looked suspiciously like the film actress Jean Harlow.

Museumgoers are often more interested in fakes than they are in genuine antiques, and I don't blame them. Fakes are fascinating. Another show I did in Milwaukee, one of our most well attended (if not quite as popular as the Harley-Davidson show), was about a group of American furniture pieces that purported to date from the seventeenth and eighteenth centuries. In truth, all had been made to order in the 1960s, by a single craftsman working for a single dealer selling to a single client. Over fifty years ago, when these fakes were made, the connoisseurship of American decorative arts was in its early days, so it was relatively easy to perpetrate this hoax. As Luke Beckerdite and Alan Miller, the experts who discovered and

analyzed the Milwaukee fakes, have written, "Nearly every collection of American furniture assembled during the last century has included objects that were intended to deceive."[3]

Yet the objects in our exhibition were, in their own way, rarities. The unscrupulous dealer had been particularly bold in selling inauthentic pieces to the same collector over and over again, and had relied on the same artisan to execute the forgeries. As a result, we had the opportunity to study this faker's work in some quantity. It was fascinating to see certain recognizable techniques pop up in one apparently old piece after another: habits of using the chisel when making decorative carvings; chemical treatments used to make the wood look older; artificial distressing done by banging a bunch of heavy keys against the surface, which looks convincing the first time you see it, but is easily spotted when you know what to look for. The faker sometimes salvaged parts from old objects, which were perhaps broken or incomplete or simply not very valuable, and integrated them into his creations. He also was in the habit of directly copying genuine pieces, particularly chairs. Seating furniture was often made in sets of six or more, so if a "new discovery" looked just like an existing example, it raised no questions. As Beckerdite and Miller sniffed out all these nefarious techniques, they were essentially conducting a duel across time, pitting their own material intelligence against that of the faker.

These tricks of the trade go back a long time. The market for antiques started in earnest about 150 years ago in France, and no sooner did people start paying high prices for old objects than fakers started to simulate them. One of the great characters

in the history of forgery is André Mailfert, who specialized in giving newly fabricated wood and bronze furniture a false patina, to create the appearance of old age. In a sensational tell-all biography that he published at the end of his career, entitled *Confessions of a Professional Makeup Artist*, he recalled that he roasted furniture over a fire in order to blacken it and kept large jars of dust gathered from old church attics, which he carefully sorted by date. An ersatz fourteenth-century piece at least got dust from a genuine fourteenth-century church.[4] Some of Mailfert's tales were probably as phony as his furniture, but there is no question that fakers have to know their stuff, otherwise their work can be detected straightaway.

Material transposition—remaking something in a different material from the original—is often like making a fake. When it's done really well, it can be almost impossible to tell that it has been done at all. It is a kind of making that hides its own tracks. The art of repair is another example. Though an object can be fixed in lots of different ways, the most challenging goal is to make a broken object "like new." In many cases this will involve replacing the original material with a visual double— tinted epoxy for porcelain, a light colored wood dyed to match mahogany. This requires tremendous sensitivity to both the original fabric of the object and the replacement material.

Not all repairers wish to make their work invisible. The Japanese technique of *kintsugi* (literally, "golden joining") is a celebrated example. When a valuable ceramic object has a break or chip, it is filled with clear lacquer mixed with metallic powder. Once this infill has been burnished it gleams brightly, drawing attention to the repair and hence to the life story of

the object. Because Japanese pottery is so revered for its historical associations, marking a crack in this way can even enhance the appeal and cultural stature of a particular teabowl or jar. The juxtaposition of luxurious gold against humble clay speaks to the unusual situation of these pots, which often originate from anonymous country kilns but are taken up as revered treasures by wealthy aesthetes. In the case of *kintsugi*, material transposition is not meant to pass unnoticed, but to speak clearly and eloquently.[5]

The technique of gold repair has become so iconic among designers that many have adapted it using other materials; a reasonable facsimile can be produced with materials from a hobby shop, like rubber cement and gold metallic paint. A more contemporary means of fixing, however, might be to use the fast-curing, silicon-based wonder material Sugru. Developed by the Irish designer Jane Ní Dhulchaointigh when she was a master's degree student at the Royal College of Art, Sugru is saturated in material intelligence. As I mentioned in the book's introduction, many contemporary digital devices are impossible to fix. But of course regular old analog products can be a challenge as well. The temptation is always to toss away whatever is broken. Ní Dhulchaointigh and her business partners are motivated to reduce waste, by providing an alternative to the landfill.

Imagine that the handle on your expensive Italian stovetop coffee maker breaks. What are your options? Unless you are a designer or manufacturer yourself, you are unlikely to be able to cast a new one in plastic, and though it wouldn't be all that difficult to carve one from wood, you probably wouldn't

bother. So into the trash bin the coffee maker goes. Same with a frayed power cord for your laptop. Sugru offers another way. When you squeeze it out of the tube, it has the consistency of Play-Doh or modeling clay. Yet it is adherent to a remarkably wide range of materials, including plastic, glass, ceramic, wood, and metal. And once it hardens, it has the feel and durability of rubber, so it's not going anywhere.

Ní Dhulchaointigh's success with Sugru is partly thanks to effective chemical engineering. To make the company a success, she had to line up not only investors but also scientists, who worked with her to produce just the right mix of silicone, talc, and reactive compounds to make it work properly. Even before this experimentation began, she had to have the insight that our everyday environment could be improved, if only we had the perfect material to fix stuff. The real innovation of Sugru is therefore not chemical, but cultural. It puts the opportunity to fix things into anyone's hands, whether they

are skilled or unskilled. The product is not just intended to make money or to be innovative for its own sake. It is meant to reshape attitudes to the materiality around us, putting us less at the mercy of the objects we own and enabling us to fix and alter them as suits us best.

Chapter 10

FACE TO FACE

A S ROUGH-AND-READY AS THE RESULT may look, a power cord repaired with Sugru is uniquely personalized, or we might say, "bespoke." Prior to the advent of industrial production, this term could have been applied to most anything made for use. Clothing, dishes, carts, scientific equipment: Up until the late eighteenth century, virtually everything was made to order. The whole world was bespoke. The town where I grew up—Stoneham, Massachusetts— is a good example. It is mostly residential now, with one small shopping mall. There is no manufacturing there at all. But when it was founded, it had a thriving artisanal economy. Its stony soil made for poor farmland, hence the town's name, so agriculture was not an option. Instead, the people who settled there focused on shoemaking.

To this day, the town seal is like a step-by-step diagram of the local craft: There's a goat at the top to provide the leather, a hammer in the middle to do the making, and a heeled shoe with a high leather upper at the bottom. At the local historical society you can see a "ten-footer," a little building ten feet wide and ten feet deep, with a sign reading MADE AND REPAIRED. It served as

the home and shop of a single shoemaker, or cordwainer, as they were called in those days. The town used to be full of these little buildings. The shoemakers lived in the back of each ten-footer, and customers were received in the front, where their feet were measured and shoes were made to fit. Stoneham's economy was built on these face-to-face transactions.

Today, the term "bespoke" is used mainly within the high-fashion industry, and it suggests a very exclusive, expensive form of consumption. A bespoke suit is one made just for you, fit to your body in a way that makes you look best—or at least, best according to the standards of a particular tailoring style. These details reflect traditions of place. For example, in making men's suits, the British favor heavily padded jackets, which build out the shoulders and chest. The Italians, living in a hotter climate, make suits that are beautifully cut but minimally lined, fitting more sleekly to the wearer's frame. The two styles also feature distinctive habits of craft, particular ways of rolling and sewing the shoulder, cutting the lapel, and even putting in the buttonholes. Also infused with regional character are the fabrics from which suits are made. Many upscale tailors hoard special textiles, some of them a century old, as a special selling point. As the fashion historian Christopher Breward notes, even the names of these fabrics "read like an ode to the traditional landscape: Saxonies and Cheviots in plain or Panama, hopsack or Celtic, Mayo, Campbell or Russian twill, Bannockburn, Eton stripe or Glenurquhart check."[1]

This kind of local flavor is typical of bespoke production, and again, it used to be much more commonplace. Apart from a few old buildings in its town square, Stoneham today is almost

indistinguishable from any other town nearby. The stores are all national chains, and there is little you can buy that will engender a personal encounter with a maker. If you encounter this dynamic at all, it is likely to be at the local farmers' market, which is not surprising. Freshness is a powerful incentive, and even in our days of refrigerated containers and sophisticated distribution systems, food doesn't travel all that well. It is for this reason that such products as cheese, butter, meat, fruits and vegetables, "craft" beers, and baked goods have strong regional identities. Any farmers' market functions as an accessible and (relatively) affordable means of connecting to the terrain and customs of the nearby countryside.

It is unfortunate that bespoke making has acquired such a reputation for elitism. Ideally, we would buy all of our products as we buy tomatoes at the local farm stand. Unfortunately, the economic costs inherent in small-scale production, consumption, and distribution are inevitably antidemocratic. You can see this dynamic clearly elsewhere in the food industry, in cases where freshness is not a safeguard for local consumption patterns. For a product to retain a sense of attachment to place, an edifice of connoisseurship must be built on top of it, with a price structure to match. Products like olive oil, vinegar, and especially wine, which are sensitive to the specifics of geographical terroir but can be stored and shipped without any decline in quality, are the basis of extraordinarily complex systems of evaluation, so complex that they prompt widespread suspicion that the emperors passing judgment have no clothes.

In a global marketplace, this qualitative sorting—in conjunction with legislation that protects the naming rights of

certain appellations, such as Bordeaux, Champagne, or Côtes du Rhône—is the only way to successfully maintain local identity and the profit margins that come with it. Similar structures have been put in place for crafts, such as the Geographical Indications system in India and the recognition of Important Intangible Cultural Properties (colloquially, the "living national treasures" program) in Japan.

Despite the hierarchical and exclusionary aspects of such systems, I think it is right to defend the regional identities they are designed to safeguard. Material intelligence is often at its most potent in place-specific situations, when it can best serve as an armature for social relations. Unfortunately, it is easy to romanticize such localism and either dismiss it as a sentimental throwback—suitable to Stoneham in the seventeenth century, but not today—or else accidentally caricature it. You can see the latter happening in the context of tourism, one of the few economic forces that actively rewards place-based "authenticity." Anyone who has gone anywhere with an active tourist economy will know that those scare quotes are often well deserved: A seemingly "authentic" experience can be manufactured more easily than a decent set of shoes.

A favorite example of mine concerns the island of Lamu, which lies off the coast of Kenya. Heavily frequented by tourists because of its gorgeous beaches, the island is nonetheless very poor, because there are so few local goods to sell to visitors. In the 1970s, according to anthropologist Kristina Dziedzic Wright, one enterprising craftsman living there named Murage Ngani Ngatho began to work one of the few local raw materials: coconuts. He invented a way to carve them into various

products including jewelry and bowls. In order to work the hard shells, he was forced to make his own tools, turning discarded blades into files and adapting bicycle spokes for the purpose of punching holes. Having mastered the newly invented craft, he went on to teach it to others, earning the local nickname "cleverest of the clever." Within a short time the island was home to a thriving cottage industry of coconut carvers. These craftsmen were able to build an informal economy for their wares by selling them to tourists from Europe and from mainland Africa, who in turn happily brought the objects home as souvenirs, under the assumption that they were helping sustain a centuries-old craft tradition.[2]

The story of clever Murage is clearly an extraordinary case, as his innovations began more or less from scratch. On Lamu Island, the modern tourist economy brought its own bespoke craft "tradition" into being. A more typical pattern is described by another anthropologist, Brian Moeran, who has conducted repeated visits over the course of his career to a village in Japan called Onta. For more than three hundred years, a distinctive type of ceramic has been made there. Large jars and other wares are coiled by hand and then finished on a wheel. The pots feature certain distinctive decorative techniques, with painted embellishments in a dark iron oxide pigment. A glaze incorporating ash made by burning rice straw goes over the top of the decoration. This local pottery has been held up as exemplary of authentic Japanese rural folk craft (*mingei*) since the 1920s, and in more recent years the village has been formally recognized by the Japanese government as holding an Important Intangible Cultural Property.

The twist in the tale is that production methods in Onta have changed considerably, even as the village has been rewarded for its preservation of the old ways. Traditional forms, such as large jars for pickling, have mostly given way to smaller plates and bowls that can be sold to restaurants in Tokyo. As a result, the demanding coiling technique is no longer much used, as it is much quicker and easier to produce these modestly scaled dishes by throwing on the wheel. The glaze made from rice straw ash is also a problem. Due to the decline of rice farming in the area and the introduction of modern harvesters that completely pulverize the straw (no burning required), the raw material used by the potters has become scarce. So a chemical substitute is often used. The iron oxide for the decoration, once dug and prepared locally, is also now sourced from other parts of Japan. Moeran concludes that the Onta potters exist in a contradictory relationship to their own reputation. They continue to be celebrated as exemplars of the old ways of making, but in fact they are continually adjusting to new circumstances.[3]

The "traditional" coconut carvers of Lamu and the "folk" potters of Onta, it turns out, are both very modern. They have negotiated solutions to problems specific to their own lives and work, inventively and in response to present-day supply and demand. Their experiences have much in common with those of other makers worldwide. All too often, we equate the concept of the local with that of stasis, as if only multinational corporations change with the times. As a result, we bring unrealistic expectations to makers, asking them not to adapt to the world around them. For most craftspeople in most times

and places, nearly every key variable is shifting constantly: the market, raw materials, available technology, and hence the skill set they need to be successful. This does not mean that "traditional" know-how is any less valuable. On the contrary, an artisan's ability to adapt to each of these shifting variables is impressive proof of their deep-seated competency.

It makes all the sense in the world to place a high value on localism in making, because it ensures the kind of contact that instills our material environment with meaning and provides a basis for face-to-face connection. We should remember, though, that makers everywhere always have been adaptive and have pursued options that, for an outsider, may seem inauthentic. As the anthropologist John L. Jackson Jr. points out, in recent years traditional craftsmen have been enthusiastic adopters of digital platforms, the very technology to which their work seems a compelling alternative: "ethnographic 'subjects' are already writing, filming and observing themselves," promoting themselves online, and "that might just be (ironically enough) what saves the discipline."[4]

In any discussion of making, it is easy to overstate the value of either tradition or progress. But it is best to see these two concepts as mutually interdependent, not opposed. Inflexible narratives of tradition imprison makers in an unsustainable production model, while narratives that emphasize progress tend to assume that new is necessarily better, and therefore ignore the material intelligence of established ways of doing things. We don't need to set up game preserves for endangered species of craft, nor do we need to turn every workshop into an R&D hub. There is a middle way, which is anchored in

equal respect for all forms of material intelligence, no matter how established or novel.

Once we think in these unprejudiced terms, we can see that the weaver Joseph Marie Jacquard and the coconut carver Murage Ngani Ngatho, for all of the obvious differences in their situations, had a great deal in common. Both found ways to create value through ingenious experimentation. Both dedicated themselves not just to the shaping of materials, but also to the tools that do the shaping. And both created a body of knowledge, or "cleverness," from which others could benefit. Thinking of Jacquard as a pioneering engineer and Murage as a traditional artisan obscures these points of similarity, and hence the essential human value that both men exemplify. Whenever we place makers in separate categories, we risk missing that fundamental commonality.

Chapter 11

COMMUNITIES OF RESPECT

THINKING BACK TO MY GRANDFATHER'S business card, the way he applied his farm boy's curiosity to both jet engines and wood carvings simultaneously, I am struck by the way that he intuitively grasped the idea that making is a continuum. It binds different kinds of people together, and that is true no matter how the making is done. For those who lack the skills or the firsthand experience, this can all seem a rather mysterious business. People often speak of the "tacit knowledge" of craftsmanship, and for good reason. What happens when a maker, a tool, and a material come together is difficult to grasp from the outside, because it is intuitive and embodied. That makes it difficult to see the sophistication involved.

By crossing this gap in understanding and becoming more respectful of the intelligence that is embodied in making, we inevitably find ways to live in a more integrated way. Material know-how is indeed shared across many walks of life. Our tendency to chop it up into parts—craft versus industry, producer versus consumer, art versus science—is itself a big problem. Such

easy oppositions obscure important commonalities, the potential for shared understandings. Such divisive thinking also prevents us from fully appreciating material intelligence in its totality. If we always think of making as broken into little pieces, we miss the big picture. We forget how absolutely vital it is and how much meaning it can bring into our lives.

Think of immigrants who live in urban locales like London and New York. They often have skills, deep experience, and expertise, yet are treated as if they were ignorant because they don't speak fluent English. If Londoners and New Yorkers generally were more respectful of craft knowledge (spinning thread from wool, dyeing textiles, you name it), it would create a powerful incentive to welcome such people and build communities together with them. Similarly, working-class people are often depicted as uneducated because they did not attend college. I know what my grandfather would say to that: He learned just as much on the farm at Pumpkin Creek as he did at the University of Southern California. The politics of division encourage us to see the interests of diverse, urban communities as conflicting with those of rural, ethnically homogenous communities. But when it comes to making things, they have a great deal in common.

These ideas may seem somewhat utopian. Why should people take an interest in spinning yarn by hand when European and American cities lost their textile factories a century or more ago? Why should we take an interest in tractor repair if we are never likely to spend a day in our lives on a farm? The answer lies in the power of things themselves. They offer us opportunities to connect like nothing else does

because they constitute a sort of truth that can be found nowhere else. When you make an object and put it out into the world, there is nowhere to hide. That makes it a great foundation for building communities of respect. If you are trying to keep a DC-10 aloft or carve a sculpture from a walnut block, you have to keep your wits about you. One cannot spin questions of workmanship. The results are plain to see, and that objectivity is valuable indeed in our uncertain world.

Chapter 12

FINDING OUR WAY

M Y DAD WAS NOT MUCH given to outdoor activities when he was growing up. He was then, and is still now, happiest whiling the hours away indoors. These days he spends a lot of time in front of a computer screen (don't we all!), and when I was a kid, he was avidly devoted to a now obscure hobby called correspondence chess. This involved playing out games over the span of months, with each move sent by postcard. There was a standard deadline for sending back a response, typically three days. That sounds like a very leisurely pace, except that my father was always playing multiple games in multiple international tournaments simultaneously. When he headed downstairs to play chess in the evening he had a little stack of cards waiting for him, each demanding close study. It kept him pretty busy.

I would occasionally wander down to the den and look at the cards. As a non-chess-playing child, I was mainly interested in the far-flung locales named in the postal addresses. Scotland, Russia, and Texas: They were all equally remote to me. The cards might as well have been sent by extraterrestrials. And I

was taken by the intricacy of their design. A tiny chessboard was represented in the upper left corner of each card. As it was sent back and forth, a register of the previous moves in the game accumulated below, written by hand using mysterious symbols such as Bc4 (which, I now know, means bishop to column c, row 4) or Rxg6 (rook takes the piece at column g, row 6). There was also space to formally offer a draw, or resign. Sometimes my father or his opponent would make an editorial comment— "good move," "that was a surprise"—but this was a rarity, partly because the games so frequently occurred across language barriers.

One of the outdoor activities that my dad did enjoy was orienteering, and he would often take my brother and me along. Orienteering is likely about as familiar to you as correspondence chess—not very—though it has weathered the twenty-first century more successfully so far. It's a pastime (sport isn't quite the right word) in which people compete to locate a series of flags that have been set out in the wilderness, guided by nothing but a topographical map and a compass. Orienteers sometimes race against one another, with each competitor individually timed. The person who completes the course fastest without missing any of the flags wins. Fitness is a part of it, but so is navigational ability.

Orienteering had one thing in common with correspondence chess—it also featured interesting little cards. At each flag hung a little tool that looked like a stapler but was fitted with a unique pattern of prongs that left a distinctive punch in a paper card, to prove you had been there. Given that most children are goal oriented, it is not surprising that this was my

brother's and my favorite part. We were too little to compete, so my dad let us take our time. Sure, we appreciated the sunshine and the forest and learning how to read a map, and about how a compass works, the difference between true north and magnetic north, and so on. I remember that I also really liked the contour lines on the map, which made both hills and valleys look like rippling ponds. But the most satisfying moment was spotting the bright orange flag through the trees, racing my brother there, and stamping the card.

Looking back on it now, I am struck by the fact that both of these hobbies of my father's were about territory. The game of chess meant little to me, but the fact that these postcards traversed the globe with their seemingly indecipherable messages felt excitingly like espionage. (I later learned that my father did in fact worry that the U.S. government might mistake his exchanges with countries behind the Iron Curtain.) The chessboard on the card was a tiny make-believe battleground, with the players, like generals, issuing their orders one after another. Orienteering, meanwhile, was all about finding your way through a real landscape. To do it well you needed to master your map-reading skills, learning the symbols for boulders, streams, and peaks. You needed to develop an intuitive understanding of scale to understand the correlation between the map and the terrain.

My father is a smart guy who won the Ohio statewide math championship when he was sixteen. He won two more times before going off to Harvard, so he had ample mental resources to apply to the tasks of chess and map reading. Correspondence chess was mainly done by serious players, and to compete

successfully my father had to study not only his positions, but the game as a whole. He collected shelves' worth of chess books and subscribed to more than one magazine on the topic. My dad was not so competitive at orienteering, not being a man who generally likes to break into a sprint, but he could navigate quickly and accurately, and taught my brother and me to do so as well. In both cases, his considerable brainpower was fully engaged.

There is also a big difference between correspondence chess and orienteering, though, which when you come right down to it is the difference between a chessboard and a forest. The former is a pure abstraction, in black and white. You can make a chessboard out of any material you want, cheap or expensive, pencil on paper or ivory on wood, but it doesn't really change the game. That is why you can play by postcard. Chess itself is intangible, so it can go anywhere. A map, however, can only be used to navigate one particular place. Through a series of conventions, hopefully accurately, it provides a one-to-one analogue to the landscape. No matter how good a map may be, it can only ever describe one location.

So here's a good question to ask yourself as you navigate the world around you: Do you feel more like you're playing chess, or more like you're orienteering in a forest? In both cases, you are using your intelligence: understanding the lay of the land, applying conceptual tools and frameworks, deciding what course to take. But the two modes of movement are completely different. When you're playing chess, you are detached from the actual environment; you exist within a matrix that is repeatable and regular. You could be anywhere,

and the results of your choices would remain the same. The intelligence you are using is abstract. This wasn't a very common experience until recently, but now that we're online, we all do it all the time. In the artificial terrain of the digital, there are an infinite number of potential experiences available to you—just as there are an infinite number of potential chess games, but infinitely more so.

Navigating through a forest is not like that, nor is experiencing any aspect of the material world. You may use a guide to find your way, just as I puzzled over the orienteering map as a kid. At the end of the day, though, you'll need to lift your eyes up and look at the trees that are right in front of you. In that moment, you will be using your material intelligence. And yet, though it is concrete and objective, the realm of physicality can never be fully mapped, either. It is always around us but, in a sense, forever beyond us. Science has unlocked many of the structures by which materiality operates, and goodness knows, we humans have reshaped the world to suit our needs and desires. But materiality always remains to some extent outside our comprehension and control, a terrain that we can continually explore.

Chapter 13

THE CONTACT ZONE

IF YOU'RE SITTING DOWN RIGHT NOW, ask yourself this question: How much do you know about the chair you are in? Maybe a lot. Maybe you made it with your own hands or got it from a friendly woodworker of your acquaintance. But my guess is you don't know much about it at all. My guess is that your chair was mass produced, whether out of plastic, metal, or wood, and upholstered with leather (real or fake) or fabric. Whether it is an armchair, couch, airplane seat, park bench, recliner, or whatever, odds are that you don't know much about its materiality. Who made it? How? Where, under what circumstances? How well could you answer any of these questions?

I have asked audiences the Chair Question many times during public lectures over the past few years. "Stop for a minute and pay attention to the chair you are sitting in," I'll say. "How many of you could describe to me how it was made, or where, or by whom?" Usually my listeners look down in surprise, probably thinking about the objects they are sitting in for the very first time. Not only don't they know much about

this thing that is holding them up off the ground, they had not even really noticed it before I directed their attention toward it. It seems to me remarkable that we can carry out our lives in such detachment from our surroundings. The same goes for many of the other objects that we encounter in our everyday life. The fork and spoon you eat with. The dish with your dinner in it. The front door to your home. The keys in your pocket, the clothes on your back, the shoes on your feet. You are in physical contact with these things all the time. But how often do you truly focus on them, to the extent of enjoying their surfaces, investigating their material origins, considering the intelligence they embody?

How often, in other words, are you in the contact zone? In a way, it's not so hard—just a matter of redirecting your awareness. I think of an occasion last year, when I was lecturing at a conference. I had asked the Chair Question, then followed it up with my stump speech about material intelligence, advocating that we be more curious about the physical world around us. A student came up to me afterward. She didn't say anything—just handed me a piece of paper, smiled, and walked away. What she had given me was the manufacturer's specification for the upholstered metal furniture in the lecture hall, which she had ripped off the bottom of her chair. The information on the label was limited: how many stacking armchairs had been in the order (190 total) and a list of all the materials that were present: rubber cushions, metal glides, beech, and "medium mahogany grade B in a sassy purple finish." The label did not include the place of manufacture,

much less the names of the people or the specific processes that had been involved in the chairs' making. Even so, I loved this moment. I felt I had reached the student and she in turn had reached out to explore the world that was literally right underneath her.

Curiously enough, at the same conference where I had this encounter, I met a scholar whose work perfectly exemplifies this principle of awareness. Her name is Susan Tunick, and she is the foremost authority on the topic of architectural terra-cotta—ceramics used in the façades of buildings. This was ceramics made on an industrial scale, by hand: teams of skilled artisans working in big factories. Terra-cotta (the term is Italian, and means "baked earth") is an ideal material in many ways. It is remarkably resistant to damage from fire, water, and seasonal temperature fluctuations. It was big business in America at the turn of the century and has enjoyed something of a revival recently among builders, preservationists, and architecture lovers. Even so, many people are entirely unaware of it.

Tunick is fond of quoting a passage from the *New York Times* published more than a hundred years ago: "The New York skyline—which, without exaggeration, is the most wonderful building district in the world—is more than half architectural terra-cotta . . . And yet—not more than one lay mind in a thousand appreciates the fact, and even to some architects and builders, this truth will come as a surprise."[1] This is because terra-cotta is a chameleon material. It can be made to look like various types of stone or even patinated metal, a good

example of the phenomenon of material transposition. I can't resist quoting a slogan the material's enthusiasts sometimes use: "Don't take it for granite!"

Terra-cotta is not used much by architects today, not because it's expensive or impractical, but because the skills to fabricate it don't exist as they once did. If most people were unaware of terra-cotta in the early twentieth century, today the material is virtually unknown to the public, even though it still makes up a significant percentage of our historic built environment. This is a good example of the fact that you don't need to be walking through a forest with your dad to be in the contact zone. I live in New York City, so I have plenty of opportunities to appreciate the qualities of terra-cotta façades: the undercut details of decorative scrolls, the various glazes with their shimmering or matte effects, the adroit carving of ornament figures. All this skilled handwork towers above our heads as we walk around below unaware.

The fascinations of materiality are everywhere in the city, if you know where to look. Let's say you are crossing Fifth Avenue in Manhattan. Look down, and you'll see pavement of hot poured and rolled asphalt. It is punctuated by steel manhole covers, which are round, because a square or rectangular cover turned at the wrong angle would drop right into the hole. To make them, a design first had to be carved in wood or machined in aluminum. The resulting pattern was then set into fine and densely packed sand, leaving a very detailed impression, into which the foundry workers poured molten iron, which is usually recycled from scrap. Prior to the pour, other metals may have been added to the cast iron to

improve its strength and ductility, as well as a chemical flux, which binds to impurities so that they float to the surface and can be removed. (The same process was used in the past to make stoves, bridges, and most industrial machines, and still continues in many architectural applications.) If you happen to spot an old quarter or dime lying next to a manhole cover, you might reflect that it was made using a related process, in the sense that it was also based on a pattern. But in the case of a coin, the prototype must first be scaled down into a die, which is then used to stamp the surface of the metal.

Lift your eyes from the pavement, and you'll see, in addition to lots of terra-cotta ornament, awnings of brass or steel or aluminum hanging over many of the doorways. These are formed of sheet metal using giant rolling and crimping machines, which are often fed by hand. I have seen this done at a Brooklyn factory with the fabulous name of Milgo/Bufkin, the largest surviving metal shop in New York City. The company also manufactures a lot of public sculpture, and in New York you can see its artworks sitting in close proximity to buildings that it helped to fabricate. Little do passers-by realize that the sculpture and the awnings were made at the same place using the same machines.[2]

On the façades of Fifth Avenue you can find American flags, seamed using sewing machines, again by hand, and possibly not in America.[3] The reflective glass curtain walls of midcentury skyscrapers, which one might think of as the definition of affectless materiality, were constructed by daredevil crews working high up in the air, who riveted the frames by hand. At street level in these buildings, you'll often see a row of

mannequins in a storefront window. These were cast in fiberglass using molds that were, in turn, based on hand-carved clay models. The garments worn by the mannequins have their own history of production. At the design phase they were likely cut out in paper patterns, then remade using a light toile fabric so that they could be draped over a mannequin, to ensure the right cut. Once the design was finalized, the mass production phase could start, but even then handwork was probably involved; like American flags, the pieces are generally cut out using automatic machines, but are then assembled by garment workers using sewing machines.

You get the point. Fifth Avenue can be appreciated as a mass gathering of material intelligence, and the same is true for nearly any street anywhere in the world. It is that human investment, whether it is laid down thick or thin, over time or quickly, that provides a city or town with its particular flavor. The street where I grew up, Fatima Road, was definitely on the thin side. Stoneham, once a thriving little town of shoemakers, had long ago become a garden-variety, standard-issue suburb. Nearly every house on my block was built according to the same plan. Individuality was achieved simply by setting the houses in different orientations on their plots and painting them different colors. I remember how peculiar it was to go into one of my neighbors' houses. The living room, kitchen, and dining room were exactly the same, just with different wall colors and different furniture.

Fatima Road did have a material story to tell, just not a very inspiring one: It spoke of the expediency of modern development. Of course, older places have incomparably

more complex stories written in their architecture. In Rome, you can see centuries' worth of plaster and stone layered atop one another, patches on patches on patches. Back in the 1930s, the writer Maurice Halbwachs observed that this city was the perfect metaphor for what he called "collective memory." Rome was built up over many years, like Italian culture itself, and Halbwachs thought that this kind of accumulation was essential to life there. He distinguished collective memory from the bare facts of history: It is less reliable, often responding to new ideas and needs, but also much more meaningful. As the philosopher A. C. Grayling puts it, "Tradition differs from individual memory in one important respect: the latter can be true or false, but the former is neither—it just is what it is."[4]

I can offer an example from my years living in Milwaukee. If you have never visited the city, you might think of it as one big brewery. But actually its architecture has a humble beauty, because it is mostly built from cream-colored bricks made from local clay. Each brick is subtly different in its color and gloss because of the position where it sat in the kiln during firing. These bricks have tales to tell. For example, the Basilica of St. Josaphat, in the southern part of the city, was built to serve the Polish immigrant community that had arrived in huge numbers toward the end of the nineteenth century. It's an impressive building, but what really makes the place special is its story: It was made out of a post office.

The enterprising pastor of the parish, Wilhelm Grutza, had hired a German architect to create a design for the new church, closely following the model of St. Peter's in Rome. It was plenty

ambitious, a fitting centerpiece for a large and still growing Polish neighborhood, but it was going to be very expensive. As the plans were nearing completion, Grutza found out that the post office and customhouse in Chicago, two hours to the south, was slated for demolition. He struck a deal, purchased the bricks for the relatively cheap price of twenty thousand dollars, and brought the material up to Milwaukee on five hundred railroad flatcars. Construction was completed in five years. When the church was finished it had the largest dome in the country apart from the one atop the U.S. Capitol. I must have driven past St. Josaphat a hundred times before I heard this story. Not being Polish or Catholic, the building meant next to nothing to me. Once I knew about Father Grutza and his enterprising feat of recycling, however, I regarded the building with awe and fascination.

Details like these usually pass us by without our noticing, but they form the rich texture of our surroundings. When we become aware of that specificity, as it has built up over time through the actions of others, we are also conscious of being part of a community, in the broadest sense of that word. Conversely, when we ignore our material environment, we are essentially forgetting who we are and where we came from. If we divorce ourselves from the collective memory of a place, we alienate ourselves from our surroundings and from people alike, choosing isolation over group identity. The ancient Romans had a wonderful phrase to describe this: *genius loci*, the spirit of a place. They realized, too, that it was only achieved through the steady application of material intelligence (the word "architecture" itself derives from the Greek *architektón*,

meaning "master craftsman"). Locale is vitally important within cultures of making, and also when it comes to our quality of life. Daily experience is made up of innumerable encounters that we have with the material world around us, and these encounters can be as fulfilling or as flimsy as we choose to make them.

Chapter 14

THE PARADISE OF TOUCH

H ELEN KELLER, who became deaf and blind in infancy, is an exemplary case of someone with material intelligence. Everything she achieved, she achieved through touch. Her hands were the only means that she had to encounter the world. And yet she became famous for her sophisticated writing and passionate activism. Keller once recalled being taken to the Chicago World's Fair in 1893, where she was given special permission to touch the exhibits. She spent hours there, learning how the machines worked by carefully handling them as they moved. "I took in the glories of the Fair with my fingers," she recalled. "It was a sort of tangible kaleidoscope."[1]

If you know only one story about Keller, it's the one that concludes the 1962 film *The Miracle Worker,* in which her teacher Annie Sullivan (played by Anne Bancroft) places her wayward charge's hand underneath a running faucet, having spelled the word "water" over and over into her hand using sign language. This seems like a cinematic conceit, but it really did happen, on the fifth of April, 1887, when Keller was six years old. She recalled the moment in her autobiography: "Suddenly I felt a

misty consciousness as of something forgotten—a thrill of returning thought; and somehow the mystery of language was revealed to me." She had finally made the connection between ideas and things, a connection from which all other understanding could grow. Immediately, she recalled, even as she returned to the house from the well, "every object which I touched seemed to quiver with life."[2]

Though she had spent her first years uncomprehending and unruly, Keller began devouring knowledge through her hands from this point onward. She read her Bible in Braille, so avidly that she wore the bumps flat. Keller was also able to learn intangible concepts by connecting them to her bodily perceptions. For example, Sullivan taught her the meaning of the word "think" by spelling the letters repeatedly on her forehead. Keller wrote that this was her "first conscious perception of an abstract idea."[3] But the experiences that she wrote about most passionately were entirely physical. She began "The Seeing Hand," perhaps her greatest essay on this theme, with the lines: "I have just touched my dog. He was rolling in the grass, with pleasure in every muscle and limb. I wanted to catch a picture of him in my fingers, and I touched him as lightly as I would cobwebs." The dog responded, licking her hand. "If he could speak, I believe he would say with me that paradise is attained by touch; for in touch is all love and intelligence."[4]

Keller wanted others to appreciate the tactile world as fully as she did, and used various arguments to persuade her readers of the centrality and significance of touch. Our language, she pointed out, is full of haptic metaphors: manufacture, maneuver,

manual, firsthand knowledge. "All life," she noted cleverly, "is divided between what lies *on one hand* and the other."[5] She said that she could arrive at a sense of another person's character simply by touching their hands, for which she had a marvelously subtle and emotional understanding, just as a sighted person would understand the nuances of facial expression. Keller realized, of course, that many aspects of experience were shut off from her. But equally, she pointed out to her sighted readers, "there are a myriad sensations perceived by me of which you do not dream."[6] Movements of the air, the smell of rain at different times of the day, the change of seasons—these were all immediate to her in a way that someone attuned primarily to sight and sound would never know. "In autumn," she wrote, "soft, alluring scents fill the air, floating from thicket, grass, flower, and tree, and they tell me of time and change, of death and life's renewal, desire and its fulfilment."[7]

Keller's words serve as an ideal map for the contact zone, a term I use not in the sense of being literally hands on (though as her example proves, that can be a great start), but rather to describe a state of heightened material awareness.[8] There is a good reason that people bring their kids to petting zoos, corporate morale boosters organize blindfolded team-building exercises, and some adventurous diners eat at restaurants where the food is served entirely in the dark. What all of these activities share in common is a focus on tangible experiences that are usually overlooked.

There is a long tradition of disregarding this domain. In classical European thought, touch was always ranked as the lowest of the five senses, with vision at the top, followed by hearing, smell, and taste. Touch was placed at the bottom of

this hierarchy because it seemed most closely tied to the body, associated with our animal rather than rational selves. Tactility was also linked to carnal desire (as opposed to spiritual love), and to manual labor and lower social status. Vision, by contrast, was taken as both the model and the method by which knowledge entered the conscious mind—via reading and observation. Roger Bacon, the thirteenth-century philosopher, thought that blind people could learn "nothing that is worthy in this world" (I wonder what Helen Keller would have made of that!), while Giorgio Vasari, the sixteenth-century Italian who is often described as the first art historian, wrote, "It is necessary to have the compasses in the eyes and not in the hand, because the hand works and the eye judges."[9]

There are many reasons to doubt this traditional perspective. It turns out that a computer can defeat the world's greatest chess player, but cannot physically move a pawn across a board with the fluid, flexible, and decisive motions that come naturally to a human. Similarly, a robot can easily read a map, but we are a long way from designing one that can run quickly through a forest or climb a tree. Touch is a complicated phenomenon. It also has virtues that ancient and Renaissance commentators did not even consider. Studies suggest that doctors and nurses can improve medical outcomes for their patients, for example, simply by touching them more often. This remains a marginal area of research in modern Western medicine, but would hardly come as unexpected news to a traditional healer in Tibet or the Andes.[10]

In her 1990 book *A Natural History of the Senses*, Diane Ackerman pointed out just how amazing our tactile faculties are. Skin, she writes, "imprisons us, but it also gives us

individual shape, protects us from invaders, cools us down or heats us up as need be, produces vitamin D, holds in our body fluids." It is self-healing when injured, and also "waterproof, washable, and elastic." We can decorate it; tattoo enthusiasts turn their epidermis into an artistic canvas. But the most amazing thing about our skin is that it is a totally active surface—the largest sense organ we possess. Usually we do not think of skin this way. Touch seems to us more passive than active, perhaps. This is why the skin is rarely understood as a site of intelligence. But this long-standing prejudice needs to be set aside. As the journalist Adam Gopnik puts it: "Our experience of our bodies . . . [is] our primary experience of our minds."[11] Strange that we should be less than conscious of this primary experience.

Chapter 15

THE VIEW FROM
THE HARDWARE STORE

IT SO HAPPENS THAT RIGHT AROUND THE CORNER from my apartment building in Brooklyn, every day but Sunday, you can find a philosopher of materiality. His name is Jerry Walsh, and he runs Mayday, the local hardware store. He has been working there for more than fifty years.[1] Think about that: He has been standing in the same place, behind the same counter, every working day since the 1960s. In fact, Jerry grew up right down the street. From the vantage point of his counter, he has seen the area change several times over. When he was a kid, it was an Irish-Italian working-class neighborhood, with a bar on every corner. (He points out that this meant four bars per intersection.) He did all the things you might imagine boys of that age doing, building go-karts from busted roller skates, running a shoeshine route to earn pocket change, and getting in lots of fistfights. "White flight" was happening when he was growing up. The community gradually became poorer, more heavily African American. There was a lot of racial conflict.

In fact, the first time Jerry set foot in Mayday Hardware was when he was running from some local black kids. He went into the store only to take refuge. The owner, Arnold Davidson, looked him up and down and said, "If you're going to stay here, at least make yourself useful." He handed Jerry a broom, and Jerry never left. He worked in the hardware store through high school and college, and finally bought the place from Davidson, who by that time had become a mentor, a surrogate father. In the years that followed, through the rough economic times of the 1970s and into the 1980s, he was there. It is safe to say that he is a man deeply invested in his community. During one citywide power outage he went outside with a flashlight and directed traffic. During another, he sat out front with a shotgun in his lap to discourage looters. On September 12, 2001, he opened the store as usual and people from the neighborhood came in to give him a hug, as if holding on to the strongest pillar of continuity they knew.

You can't spend more than half an hour with Jerry at his counter without being struck by his familiarity with many of the customers, and the range of skills that he brings to every exchange. He knows many, many people by name, from all walks of life. He also may well know the particulars of the building you live in, what kind of plumbing you're likely to have. Though Jerry has seen more than his share of the race-related troubles that beset so many American cities, he serves the diverse community of Prospect Heights as fairly as he can. "My business was able to survive when everything was in turmoil," he said to me, "only because I respect every individual that comes in the door."

What's really interesting, though, is the way that Jerry shows that respect. He is a merchant, to be sure, but he's also a philosopher, in the necessity-is-the-mother-of-invention line of thought. He is struck by the large difference between people who have a knack for materials and others who don't: "I have actually had the experience of explaining to a grown man how Velcro works." Being of a hands-on persuasion himself, he has a basic theory that informs his every interaction in the store. The motto, no doubt based on his own life experience of growing up poor, goes like this: "When you don't have the resources to get a job done, but still have the need to accomplish it, you have to think outside the box."

So while Jerry is certainly willing to sell a customer what they came in for, more likely he'll suggest a better approach, which involves spending less money and saving time and effort. If you have to scrape a floor, don't get down on your hands and knees; mount a scraper onto a broom handle. Don't worry about buying a separate set of T-shaped tile spacers; just snap off the bit you don't need from the cross-shaped ones you already have. The craftspeople Jerry regards most highly are plumbers, because they are forever having to design and execute workarounds. Adapting to circumstance is the real test of skill. He tells me a joke: A plumber does a job for a heart surgeon, then hands him the bill. The surgeon claps his hand to his forehead and cries, "My God, you get more money per hour than I do!" The plumber says, "I know, that's why I quit being a surgeon."

Jerry is sixty-five years old. He has trained many people to work for him over the years and observes that what they really

need is not the ability to memorize the names of parts and equipment, but spatial and visual awareness. I asked him what his plans were for retirement—did he intend for someone else to take over from him? He said no. It would be tough for someone to start out in the business today, with the intense competition from big-box stores like Home Depot. He has kids, but he'd never ask them to inherit the store; he doesn't want them to have to work so hard.

In any case, his bricks are worth more than his business. He's already had many offers from real estate developers to buy the property. Someday in the not-too-distant future, that is probably what will happen. Mayday Hardware will be gone, and there will be an apartment building where it used to stand. The Home Depots of the world cannot offer the personalized service that Jerry can offer—helping people design their own floor scrapers, or allowing a struggling local handyman to buy ten dollars' worth of merchandise on credit. But when I asked him if he was sad to know that his store would not survive him, he again said no. Consistent with his theories about adaptability, he feels that if a community can't financially support a mom-and-pop concern like his, it will just have to make way. For now, Jerry is behind his counter, exemplifying the principle that material and social connectedness are just two aspects of the same thing, and serving his community, as he always has. "Police change precincts," he says. "Priests change parishes. Firemen change firehouses. I'm still here."

Chapter 16

TIME TO PAY ATTENTION

JERRY WALSH IS EXEMPLARY in a number of ways—as a hard worker, a technician, a local historian, and much else besides. But perhaps the most important value that one can learn from him is that of simply paying attention. When someone comes to the hardware store with a request, he doesn't just sell them something; he asks why they want it, what they are trying to achieve. Busy as he is over the course of the day, he spends as much time as is needed with each customer, to ensure he is giving them the right advice. In one exchange at the counter that I observed, he listened to a customer describe a home improvement job and request a certain product, miming its use with their hands; he remarked, "I hear what you're saying, but your body language tells me something different." I think that it is in this simple act of paying attention that Jerry's real genius lies.

Many people today are worried that we have become a thoroughly inattentive society. A recent essay in *New York* magazine by Andrew Sullivan does a great job conveying the feeling that something has gone deeply wrong. Sullivan is a

well-known conservative pundit, who established himself in the early years of online political commentary. He founded his blog *The Daily Dish* in 2000 and quickly became a prominent and unpredictable voice, holding forth on issues ranging from same-sex marriage (which he supported) to George W. Bush's war on terror (which he also supported). After years of blog postings, however, he began to feel that his life was gradually migrating to the web, leaving his body marooned behind. Even slowing down to read a book became difficult for him: "After a couple of pages, my fingers twitched for a keyboard."[1]

Sullivan gradually came to realize that his physical and mental health was being compromised. He took drastic measures, going on a meditation retreat. Only then did he come to realize his underlying predicament:

> Every hour I spent online was not spent in the physical world. Every minute I was engrossed in a virtual interaction I was not involved in a human encounter. Every second absorbed in some trivia was a second less for any form of reflection, or calm, or spirituality. "Multitasking" was a mirage. This was a zero-sum question. I either lived as a voice online or I lived as a human being in the world that humans had lived in since the beginning of time. And so I decided, after 15 years, to live in reality.[2]

As he returned from the meditation retreat and resumed his normal work life, Sullivan resolved to spend less time on-screen. Though he did manage to break some of his old habits, it was

not easy to maintain his discipline. Like any addict, he found himself slowly but inexorably drawn back to the screen. He ends his essay on a melancholy note. The threat is not to our minds, he writes, but to our souls: "At this rate, if the noise does not relent, we might even forget we have any."[3]

Sullivan's conclusion is an extreme one, and by virtue of his profession, so was his personal experience. Yet he is right to sound an alarm about what is happening today. Stories like his are becoming increasingly common, as online work expands further into the traditional sectors of the economy. Even when we go to museums—institutions that surveys suggest are increasingly valued as places to "escape stress" because they offer calm and sustained reflection—we spend only about seventeen seconds with each work of art, on average.[4] In response, ironically, many museums have turned to technology, in hopes of engaging their visitors more effectively.

When the Cooper Hewitt, Smithsonian Design Museum reopened its Gilded Age building in New York City in 2014 following a major renovation, it also introduced a whole array of interactive technology into the galleries. The results are impressive. There are huge touch screens that allow you to play at being a designer, an immersive exhibition gallery that gives you the chance to project historic wallpaper patterns onto the walls, and a digital pen that quickly tags and stores an object into an online "collection" when tapped against a museum object label. In the case of the pen, the goal is to trigger people's natural instinct to enjoy scavenger hunts, the same instinct that brought my brother and me such joy when we raced toward those orange flags in the woods while orienteering.

The Cooper Hewitt's mission is to promote understanding of product design, so it is certainly an appropriate setting for such experiments. And there is no denying the ingenuity of the execution. But to be honest, I would not want to see technology of this kind becoming commonplace in museums. Curators often describe their exhibitions as being "enhanced" by interactivity, borrowing a term from the tech sector. And in a way, that's true: Such platforms as the Google Art Project allow virtual visits to museums across the globe and also allow users to "go deep" into an object, as if looking at it under extreme magnification. There have also been instances of animating historical images, such as Chinese scroll paintings, in an attempt to intrigue new and younger audiences.

Yet, as the magazine *Art in America* asked in 2016, "Where is the line between enriching the experience of viewing a work and fundamentally transforming it? . . . When the museum and its corporate partners bring these works 'to life' with cutting-edge tech, are they also implicitly declaring the death of the static art objects that fill physical galleries?"[5] To the extent that it displaces traditional encounters with material objects, interactive technology actually detracts from the power of museums, making them more similar to other cultural experiences, like movies, or just browsing the Internet at home. Alongside talk of enhancement, perhaps we need to start speaking of the opposite: "diminished reality." For technology can easily imply that the original artifact, which viewers experience unmediated by anything but their own knowledge and intuition, is no longer enough. It is as if careful looking is itself threatened with obsolescence.

The role of digital technology in museums is just one example of this widespread phenomenon. As our attention spans get shorter, the concentration we bring to the world around us is constantly being manipulated and distorted. Basketball players at Madison Square Garden are dwarfed by a simultaneous broadcast of their exploits on huge monitors overhead. Pop and soul singers get the same treatment in concerts, and their voices are pitch-corrected on recordings, using programs like Auto-Tune that produce an eerily perfect, not-quite-human timbre. Even parents' experience of their own children is being transformed by the constant taking of photographs and videos. These still and moving images impart the children with (in the words of novelist Zadie Smith) "an experience of self-awareness literally unknown in the history of human existence—outside dream and miracle—until very recently. Until just before now."[6]

Chapter 17

THE MYTH OF THE DUMB OBJECT

WHEN I LIVED IN LONDON, I had a downstairs neighbor who decided to scan every single book he owned. Then he gave his books away. I visited his apartment as he was nearing the end of this process of dematerialization. He proudly showed me his empty bookcases (which he was also going to get rid of) and told me I could take any title I wanted from the small and shrinking pile of volumes that were left, the last survivals of his once-large library. A newish iPad was propped up on his dining table, loaded with the entire contents of the hundreds of books that he had vaporized from his life. To him, this felt like a great step forward into the future.

There is a general theory going round that advocates for such a light-on-the-land approach: The more we can relocate our lives and our economy to the immaterial realm, the better off we'll be. From this perspective, digitization is a sustainable strategy, a "killer app" that will resolve the conflict between capitalism's constant growth and the finite resources of the planet. Add to this the excitingly instantaneous and global

possibilities of interactivity, and it's no surprise that digital experience is so tantalizing to so many. In extreme cases, like my neighbor in his empty apartment, this impulse points away from tangible things entirely. He perceived himself to be a pioneer in this respect, and it may well be that he was right.

This is a dream that we have known previously only in science fiction. We've all seen movies set in worlds that are thoroughly depopulated of anything but a few designer chairs. All necessities are furnished instantly through a mood-lit alcove in the wall. Professional futurists are now predicting just such a situation, in which objects are only temporary residents in our lives. Neil Gershenfeld, the founder of the Center for Bits and Atoms at MIT, argues that we are heading toward a revolution in making just as profound and widespread as the change in print enabled by desktop publishing.[1] He points to the promise of 3-D printing and other rapid manufacturing processes, by which just about any shape can be rendered in a compound of adhesive and powdered metal or plastic.

As this technology improves, Gershenfeld and other futurists suggest, we will increasingly be able to live in an environment-on-demand. Teapots and toasters, sofas and shoes, even whole houses will be fabricated as and when we need them. Even better, they can be made of recyclable plastics, so that we can remake them into new forms as required. Done with your dinner plate? Rinse it off, toss it into the hopper on the side of the printer, and it can become your bedtime reading light. Objects will be merely transient expressions of digital information, much like the words that appear on our computers. The only permanent anchor in our lives will be the "cloud"

where the files are stored, which we never visit in person, only through our screens.

These screens, these black mirrors which play such a decisive role in our lives, are the exception that proves the rule of pervasive antimaterialism. As Deyan Sudjic, director of the Design Museum in London, has written, the smartphone "is the most characteristic object of our times, the one which has turned us all into slaves, constantly on call to the world, constantly visible and monitored, an artifact that has led to the mass extinction of so many other objects we once held precious."[2] Every year they absorb more and more functionality into their taut, hard little bodies, superseding the role of other objects in our lives. It's not that we are uninterested in digital devices as physical artifacts. Their every curve, button, and feature is a matter of public interest; their arrival at product launches is keenly anticipated, like the births of royal children. Designers compete to make them ever smaller, ever lighter, ever smoother. The problem is that, as we come to depend on these mysterious machines more and more, we are less and less aware of our physical environment. We don't even understand how the phones themselves are made, or how they work.[3] They are sealed off from us, performing their tricks as if by magic. To many people, again, this feels like progress—even freedom. No longer weighed down by things, we hope to emerge bright and blinking into a new world.

Only a fool would deny the many positive effects that the Internet and portable, digitally connected devices have brought into our lives. We can listen to any music we like, anytime we want. Information on a huge range of topics is readily available,

so that writing a book like this one (for example) is made immeasurably easier. We can speak to our loved ones for free over enormous distances. We can learn about faraway cultures and foreign languages, donate instantly to charitable causes, look at videos of kittens all day long if we wish. Nonetheless, even taking into account these and many other advantages, this wave of technology is crowding a lot aside. The term "smart" as applied to a phone (not to mention the "smart" cars, refrigerators, thermostats, and other gadgets that increasingly organize our lives) implies that other objects are "dumb," in both senses of that term—mute, and unintelligent.

A "dumb object" could be anything that doesn't talk back to us, track data, show us a stream of images, or otherwise serve as the endlessly adaptable archive of our day-to-day existence. As I write at my laptop computer, I am looking at quite a few of them: a table, a lamp, a glass pitcher filled with water, a ballpoint pen, terra-cotta pots with houseplants in them. None is particularly remarkable as these things go (with the exception of the pen, which is from Japan and can write in four different colors of erasable ink). It is easy to see why my computer, or my smartphone sitting next to me, could be construed as more powerful and, yes, smarter than all of them. But consider the complexity that is contained within all these things. Very few people would be able to design and make a wooden table, a terra-cotta pot, or a glass pitcher, much less a ballpoint pen or a lamp. In fact, I'm not sure I have ever met a single person who could make all five—though, unlike a smartphone, it is fairly easy to tell how they were made, and how to repair them if necessary, if you know something about the materials and

techniques involved. They are only mute if we fail to speak their language.

So how dumb are these everyday objects, really? I would argue, on the contrary, that such inert things are eloquent and precious repositories of human intelligence. As the historian of science Pamela Smith puts it, "Objects inscribe the memory of previous generations."[4] They are "smart" in a way that our digital devices don't even try to be. A hyperfunctional object like a laptop computer is only a neutral portal, a window that can open anywhere in the world. That is indeed powerful, but its omni-flexibility is also a kind of banality. It can do so many things that it need not have any intrinsic, richly specific character. So it doesn't.

Chapter 18

GOING DEEP

THE PSYCHOLOGIST SHERRY TURKLE, who has been perhaps the most prominent expert warning us about the impact of digitization, puts it well: "People want to customize their lives. They want to go in and out of all the places they are, because the thing that matters most to them is the control of where they put their attention."[1] The resulting tendency is toward speed, compression, and superficiality. It even happens out in nature, where one might least expect it. This past summer I went to Yellowstone National Park, one of the most staggeringly beautiful landscapes on earth, strewn liberally with canyons, forests, and waterfalls. If you have ever been (which is not unlikely, as about four million people visit each year), you will perhaps remember that the park is set in a geological feature called a caldera, a basin formed by an ancient volcanic explosion. There is still a reservoir of molten lava beneath, buried anywhere from three to twelve miles deep.

This underground heat source causes a wide range of hydrothermal effects. Superhot gases and water constantly push upward to the surface; when they get there, they sometimes

explode in the form of periodic geysers, sometimes burble and hiss continually, like a witch's cauldron. Once exposed to the air, the water cools and then trickles back into the earth, together with rain and snowmelt. And so the cycle continues. If you were a poet reaching for a metaphor about the way creation bursts forth from the depths of materiality, you could do no better.

Yet what do many visitors do when they go to Yellowstone? They spend their time lining up their next Instagram shot. This is particularly striking at Old Faithful, the park's most famous feature, which erupts at irregular intervals within a range of 60 to 110 minutes. Because the timing is erratic, it's not possible to say exactly when the geyser will go off. The result is that large crowds gather and wait, sitting on benches in a big semicircle. The atmosphere is congenial and relaxed. Yes, people do check their phones. But they also chat with those around them, and, apart from a few overtired children, everyone seems content to put their vacation on hold until Mother Nature is ready to put on the big show. Sitting there, I realized how rare an experience like that has become. How often do we gather together in public without an undercurrent of impatience, bred by our expectation that our desires will be met on demand?

Sure enough, when Old Faithful's superheated water did finally jet into the sky, there is a return to form. As if in an answering motion, the crowd suddenly bristles with digital devices, held aloft to take pictures and videos. Conversation ceases. The massed gesture is like a strange contemporary echo of the way that ancient peoples once genuflected to the

gods. I don't want to be too critical. Of course it's understandable that people want to preserve an amazing moment of geological power unleashed, and there's nothing wrong with wanting to share the moment with folks back home. All the same, I couldn't help but feel sad that so many have an instant urge to mediate their experience, rather than share it with those standing right next to them; that they would rather shoot a video (a video that will be virtually identical to many that they could see online, by the way) than actually look at the spectacle with their own eyes.

The scene at Old Faithful reminded me, oddly enough, of the gallery in the Louvre where Leonardo da Vinci's *Mona Lisa* is displayed. The crowd around the painting is often dismayingly large, so much so that despite its fame, many people give up on seeing it. They just stand up on tiptoe, point their phones in the right general direction over the heads of the other visitors, take a picture, and walk away. It is as if they are acting out a satirical comment once made by Art Buchwald: "It is common knowledge that there are only three things worth seeing in the Louvre. They are the Venus de Milo, the Winged Victory and the Mona Lisa. The rest of the stuff is all junk."[2]

Yes: We are distracted. The sheer amount of information that is available to us nowadays promotes superficiality in our relationships to one another and our environment. This encourages us to miss things of value that lie all around us. As Maggie Jackson, author of *Distracted: The Erosion of Attention and the Coming Dark Age*, warns, "It's a darkening time when we think togetherness means keeping one eye, hand, or ear on our gadgets, ever ready to tune into another channel of life."[3] She

enumerates a frighteningly large number of examples in which we are simply not paying attention to what matters, from seemingly benign but actually sad habits (like lovers lying in bed, checking their Twitter feeds) to situations where information overload can be potentially disastrous (veteran airport baggage screeners, it turns out, will look right at the outline of a gun in a passing suitcase and still miss it a third of the time).

We aren't even aware of how unaware we are. Recent research indicates that when people are asked to estimate the number of times per day that they check their digital devices, they routinely guess far too low. In one test, volunteer participants between the ages of eighteen and thirty-three were tracked using their own phones and then asked to quantify their usage. They were wrong by more than 50 percent—on average, they guessed they checked their devices around thirty-seven times per day, and the real figure was eighty-five. The volume was simply astonishing: On average, the study group had looked at their phones every eleven minutes, and each person spent an aggregate of more than *five hours* engaged in the activity, broken down into many thirty-second installments.[4] No doubt lots of good things are happening in these bite-size chunks of communication. Work is being done, entertainment is being had, people are being told how loved they are. All the same, it is not hard to see that much else in life must be sliding past, unnoticed.

This applies particularly to our material environment. The problem is not so much that the digital world is "unreal." Rather, it is that we constantly have half our attention in the

digital world and half in the physical world, so that we are never truly concentrating on either. If we are to combat this tendency, if we want to get ourselves undistracted, we need to remember (or relearn) what it is to truly be with objects around us. This is the opposite of "browsing," as we do online, or in stores, or in libraries (once upon a time, when people went to libraries), walking up and down the rows of bookshelves. Attending to our material surroundings means stopping and slowing down. It's like taking a single volume off the shelf and reading it cover to cover.

The travel writer Jan Morris has remarked that one of the things she looks for in a building is the feeling that "you could pick [it] up, to my mind a characteristic of great architecture—think of the Chrysler Building, or the Doge's Palace, or the Romanesque chapels of Spain!"[5] I like this idea, because it aptly captures the sense of imaginative possession that one can have in the contact zone. It would be a mistake to believe that material intelligence is only applied through tactility, via making or touching. Nor does it necessarily require that we have lots of information at our disposal. If you are standing in front of a building, say a Romanesque chapel in Spain, you can find out all about it on Google—the date, the style, the history of its renovations. But this is not living in the contact zone. It's not a matter of being informed, or simply having seen something, checking it off the list. Rather, it is a habit of mind, in which we have receptiveness and curiosity about the world around us.

Chapter 19

THE WAY OF TEA

IN THE ANNALS OF PICKING THINGS up and admiring them, an ideal model is the Japanese custom of the tea ceremony, *chanoyu* (literally, "the way of tea"). This tradition is so celebrated that it has become something of a cliché, and we should bear in mind that there is a lot of fiction associated with its supposedly ancient principles. As the historian Christine Guth has explained, the customs of the tea ceremony were formulated not back in the mists of time, but at the end of the nineteenth century, an uncertain period in Japan when modern, Western ideas were sweeping aside the old order of society. As regional lords gradually lost their grip on power, an urban mercantile class rose in their place; and it was these wealthy modern businessmen, not traditional samurai, who actually codified tea drinking. They collected fine tea leaves and precious ceramic and metalwork vessels, and constructed beautiful teahouses, all as a way to shore up their cultural legitimacy and their consciousness of Japanese national identity.[1]

Be that as it may, *chanoyu* as it exists today remains an inspiring example of how simple, everyday experiences can be enhanced

through a deep investment in materiality. At the turn of the twentieth century, just as the tea ceremony was being revived as an aesthetic practice, the art historian Kakuzo Okakura wrote a book on the topic, describing it as "a cult founded on the adoration of the beautiful among the sordid facts of everyday existence." Yes, his descriptions of the seventeenth-century origins of tea drinking were somewhat fanciful; but it was just that imaginative quality that made his writing so inspiring to many in Japan and America. The philosophy of tea, he wrote,

> is not mere aestheticism in the ordinary acceptance of the term, for it expresses conjointly with ethics and religion our whole point of view about man and nature. It is hygiene, for it enforces cleanliness; it is economics, for it shows comfort in simplicity rather than in the complex and costly; it is moral geometry, inasmuch as it defines our sense of proportion to the universe.[7]

What actually happens in a tea ceremony? The process varies somewhat depending on the school and style of the tea master, but the basic elements are fairly consistent. First, the setting is carefully considered. A classic teahouse is set within a garden and is made of humble materials, usually unfinished wood and woven straw mats called *tatami*. One upright post may be left as a raw branch, a reminder of the natural source of the building's timber. The doorway is often built at half height, obliging visitors to bow and crawl into the space, thus humbling themselves at the point of entry. Within the teahouse there will typically be a *tokonoma*—an alcove in which art

objects are set out for appreciation, often a vertical scroll painting and a vase with an *ikebana* flower arrangement.

After a bit of polite conversation, the tea master begins the ceremony proper and the room falls silent. First the teabowl (*chawan*) is passed to the first, most honored guest, with the best side of the bowl facing them. The guest admires the bowl, turning it in their hands and examining it. The other guests repeat this little scene of appreciation. Then the bowl is returned to the tea master, who ladles water from a special ceramic container called a *mizusashi* into a heated iron kettle called a *tetsubin*. A small amount of powdered green tea is taken from a ceramic or lacquer caddy (*chaire*) and placed into the teabowl using a narrow bamboo scoop. The hot water is then poured into the bowl and decisively whisked by the tea master until it bubbles up into a froth. Each guest then takes the scent of the tea and drinks.

A lot is happening during the course of this ritual, but one of the most interesting points of connoisseurship concerns the bottom of the teabowl. This is important, partly because the way the foot is finished is held to be a particularly individual detail within the potter's art and partly because this spot on the bowl is usually unglazed (otherwise it would fuse to the kiln shelf during firing). As a result, here one can appreciate the "flavor of the clay" (*tsuchi aji*), a matter that is as variable and specific as the terroir of a wine-growing region.[3] When the bowl is passed around, it is always inverted and examined, as the potter Bernard Leach memorably put it, "as carefully as a banker a doubtful signature."[4]

Each implement used in the tea ceremony is specially chosen for its materials, ornament, and form. An elite tea master is

likely to own a *mizusashi* and a *tetsubin*, several teabowls and tea caddies, and other pieces of equipment, all of which may be extremely valuable, and might in some cases be hundreds of years old. Teabowls in particular are objects of great reverence and will be valued for their provenance—that is, who has owned and used them in the past—as well as their appearance, which may prompt poetic names like Seppo (Snow Peaks) or Amagumo (Rain Clouds), to cite two works by the seventeenth-century potter Hon'ami Koetsu. The use of gold repairs (*kintsugi*) is common for such teaware, evidence of the value that is placed on the history of their use. Seppo is an example, with a great branching rift coursing down the entirety of one side.

Chanoyu is obviously an exceptional case, a carefully controlled environment with esoteric aesthetic standards. Again, it is right to retain some skepticism here: For the uninitiated, the experience may seem more bewildering than aesthetically transporting. The collector Allen Weiss tells an

amusing story of his first tea ceremony, which was all but ruined by anxiety. He felt sure that he would do the wrong thing; only gradually did he realize that all the other guests were equally inexperienced, and each was looking at the others in a desperate attempt not to embarrass themselves.[5]

Artificial it may be, but there are real lessons to be drawn from the tea ceremony. Toshio Ohi, a potter and tea master I once visited in Japan, points out that it is an experience that engages all five senses equally. The guest at a tea ceremony appreciates with the eyes, looking at the artworks in the *tokonoma* and the various pieces of tea equipment; with the nose, taking in the smell of the *tatami* mats, the fragrance of the flowers, and the scent of the tea; with the ears, as the tea scoop chimes against metal and ceramic rims in an atmosphere of total quiet; with the hands, as they handle the rough, warm surface of the *chawan*; and of course with the mouth when drinking the tea, a little bit bitter, with a complex flavor somehow reminiscent of both freshly cut grass and smoke from a wood fire. A beginner will miss a lot, but one doesn't need to be an experienced connoisseur to get the message. Evanescent pleasures like these can be found anywhere in the material world, if one is ready to notice them.

Chapter 20

ALL THAT IS LEFT

K*INTSUGI*, THE TRADITION OF REPAIRING a teabowl with gold and lacquer, marks the experience of loss in a very particular way. Once broken, the bowl will never be as it was before, and the use of precious materials in the repair serves to remind us of that fact. Often, such a bowl will be prized because of its relationship to a past tea master. The fact that it was touched and treasured by such a revered figure becomes part of its history and hence its value. The British artist David Clarke has made a work that powerfully embodies this idea. After his mother died, he took the last teacup that she had drunk from and made a cast of it in pewter. He then cast it again, and again, and again, each time pouring a little less metal into the mold. What had been a full cup gradually disappeared, leaving only the rim that her lips had touched. The finished piece, in which all the casts are simply stacked up with the fragile rim on top, is a visual poem on grief—what it means to lose a loved one and have them disappear.

This way of remembering through things is one of the most powerful forms of connection to materiality that we have

as human beings. Most people have at least one object in their possession that they hold dear because of its connection to a departed loved one. We often term such objects "relics," which perhaps prompts thoughts of medieval saints' body parts, kept in elaborate gold and crystal boxes. But, while the Middle Ages were indeed preoccupied with such remains, the respect paid to relics is still a pervasive thing today. It is a material practice that is intelligent, not in the sense of being analytical, but rather an intuitive drive that speaks to the most fundamental human psychological needs. This is where material intelligence and emotional intelligence overlap.

Relics have arguably become more prominent in contemporary American culture in recent years, since the terrorist attacks of September 11, 2001. Following the tragedy, the United States confronted a new set of problems, and not all were political in nature. The nation had not been faced with trauma of this kind for many decades, arguably since the Japanese bombing of Pearl Harbor. Moreover, for most people

the attacks had played out "live" and on-screen. It seemed impossible to find an appropriate emotional response; but in the years since, Americans have found many ways to process the experience. One of the most prominent has been the veneration of relics. The National September 11 Memorial, built on the site of the World Trade Center, is one of the largest and most sophisticated historical museums ever to be built. It displays artifacts from the enormous to the intimate: monumental steel fragments, scorched fire engines, scarred cell phones, police badges, teddy bears, handwritten notes. The hope is that through the preservation, documentation, and display of these objects, some justice is being done to the memory of those who died in the event.

After the attacks a consensus quickly formed that it was unethical to focus on images of the victims, particularly the distressing pictures of people falling to their deaths from the burning towers. Also difficult to contemplate was the fact that so many who lost their lives were never found, their bodies lost in the ruins. The material remains of the World Trade Center became stand-ins. Twisted metal girders and crushed emergency vehicles, which preserved the precise moments of impact and collapse, served as metaphors for the bodies of the bereaved.[1] It is no disrespect to the 9/11 memorial, or to those whom it commemorates, to compare this instinct to the way that medieval people understood religious relics. In both cases, the principle is that absence can be rendered meaningful through the reverential contemplation of physical traces.

Contemporary America's relationship to relics is not limited to those associated with 9/11. Mass shootings, foreign

wars, natural disasters, automobile accidents, the deaths of celebrities: All are occasions to collect and preserve, and thereby to memorialize. What are these relics doing for us, exactly? The *Oxford English Dictionary* defines the word as "all that is left," and a relic is indeed often a physical piece of what has been lost, or at least was touched by it. It is a remnant, a trace, a part that stands in for the whole (a synecdoche, to use a technical term from poetry). A relic must be authentic, or at least be believed to be genuine. It operates through direct testimony. Usually, relics also have some form of "indexical" relationship to the person or thing that is gone, meaning that the object is a direct mark or sign of presence: The word "foot" isn't an index, but a footprint preserved in the ground is (imprints of the Prophet Muhammad's left foot are held holy by many Muslims). The name "St. Francis" isn't an index, either, but his left index finger definitely is, because it was physically part of him.

In its directness and emphasis on physical touch, the relic stands in total opposition to many aspects of twenty-first-century experience. We live at a time when technological mediation has become ever more powerful, indeed, a dominant force in our lives; it is striking that digital mass media in particular are, in several respects, the direct opposite of relics. One could hardly call them authentic, nor do they operate according to the logic of parts and wholes. Though the word itself derives etymologically from counting on our fingers (ten digits on two hands), we cannot really touch the digital, even when we hold a device in our hands. The potency of contemporary media, indeed, is precisely its detachment

from physicality. This is what permits it speed and malleability. Contemporary relics may have risen in our awareness due to the singular events of 9/11, but more generally, they can be seen as a counterforce to this pervasive dematerialization.

One way of understanding the relic is as a type of souvenir, a term discussed at length in a wonderful book called *On Longing*, by Susan Stewart, from 1984. Stewart writes about objects in relation to psychological narrative. She is fascinated by the "kind of ache" that arises when we care about something deeply, and wants to understand what happens in that moment of longing: a moment when, one might say, we are the opposite of distracted. In the book, she discusses four different inducements to this extreme attention—the gigantic, the miniature, the collection, and the souvenir. What all of these categories share is that they are states of being that a person cannot fully inhabit. The gigantic and the miniature lie beyond our direct experience because of their size. Too big or too little, they are beyond human scale, so we can only enter them in our imaginations, as Jonathan Swift did in writing *Gulliver's Travels*. What would it be like to be enormous, or tiny? We don't know, but in thinking through the question, we focus on issues of material experience that we might otherwise overlook.

Similarly, Stewart argues that the collection stands for a dream of completeness that we cannot ever truly attain. She illustrates this idea with an apocryphal story about an English book collector who owns what he believes to be the only existing copy of a particular precious volume. When he learns that there is a second copy, in the possession of a French

collector, he offers to buy it for one thousand francs. The Frenchman turns him down, but the Englishman insists, raising his offer. Two thousand francs. Ten thousand. Twenty-five thousand! Finally, the French collector can no longer resist, agrees to the fabulous price he has been offered, and hands over the book. The English collector grasps it and immediately throws it into the fire, thereby restoring his own book's uniqueness and his peace of mind.

Like many tall tales, this one has a kernel of truth to it. I used to work in the Research Department at the Victoria and Albert Museum in London, which has an absolutely enormous collection of all sorts of things. I once asked Craig Clunas, who had previously been keeper of Chinese Art at the V&A, why there were so many ceramics in the collection (more than forty thousand, at last count). He explained that when the collection was first formed, the curators noticed that there were gaps. For example, they might have an early example from a certain manufacturer, but not a late one; or they might have a teapot but not a teacup; or a red one but not a blue one. So they kept adding objects to fill the gaps. "The problem," Clunas observed, "was that every time they acquired a new object, they discovered new gaps on every side of it."

The unquenchable longing that lies behind such acquisitiveness, Stewart thinks, bespeaks a desire to control the world by making a complete account of reality. This brings us back to the souvenir, the fourth category that she discusses in her book. In this case, the longing has to do not with scale or completeness, but rather with our desire to reinhabit the past. Whether a souvenir is momentous, like one of the 9/11 relics,

or trivial, like a little plastic reproduction of the Eiffel Tower, it offers us a route backward in time. We prize such an object not for its inherent worth, but for the way it connects us to something lost, "events whose materiality has escaped us," as Stewart puts it.[2] We might here recall Maurice Halbwachs's idea that all memory is collective; in this sense, a souvenir is a way of anchoring our place in time, a material connection in a world that is always in the act of slipping away.

Chapter 21

SMALL WORLDS

ONE OF THE STRIKING THINGS about Stewart's book is that the states of longing that she discusses, which prompt such attentiveness and care, all have a material basis: the overwhelming physicality of the gigantic, the carefully chosen artifacts in a collection, the way that a souvenir translates an original experience into portable form. The miniature is particularly intensive in its materiality, in that it involves the condensation of the world as it usually appears to us. Because we cannot actually enter that small scale, we instead mentally project ourselves into it. Stewart writes of this dreamlike experience as a means of getting in touch with the "the secret life of things."

One example of this sort of microcosm is the dollhouse, a home kept within a home. When they first appeared in the seventeenth century, dollhouses, and the tiny furniture and other objects that were put inside them, were made by specialist craftspeople. (Such early examples, incidentally, preserve valuable evidence of the way that houses at the time were furnished. It is particularly helpful to the historian that

seventeenth-century dollhouses tend to include kitchens and other functional spaces, which are unlikely to be shown in a painting of similar date.) They are outstanding specimens of craft, in which techniques such as metalwork, wood joinery, and ceramics are made at astonishingly fine scale. For today's viewer, the most compelling aspect of a historical dollhouse is precisely the same as the appeal it had when newly made: It invites us to fantasize about living in that place, oddly enough, much more effectively than an actual preserved historical interior could ever do. Just as Stewart says, the shift in scale that we experience with this "house within a house" makes it easier for us to imaginatively take up residence: "The dollhouse's aptest analogy is the locket or the secret recesses of the heart: center within center, within within within."[1]

Returning briefly to the example of the Japanese tea ceremony, we might note that while it does not involve actual miniaturization, it is certainly tightly controlled, not only

spatially but in every other respect as well. What is said, the gestures each person makes, the objects that are used, the art on the walls, the tea itself—all are carefully prescribed. The teahouse is very confining in scale and precise in its specifications, and in this sense somewhat comparable to a dollhouse. Even the small doorway helps to convey the impression of constraint: It makes the experience of tea into a microcosm, a world in miniature.

There are many other situations that involve confinement like this, and that similarly challenge our imaginations. Alexandre Dumas's novel *The Count of Monte Cristo* includes a memorable scene describing an ingenious prisoner who, desperate to pass the long days by study and writing, fashions ink from a mix of soot and wine, carves pens from fish cartilage, and cuts pages to write on from his own clothes.[2] This is the stuff of fiction, but I did once meet a retired corrections facility officer who had many similar stories to tell of prisoners' ad hoc craftsmanship. In addition to legitimate projects that inmates undertook to earn a little money or just as a hobby, like quilting, he had seen many examples of jail crafts that were less congenial, like plastic toothbrushes whittled down into lethal shivs and, in one remarkable instance, a thirty-foot-long rope made of braided dental floss, hidden under a bunk. The man who had made it, intending an escape, had even managed to fabricate a grappling hook and smuggle it out of the penitentiary's metal shop.

Such extreme inventiveness can be a matter of life and death. Consider the similar but more sobering case of prisoners of war, whose very survival may be dependent on their ability to

understand and manipulate their material environment. Louis Zamperini, who had been an Olympian track athlete for the United States before serving as a soldier in the Second World War, wrote of his experiences as a captive in a series of POW camps—a very different side of Japanese history from that of the refined tea ceremony. Zamperini wrote forthrightly and wrenchingly about his harrowing experiences, which included routine beatings and near-constant starvation. Not all of his fellow prisoners made it. Those who survived did so by inventing numerous ways to keep themselves alive, including devising a pointed piece of bamboo that could be used to spear a rice sack through a rough wall and funnel the grains into their waiting hands; and starting fires with a stick and friction, Boy Scout style, to keep warm. They smuggled tobacco into camp by wrapping the leaves around their ankles, under their military-issue leggings; and they even found ways to sabotage Japanese war production while working as forced laborers, for example, breaking bricks in half by banging them together just so and restacking them so that the breaks didn't show.[3]

Another World War II story concerns shipwrecked crew members of a navy ship that was torpedoed a few hundred miles off the coast of Brazil. The survivors found themselves adrift on a raft—a simple affair of wooden slats buoyed by empty steel oil drums. What happened next, as recounted later by one of the castaways, was desperation countered by invention. He and his mates constantly turned one thing into another. They cut a hole in the center of the raft and fished through it with a spear tipped with half a pair of scissors. They retailored their clothes to provide maximum protection from the elements.

They made a lasso out of rigging rope to snare a shark for food (this sounds impossible, but they did it, one of the sailors dangling his feet into the water as bait). If they caught a bird, they would repurpose its intestines for fishing line. The glass lens of a burnt-out flashlight provided the material for a knife, which they used to cut up anything they caught. In this way three of the men managed to survive the ordeal; they were picked up by a passing convoy eighty-three days after the wreck.[4]

This type of improvisation, rather than the grand battles typically depicted in film, is the real heroism for many in war. Soldiers and civilians alike often take up craft as a salvation, not only physically but also psychologically. The famed "Make Do and Mend" campaign that British women undertook during World War II was partly practical but also patriotic. Pat Kirkham notes that "the longer the war went on, the more ingenious the makeovers":

> wedding dresses from lace curtains; evening dresses from nightgowns; nightgowns from evening dresses; lightweight suits from plush tablecloths; underwear from scraps of parachute silk; dressing gowns from captured enemy flags; new hats from old ones and even from thick dyed knickers; jewelry from corks, buttons, and scraps of felt; "rainbow" sweaters from oddments of wool; siren suits from old blankets and kilts; and patchwork housecoats "from scraps of the frocks he loved you best in."[5]

While the women on the home front were performing these feats of remaking, and Zamperini was finding ways to survive

in Japan, the British army major Alexis Casdagli was living in dire circumstances as a captive of the Nazis in Europe. He turned to needlework as a way to occupy his time, cross-stitching patterns and homely verses about the experience of imprisonment. In one sampler, he secretly incorporated Morse code into a decorative border to spell out a subversive message: FUCK HITLER—GOD SAVE THE KING. His son Tony later wrote of his father, "He would say after the war that the Red Cross saved his life but his embroidery saved his sanity."[6]

Living on a stranded raft or in a brutal POW camp has nothing to recommend it, of course. But notice how in these experiences the drastic restriction of material comforts immediately produces human creativity. Such "microcosmic" situations, if I can put it that way, are powerfully suggestive of how we might all live a little more effectively. You may have seen a film a few years back called *The Martian*, in which the lead character, played by Matt Damon, is accidentally marooned on Mars and must exert every bit of his material intelligence to survive. He manages to grow potatoes using his own excrement as fertilizer, irrigating it with water that he makes from a tank of oxygen combined with hydrogen extracted from a reservoir of rocket fuel. This, too, is the domain of fiction, of course, but similar experiments have been tried here on Earth, sometimes with results that were even more interesting than intended.[7]

A few years ago, NASA set up a simulated Martian life-support chamber, inhabited by a crew of six. Just as off-world settlers would be, they were completely cut off from outside help—meaning not only people, but also air, water, and

anything else that would support life. The goal was to understand the minimum amount of resource needed to set up an off-planet colony. Given the distance from Earth, every gram of water and soil, every light fixture, would be a huge expense. And so, in the enclosure, everything was recycled. The tiny climate was held in delicate balance, with everything necessary for life carefully calibrated.

On one occasion, the experiment was going particularly well; the crew had been in the habitat for more than eighty days, breaking their existing record for consecutive time spent in total isolation. To celebrate, the support staff who had been monitoring them printed up T-shirts commemorating the milestone and put them into the enclosure via an airlock. What happened next surprised everyone involved: Within twenty-four hours, all the plants that the team had been growing for food wilted and died. It took them a while to realize what had gone wrong. The iron-on transfers on the T-shirts had released minute amounts of formaldehyde into the air supply. It was just enough to knock the biosphere out of balance. End of experiment.

I heard this story from a remarkable woman named Constance Adams, who has one of the coolest job descriptions imaginable: She is a space architect for NASA.[8] What this means is that she designs the living quarters for astronauts. As the example of the Martian simulator suggests, the tolerances on this sort of interior are extraordinarily tight. Adams can only use a handful of materials, because almost all substances either "off-gas" (like the decals on the T-shirts), conduct electricity (not a good idea in a densely wired spaceship), or

are flammable, which could be disastrous in an enclosed environment with limited oxygen.

Even within the narrow range of these specifications, Adams has to choose materials that are strong but very light in weight. Most materials that are both inert and nonflammable are also very dense, so they add unacceptably to fuel costs during liftoff. So what can she use? Aluminum, for starters, is an essential material. She also uses Nomex, a ceramic-fiber fabric manufactured by DuPont, though only in a few of the available colors; most of the palette has flame properties that are above the permitted ratings. That's okay, because NASA doesn't much care about style. Purely functional considerations always come first. As Adams puts it, "There is an aesthetic quality to the living spaces we're putting together, but it's almost completely accidental. I almost never have a choice between beautiful and ugly."

One of the few factors that Adams does consider from a visual perspective is gravity, or rather, the lack of it. Once in orbit, an astronaut lives in a weightless and directionless space. Over a long period of time, this can be unhealthy, as the body and mind are engineered to function on Earth, which exerts a constant downward pull on our muscles, bones, and brains. She can't do all that much to compensate, though she does think carefully about issues like lighting position and, when she has the opportunity, creates decorative patterns that steadily diminish in one direction, creating a visual code for up and down.

Over the course of her long career, Adams has managed to introduce only one new material to outer space. She had been

considering a problem of the kind that only a space architect would be likely to notice: All of the materials approved by NASA were opaque. That is not usually an issue, but in an emergency situation when every second counts, transparency might be very useful—say, if an injured, spacesuit-encumbered astronaut were trying to find an item in a first aid kit. For such applications, Adams developed a clear, injection-moldable bioresin based on cornstarch. Chemically, it is not unlike the recyclable packing peanuts that get all over your floor when you open a shipping box from UPS, but it is transparent. This is a good example of the way that the extraordinary constraints of space travel motivate innovation.

Another celebrated instance is the development of LEDs (light-emitting diodes), a technology that was refined in the space program, though not in Adams's lab. LEDs release no heat, are not particularly fragile, and last for a very long time, all of which makes them ideal for space—astronauts don't want to worry about changing lightbulbs. Of course, the technology is now widespread here on Earth, and is helping to reduce our overall carbon footprint. As professionals involved in space exploration (who are dependent on public funding) like to remind us, this kind of breakthrough is fairly common in their work. Extreme conditions force designers to be smarter. They come to realizations that they might not have if they were working in a more permissive environment. This is the point of Adams's story about the killer T-shirts in the Martian simulator, too. Prior to the introduction of trace amounts of formaldehyde, the habitat had been capable of supporting human life, but it was held in precarious balance. In this respect,

it was like the environment we inhabit here on Earth. The only difference is that our ecosystem is much, much bigger, so it reacts to materials like off-gassed formaldehyde relatively slowly; but this doesn't change the fact that it is reacting all the time. The sad fact is that, as Adams puts it, "most plastics are just not compatible with life."

As a space architect, Adams is in an unusual position. She does not enter her created microcosms imaginatively, like a child with a dollhouse, but literally, shaping a miniature prototype of our whole planetary situation.[9] We are all living, as the visionary scientist Buckminster Fuller used to say, on Spaceship Earth. By understanding the difference between the material environment we actually inhabit and the one we would need in order to survive on Mars, without the abundant resources of our own lushly habitable planet, we may be able to get some measure of the distance between the way we live now and the type of existence that would be permanently sustainable on Earth. So, while Adams works with a uniquely narrow range of materials, her thinking has broad implications. Rather than asking herself what the most attractive or livable option would be, she is obliged to wonder, "What is the minimal set of requirements that are not going to kill us?" Spacecraft are necessarily fabricated with super-eco-friendly, nonreactive materials. Is that what our future, too, will demand? It's a question we will all be faced with, and sooner than we'd like.

Chapter 22

FEWER, BETTER THINGS

ONCE YOU START THINKING about achieving true
sustainability, you begin to realize how very challenging
a goal it will be in the long run. Only two centuries have passed
since the onset of the industrial revolution—an eye blink in the
span of geological history—and already, we humans have
managed to wipe out innumerable animal species, cause
temperatures and sea levels to rise, induce freak weather patterns,
and make the air in some cities unpleasant to breathe. And we
are just getting started. Given the likely impact of ongoing
global industrialization and continued population growth, it
is hard to see how we can avert climate change of epic and
perhaps disastrous proportions. There is no easy fix for this
situation, but there can be little doubt that applying our
collective material intelligence is an important part of the
remedy. Not only will it allow us to devise more efficient and
less damaging solutions to our own "life support," appreciating
materiality also encourages us to more highly value objects in
general. By cultivating a cultural interest in fewer, better things,
we can reduce our twin propensities toward overconsumption
and waste.

This principle—that the more we invest concern in particularly meaningful objects, the less our world will be awash in disregarded trash—has often been used as an argument in favor of craftsmanship. People will gladly reuse expensive handmade cutlery again and again, whereas they don't think twice before chucking out plastic forks and knives. In general, the more well made an item is, the more care has gone into it, the more likely it is to persist. Ideally it will last a whole lifetime and even get handed down from one generation to the next.

This model of sustainability through high-quality things has the unfortunate reputation of being elitist. Even more unfortunately, that reputation is completely accurate. Few people can afford to fill their homes with finely crafted objects; insisting on excellence as our best pathway to ecological balance is simply impractical. This is a replay, at a different scale, of the problem faced by William Morris, the father figure of the Arts and Crafts movement. A committed socialist, he wanted to make beautiful things for all; instead, as he complained bitterly, he spent much of his time "ministering to the swinish luxury of the rich." This conflict, between craft's intended populism and its actual expense, is to some extent insoluble. Yes, luxury objects like beautifully carved furniture and handmade leather shoes are likely to last a long time. But if hardly anyone can afford them in the first place, it doesn't make much of a difference in the quality of our overall lived environment, much less our survival on the planet. In fact, there is a sense in which luxury craft exacerbates our existing difficulties, because it implies that you can always tell a thing's value by its price tag, which is simply not true.

An object does not have to be beautifully made in order for us to care about it. Fine craftsmanship is important, but it is not necessary. We can apply the affinity we bring to fine craftsmanship in a more general way. For example, we can appreciate the accessible rigor dreamt of by modernists in a mass-produced tubular steel chair (though in doing so, we should be curious about where the iron and other metals in the steel were mined, who made the chair, and so on). There is no one right way to furnish our environment. Any way of making and living with objects can be equally valid, so long as it serves our basic needs and we find meaningful connections within it. I think again of my grandfather, with his hand-split fence posts and homemade ice cream. There was not a lot of luxury on Pumpkin Creek Farm, but the things they did have were appreciated.

A purposeful, even exaggerated return to a hardscrabble lifestyle can be seen in a recent trend called "freeganism," in which people reshape their lives by scavenging and reusing waste rather than buying new things. Surprisingly, this turns out to be a lot easier in cities than it is in the countryside, because of the huge amount of waste that occurs in urban settings. One acquaintance of mine in London, Katharine Hibbert, decided to spend as little money as possible for a period of a year, then wrote a book about the experience.[1] During her time living "on the margins of a wasteful society," she acquired her furniture and home goods by Dumpster diving. She squatted in an abandoned building (which is legal in the UK). She even managed to take a vacation by hitching rides.

The neologism "freegan" is a play on the term "vegan," and as that implies, much of the movement concerns food, rather than objects. Astonishing amounts of perfectly good food are thrown out every day: In the course of a year, according to Hibbert, Britain alone produces twenty million tons of edible waste. Why not eat it, instead of putting it in a landfill? One can combat these forces, but it requires an open mind. Hibbert lived like a frontier homesteader during her year of freeganism, though she was right in the middle of one of the world's most populous cities. She became adept at evaluating food wherever she found it, so as not to become ill. She learned repair skills, restored scavenged possessions. Where others saw waste, she saw opportunity.

Freeganism is obviously not for everyone. Even Hibbert herself has not persisted in the lifestyle, though she has gone on to build a business called Dot Dot Dot, which works to house low-income residents in properties reclaimed from abandonment. But even those of us who are happy living within the usual norms of capitalistic society can learn from her experiment. Among the unexpected takeaways from her book, for example, is the importance of mutuality within squatter communities. In important respects, her life at the margins was different from that of others she encountered, or indeed homeless people, who also survive day to day with very little money. She was living in this way by choice, not necessity, and also knew that her undertaking would come to an end eventually. Yet those who had very little and did not necessarily expect their prospects to change tended to be very generous with her and with one another. Hibbert describes them as

pooling their hard-won resources in ways that might never even occur to suburban residents. By and large, she found, squatters share.

In Lewis Hyde's widely read book *The Gift*, there is a lovely passage that describes a custom in a French countryside café. "The patrons," he writes, "sit at a long, communal table, and each finds before his plate a modest bottle of wine. Before the meal begins, a man will pour his wine *not* into his own glass but into his neighbor's. And his neighbor will return the gesture, filling the first man's empty glass." The whole exchange might well happen wordlessly. Neither man has any more wine than he would otherwise have had. Yet to Hyde, this simple scene seems to capture something essential in human affairs: "In an economic sense nothing has happened . . . But society has appeared where there was none before."[2]

If we set Hyde's example alongside Hibbert's, we can see that they have something important in common: finding value in the valueless, as a way of creating common cause. Like the keeping of relics and the creation of controlled environments, this is another important way that we can infuse our lives with meaning. If we want to reshape our physical environment to be more humane and ecological, understanding it as an untapped resource of significance will be much more effective than luxury production or the top-down solutions that designers tend to offer us. Gifts are a great example of this found significance, because in one sense, whether or not they have economic value doesn't even matter very much. An object given freely from one person to another may well have been purchased as a commodity, and it may eventually become one

again. But in the moment of exchange, its value is primarily social. It is a bond, both material and personal.

There are factors to acknowledge here that complicate any simplistic understanding of altruism. First of all, gift giving is often attended by expectation: One doesn't come empty-handed to a Christmas party. In many social contexts, such expectation can be extremely formalized, so much so that gifts have widely been employed as diplomatic tools. In the "potlatch" ceremonies of indigenous communities of the Pacific Northwest, for example, major events like the inauguration of a new chieftain are marked by the distribution of engraved copper plaques, blankets, and guns. In extreme cases, such rituals can be intensely competitive: Among the Kwakiutl peoples, conflicting claims of leadership were resolved through lavish giving and even the outright destruction of valuables en masse. By the mechanism of potlatch, individuals who had not previously enjoyed high status but who had become wealthy through trading could establish themselves as new authority figures—the Native American version of the nouveau riche.[3] Feudal lords in medieval and Renaissance Europe, similarly, bestowed fabulous curiosities upon one another: mounted nautilus shells, coral specimens, and narwhal tusks (often thought to be unicorn horns at the time). We can be sure that the economic costs of such gifts were closely observed, and behind the expenditure lay clear indications of political intent.

Nor is such self-interestedness only found in traditional and historical societies. In just about any context, a gift may mark a social boundary that otherwise remains unspoken. The scene that Hyde observed, in which French peasants quietly

exchanged their wine, could be seen in a skeptical light: Would the men have poured for anyone who lived outside the village? For a woman sitting on her own? For someone of a different ethnicity? Maybe, but maybe not. Gifts can work to exclude as well as include.

Even so, because a gift doesn't involve an exchange of money, it can stand for other ways of valuing things. This is a familiar idea, if not one that we often stop to consider deeply: A gift is precious not because of what it is, but because of who did the giving. When we wrap a birthday present, etiquette demands that we peel off the price tag but add a personal note. Think of a child picking up a pretty stone on the beach, then handing it to a parent or sibling. This is the sort of moment that Hyde celebrates: a material thing given personal consequence through a simple act of generosity. Just as souvenirs connect us metaphorically to past moments, to places once seen and now remembered, a gift connects us to a person in our lives. When really well chosen, it may even seem like a symbolic portrait of the relationship between giver and receiver.

Chapter 23

TO HAVE AND TO HOLD

W E CAN SEE HOW MATERIALITY is implicated in gift culture by considering two contrasting examples, at the far extremes of preciousness: stuffed animals and diamond jewelry. These categories of object are unusual, in that both are acquired almost exclusively as gifts. They are also strongly associated with specific stages of life. Toy companies aim their messages primarily at children and their close relations, while jewelers invariably represent their wares as tokens of romantic love, often associated with weddings or anniversaries. In both cases, companies imply that well-adjusted people are almost morally obliged to buy their products. One toy company uses the slogan "Gotta Getta Gund," while the well-known tagline of the giant conglomerate De Beers, "A Diamond Is Forever" (advertising copywriter Frances Gerety came up with that in 1947), is quite literally a pronouncement of cultural conservatism.

Beyond the marketing, however, lie genuinely deep wellsprings of meaning. It is easy to be skeptical about emotional claims made for commodities, especially claims made by those who are selling them. But stuffed animals and diamonds really

do connect to people's lives in rich and abiding ways. It is interesting to note, as anecdotal proof of this notion, that children who have many teddy bears and adults who have lots of diamond jewelry (lucky them) tend to feel slightly self-conscious about the hoarding. Often they claim to prize one bear, or one jewel, above all others. The whole point of a stuffed animal, or a diamond ring, is to be special.

In the introduction, I wrote about the starring role that a teddy bear played in my own growing-up years. Since the runaway popularity of the toy in the early twentieth century—famously inspired by, and named after, President Theodore Roosevelt—it has become an emblem of childhood itself. For many infants, teddy bears are the very first objects of psychological attachment. By association, they play an important role at the end of life, in mourning practices where they serve as symbols of lost innocence, and perhaps redemption.

When Michael Jackson died, in 2009, his childhood home in Gary, Indiana, was piled high with stuffed animals left by legions of heartbroken fans. The same happened at the gates of Kensington Palace after the death of Princess Diana. Teddy bears were a favored medium for expressions of grief after 9/11, and anyone who has driven down a highway knows that they frequently are incorporated in markers dedicated to the victims of traffic accidents. As the range of these examples indicates, toys can play an important emotional role for people struck by a sense of loss, whether that feeling is imparted by an overidentification with mass culture or the tragic death of one's nearest and dearest.

Whatever the circumstances, in a child's crib or a roadside shrine, the materiality of stuffed animals is significant. Their

soft texture, which recalls actual animal fur, encourages tactile connection. Less obvious is the fact that a teddy bear is cleverly designed with regard to vulnerability. Not so fragile that a child will destroy it outright, a bear's surface is nonetheless easily dirtied and difficult to clean, and after a trip to the washing machine it will never be quite the same. It would be easy for manufacturers to make stuffed animals that are entirely impervious to damage, by using tough modern drip-dry textiles. But by and large they don't do this, nor do consumers demand that their bears should be more hard-wearing. This is because of an important but subtle function of the object: It requires that one care for it. A gift in itself, it also acts as a repository for further generosity from the child who owns it. This is considered to be a useful lesson and a refraction of parental love. If the bear shows signs of gentle but persistent use, particularly if the toy was handmade by a relative, so much the better. It physically registers emotional investment continually over time.

Of all the teddy bears I have known, perhaps the most eloquent are the ones included in an outdoor artwork called the Heidelberg Project, in Detroit. In the 1990s, a time when urban blight was at its absolute worst in the city, the artist Tyree Guyton began to transform an entire block of abandoned buildings into a sculpture park. He worked with kids and adults in the community to decorate the houses in unexpected colors and patterns, including bright painted polka dots similar to those seen on Wonder Bread packaging. Stuffed animals were a crucial element. Attached to the houses' façades and hung from trees, they were exposed to the elements. Festive when

first installed, the toys swiftly degraded into dingy decrepitude. The result has its own sad beauty, which resonates within the faded glory of Detroit. Though the Heidelberg Project is now a celebrated landmark in the city, Guyton neither sought nor was given official permission to carry it out. In fact, had the buildings not been abandoned, he could not have undertaken the project in the first place; in this sense, it draws attention to the tragic preconditions of its own creation. Like the *kintsugi* gold repairs on Japanese teabowls, his work both amends and aestheticizes things that are broken. Community spirit is shown to be a contingent thing, as easily misplaced as a child's toy, waiting to be found again.

Guyton's project, and for that matter any use of stuffed animals in marking grief, draws its meaning from the material qualities of soft toys—their plush warmth, vulnerability, and accessibility. A nearly opposite set of connotations manifests itself in the giving of diamonds, which are also nearly opposite in their materiality: hard, perfect, indestructible, and, of course, extremely costly. They are not the product of hours spent with needle and thread, but a different type of investment altogether. Susan Falls, author of a recent anthropological study on diamonds, has conducted extensive interviews with people who own them.[1] She discovered something of a paradox. Almost all the interviewees indicated skepticism about the romantic narratives about diamonds that are promoted in fashion magazines and on television. Other people might be influenced by such rubbish, they invariably said, but their own ring was a completely personal matter. Yet obviously, the advertisements are working; statistically speaking, about 75 percent of brides wear a diamond on their wedding day.

When consumers claim that they are immune to the sentiments peddled by marketing departments, one's alarm bells should certainly go off; and certainly, there is much to dislike about the contemporary diamond industry. Though fitful attempts have been made to address the problems of sourcing, for decades precious stones have been mined in Africa in terrible circumstances, including slavery enforced by violence. Awareness of these so-called blood diamonds is obscured not only by the lack of transparency that one finds in almost all commodity chains, but also by the dazzling sight of the stones themselves. Here, we arrive at the special quality of diamonds, which sets their paradoxes in train. Each stone is rated according to a rigorous grading system, codified by the Gemological Institute of America. The standards fall into four categories, nicknamed "the four Cs" in the trade: cut, clarity, color, and carat (a measure of the stone's weight). Any trained gemologist can score a stone according to this system. So in this sense, the value of a diamond is completely objective. Yet as Falls puts it, "In the same way that a land map cannot tell us what a place is really like—how it feels when the wind blows there—a GIA certificate cannot tell us what a particular diamond might mean."[2] Very few people are trained to grade precious stones, and even if they may know how many carats a given diamond is, they probably will have little sense of the other variables involved, and therefore its actual cost.

The fact that diamonds disguise their own value is suggestive. They are, quite obviously, expensive objects that are priced according to exacting specifications. But the receiver doesn't typically know how much a diamond is worth when they receive it. In this sense, it actually is "priceless." This makes

the giving of the stone feel nontransactional, leaving space for both giver and receiver to bring their own associations, their own values, to the exchange. The effect of light that we see in the stones is itself an apt metaphor for the way that a diamond deflects attention from the money that is invested in it. The redirection boosts the profit line of gemstone suppliers and retailers, and points to the complexity that can arise when we value objects in ways beyond the strictly monetary. When we allow these chunks of crystalline carbon to stand for some of the most emotionally profound aspects of life, we also risk thoughtlessly subscribing to all the conditions that make them possible. Even so, they attest to the fact that even tiny things can be rendered into deep repositories of feeling.

So here is a thought experiment. What if we were to regard every object in our material environment, whatever its cost, with the same set of attitudes that we bring to a much-hugged teddy bear or a diamond ring that symbolizes love? Furthermore, what if we were to approach every object according to its potential for narrative and meaning—the way that we give a toy to a child or a ring to a spouse? This would mean attending closely to the qualities of all our possessions. It would require us to make a place for each thing in our lives, treating it as singular, special, and significant. It might involve learning about where these objects come from, to follow the links of the commodity chain back as far as we can go. If we were to bring objects into our lives one by one, each time with genuine care, it would be better for us, better for society, better for the planet.

Perhaps this sounds like an unrealistic, even impossible goal. But in some places and times, it is very much the rule. There

are many situations in life where every object is subjected to great care: the tea ceremony master assembling his equipment, Jerry Walsh in his conscientiously stocked hardware store, a shipwrecked crew of sailors on a life raft, astronauts in a simulated Martian habitat, Katharine Hibbert on her elective holiday from capitalism. One can think of many other examples, too. In any nomadic culture, people necessarily live light on the land. So do thru-hikers on the Appalachian Trail, who must carry everything on their own backs. In religious spaces, like a cathedral or a mosque, every object must be liturgically approved. Great control is exerted over the atmosphere as a whole, because light, smell, and sound are all important mediums for the spiritual experience; even nonbelievers will usually lower their voices while exploring a completely empty church.[3]

Another great example of intensive material concern is a film set. Out of the camera shot, chaos reigns. There are wild snarls of power cords, tables heaving with uneaten catering, booms and lights and reflectors and scaffolding. No one cares. Within the shot, however, every single object has been selected and placed with painstaking preparation and precision. I once had the chance to speak with Ellen Freund, the prop manager for the television show *Mad Men*. The program, set primarily in the 1960s, was produced with an awe-inspiring level of attention to detail. Once the fictional date of each episode was established, Freund sourced the furniture, while the costume designer Janie Bryant did the same for wardrobe and hairstyles. Both of them scoured thrift stores, and eBay was a vital source for old crockery, packaging, and cosmetics. Magazines and

newspapers from the correct date of each episode were either sourced or reproduced. The prop department went so far as to prepare a wallet or purse for each character, filled with period-appropriate money and ID cards.

Mad Men earned its following in part due to this astoundingly precise period re-creation. Of course Freund's efforts, and indeed all of the situations I've been describing, are exceptional. They even take their meaning from their exceptionalism. Yet we can still learn from such examples. Few people would want to live in a church or as if they were performing on camera. Not too many want to join a nomadic tribe or walk the whole Appalachian Trail, either. But all of these models point to different ways that we can enhance our material attentiveness. It is a wide palette to choose from, but the key is that we can connect to each object in our environment as carefully as Ellen Freund selected Don Draper's highball glass. We truly can live with fewer, better things. All we need to do is pay closer attention.

Chapter 24

THINKING THINGS THROUGH

M Y TWIN BROTHER, PETER, is a professor of philosophy. He teaches in Munich, with special expertise in ancient and medieval thought and a subspecialism in the traditions of the Islamic world. To study those subjects, he has learned Greek, Latin, and Arabic in addition to his fluent German. Peter has long been frustrated at the haphazard and inaccurate way that the story of philosophy is often taught. The usual undergraduate courses start with Plato and Aristotle, then skip over more than a millennium to get to the Enlightenment, leaving out the medieval and Renaissance periods entirely, including most of the figures he studies for a living.

A few years ago, he began recording a free weekly podcast called *The History of Philosophy, Without Any Gaps.*[1] The project's goal is to present a twenty-minute episode a week, every week, and eventually to cover every single topic within the entire history of the discipline. Peter began his podcast with the first scraps of papyrus that record early speculative thinking—such as Heraclitus's famous riddle about the impossibility of stepping in the same river twice—and has since gone on to record

hundreds of episodes, carrying the narrative from ancient times forward, from the Mediterranean basin across Europe to the Middle East and India. In each of these places he has discussed pretty much every known philosopher, not only explaining their ideas, but how the whole patchwork of intellectual exchange has shaped and reshaped itself over time.

I asked my brother to philosophize about materiality, and the first point he made was that "matter" and "materials" are— from the philosophical perspective—quite different from each other. One of the questions ancient thinkers posed themselves was about physical transformation. How should we understand change from one state to another?

Let's say a carpenter has a pile of timber, lying in the yard outside their shop. (My brother chose this example because the word for "matter" in Greek is *hule*, which also means "wood.") Then one day the carpenter takes the timber and makes it into a simple table. What has happened? Well, there has been a rearrangement. Boards have been sawn out of logs and joined together. But it's not just any rearrangement—it seems fundamentally different, for example, from simply moving the timbers around in the yard. For the carpenter has made an entirely new thing, a table.

Where did the table come from? Aristotle answered the question like this: The materials have had *form* imposed on them, through the mind and will of the maker. The process can travel the other way, too. If the table were dropped from a great height it would smash to bits, losing its form. But the wood would still be there, just as it had been in the yard.

Thinking about this question a bit more deeply, a question arises: Did the wood already have "form" when it was sitting

out in the yard? From one perspective you might say no. It was just natural timber in a pile, waiting to become something. Raw materials. But that wood was once a tree, and the tree grew in a forest, nurtured by rainfall and soil. As it grew, did the tree not also attain form? Aristotle thought that it did, and considered that earth and water, two of the four primary elements (the others being fire and air), had combined in the creation of the tree. Still earlier thinkers, like the fifth century B.C. philosopher Empedocles, thought that these four elements were the most fundamental level of existence. But Aristotle doubted this, for it was clearly possible that one element could change into another, as when water evaporates into air.

Aristotle's observation led other ancient and medieval commentators to conclude that there must be some fundamental matter that underlies the four elements. This concept of "prime matter" (*prote hule* in Greek, *prima materia* in Latin) was sufficiently convincing that it remained an essential concept all the way up to the eighteenth century. This explains why medieval alchemists thought that it should be possible to turn lead into gold; because all substances were derived from prime matter, any material should be convertible to any other. Thinkers wrestled with this concept in numerous ways beyond the practical, too. They wondered if prime matter could be said to have any specific characteristics at all, or whether it could only be described as pure potential. Ancient and Christian philosophers also pondered its relation to the divine. All matter was thought to be lowly in comparison to God, and resistant to the perfection of ideal form. Perhaps matter was to blame for the evils of the world? That idea, originally proposed by the third century A.D. thinker Plotinus, gained ground in the

Middle Ages. That in turn raised another question: Why did God create matter at all, and how? Did he produce it out of nothing (*ex nihilo*)? Or was it always there—in which case he was more like a carpenter, giving shape to the world out of preexisting, imperfect stuff?

From the modern scientific point of view, many of these questions are now considered settled. The ancient theory of prime matter was eventually displaced by atomic theory. Physicists no longer speak of one essential foundation for the physical universe. But in a sense, the original philosophical problem remains. We can now delve down to subatomic level, and have made wondrous and counterintuitive discoveries about particles interacting with one another to form the properties of things. Yet no matter how far down we go, the foundational puzzles of ontology, the philosophy of being, remain. How should we understand matter itself? How should we characterize its changes from one state or form to another? And—of particular importance for our exploration of material intelligence—how should we conceptualize our own ideas about it?

Returning to the distinction between "matter" and "materials," we can see that the latter term only really makes sense in a moment of change—when some physical stuff is being used to make something else. A tree in a forest is only a "material" when it has been cut down and brought to the carpenter's yard, so that a table can be made from it. In this sense, the very concept of materiality is inseparable from human agency. My brother uses the analogy of cooking in the kitchen. We make dinner from things we call ingredients. But

when does something become an "ingredient"? Even regular table salt is highly processed stuff. It comes to us quite differently from how it exists in nature. Similarly, the distinction between a "material" and an object with a "form" seems to be quite subjective. If I am a furniture maker, the upholstery fabric I put on a chair is a material. But if I am a weaver, the fabric is what I am making; the material is the thread I put on the loom. And if I am a spinner, the thread is what I am making, and the material is wool off a sheep's back. And if I'm a shepherd—well, you get the point. It's all relative.

This philosophical finding, that materiality is an essentially purpose-oriented phenomenon, defined by human need, may initially seem surprising. After all, materiality is often treated as the paradigm for objectivity. The very word "objectivity" refers to the physical, and implies something that lies outside our subjective point of view. But materiality is perhaps better viewed as a meeting point, where raw matter and human purpose align. This conception of materiality, as a site where the objective and the subjective come together, helps us to see the foundation of its social importance. "Matter" only becomes a specific "material" when someone sees its potential and puts it into action—thereby finding a way to put an intention into the world.

Aristotle had a useful way of thinking about this. He wrote that materials could be considered to have a *telos*, that is, a set of intrinsic features that could be used to achieve a particular end. Form results when this *telos* is recognized and exploited. This ancient terminology is surprisingly relevant today. To adapt a popular philosophical conundrum: If a tree falls in a

forest, it only matters if someone knows about it, sees specific features in the wood that can be put to use, and decides to give it form. We might say this is the moment when materiality "happens." It is not important just in and of itself, but because it acts as a matrix for relations between ourselves and the world, and amongst ourselves as people.

Even science, seemingly the most objective type of material intelligence, is often organized according to the *telos* of different substances—materials as they are put to some definite purpose. Researchers make a conventional distinction between "pure" and "applied" disciplines, the former consisting of an investigation into matter itself, and the latter looking at how materials behave in a specific set of conditions. Having talked to my brother about these matters, I decided it was time to take a break from philosophy and get a bit more practical. So I spoke with a materials scientist and got an understanding of his way of learning about things.

Chapter 25

MATERIAL SCIENCE

"YOU MEAN YOU'RE INTERESTED IN TWEED?"
That is the sort of thing people say when Ian Hutchings,
a professor at Cambridge University in England, tells them
that he is an expert in materials.[1] In fact, he is a specialist not
in textiles, but in a field called tribology. This is the study of
materials' action on other materials, through phenomena such
as friction, wear, and lubrication. Essentially, Hutchings is
interested in what happens when things rub up against one
another. This may seem pretty niche, but it is a surprisingly
important topic. For example, if you want to know how long a
bridge will last before it starts to rust and what sorts of paint
might keep it standing as long as possible, you should ask a
tribologist, because they can analyze the way that the materials
in the bridge interact with the environment. Tribologists can
also help aircraft engine designers to understand what happens
when dust particles are sucked into an engine turbine and strike
the fan blades. And they can advise tire manufacturers on the
design of tread patterns that will grip the road more effectively,
reducing the likelihood of skidding.

Most people's grasp of materials is limited to the scale of everyday experience. When we touch clay, glass, and wood, we cannot see the microscopic building blocks of these materials. Yet all of their properties are based on the behaviors of atoms as they are combined within molecules, and molecules as they are combined together within microstructures. This is what material scientists study. One of the key insights that they offer is the importance of configuration. As Hutchings puts it, "If I say a material is made of iron and carbon, I'm saying nothing about what it's like." This one combination of elements can make a very ductile metal, like the steel used in a crash barrier; or a higher-strength steel, like that used in razor blades; or a brittle, carbon-rich cast iron, like that used in an old bathtub, which you could smash into pieces using a hammer. Similarly, most plastics are made of carbon, hydrogen, oxygen, and nitrogen, but they are incredibly diverse in their physical characteristics. It is their arrangement at microscale that determines whether they will be suitable for use in a plastic sandwich bag or a Lego brick.

Not all material scientists are tribologists, of course. Some specialize in organic materials, and think about how they grow and change. Some focus exclusively on creating new materials, rather than studying the behaviors of existing ones. There is also a distinction, comparable to that between mathematicians and physicists, between pure science and applied engineering. All material scientists work somewhere on this spectrum. Tribology, because it involves studying materials in specific situations, sits at a midpoint between the two extremes. Scientists like Hutchings are interested in both why a material behaves in a certain way—its inherent

properties—and also how it will behave in a specific set of conditions. For example, a material like the rubber in a tire has what is called a constant friction index, which measures how easy it is to slide a piece of that rubber across a surface. Tire rubber has a very high friction index, while glass has a very low one. But the asphalt used to pave a road also has a friction index, and the degree of purchase a tire has varies depending on that surface. Any given interaction between rubber and asphalt will be affected by other factors, too, like wetness and heat. Hutchings tries to come to an understanding of this whole range of potential circumstances. This is what it means to say that he works in an applied discipline. He literally studies where the rubber meets the road.

How does a tribologist get a handle on such things? Usually, by conducting experiments that replicate in laboratory conditions what is happening out in the world. For example, let's say a new bridge is being built in a seaside British town. As attractive as such a location may be (particularly when one factors in the fish-and-chips shop), it is a nightmare from an engineering point of view. Salt, sand, seawater, rain, and wind are all present as corrosive elements. There will also be occasional bright sunlight (even in Britain!) that subjects the materials to ultraviolet decay. What combinations of metal and paint best survive in such conditions? In the lab, Hutchings can try to answer this question by constructing a contained atmosphere in which samples of painted metal are subjected to the same phenomena and then quantifying the results.

A particularly important aspect of his methodology is acceleration. As Hutchings says, "You can't put the paint on and wait fifteen years; the customer won't hang about that

long." So the amount of corrosive exposure must be simulated at higher speed. The equivalent of fifty years' worth of salt spray, let's say, might be compressed into a single month, with exposures at regular intervals so that rates of change can be calculated. This requires great care in order to ensure accuracy. As a control, "real" weathered samples from a natural environment may be used as a comparison. If Hutchings does his work properly, he will eventually be able to advise bridge builders on their best options. He must also bear in mind the cost of production for various materials. Hutchings doesn't need to conduct a new scientific study to know that steel can be made more resistant by adding other elements to the alloy, like chromium. But that makes the material much more expensive, far too costly for a whole bridge. The questions are as much economic as scientific: how to achieve the greatest duration for the lowest price.

This economic factor points to one of the most significant implications for this type of materials research: environmental sustainability. When we think about reducing our impact on the planet, we tend to instinctively think about waste. How can we throw out fewer things? More recently, we have also been encouraged to think about emissions—flying less, for example, or reducing our dependence on coal by substituting other energy sources. This emphasis on reduction is important, but it leaves out the equally significant question of how we make things in the first place. How can we optimize production to minimize its impact on the environment? We have to start early in the manufacturing chain, for the choices we make in designing and selecting our materials is a key factor. Often,

different goals compete. For example, every pound shaved off a commercial aircraft will save enormous fuel costs over the lifetime of the plane. So intuitively, it would seem to make sense for us to build planes out of ultralight, extremely strong materials—carbon fiber rather than metal, perhaps. But unfortunately, carbon fiber is much more difficult to shape than metal, and hence much more costly to build with and, eventually, to recycle. To build a "green" airplane, all these variables must be assessed. Most people do not know of the very existence of tribology, or indeed, the whole vast realm of material science of which it is a specialized subdiscipline. Yet insofar as material scientists help guide manufacturers in making such critical decisions, they can benefit us all.

Chapter 26

HANDLE . . . WITH CARE

I CAN'T CLAIM MY BROTHER'S philosophical expertise or Ian Hutchings's scientific knowledge. But there is one thing I do know, and that's museums. I have worked in several, both in America and in Britain. When traveling, I always make sure to visit the local institutions, not just the big ones but also smaller, specialist, and out-of-the-way places. Partly I do this because I love looking at art and artifacts. Partly I do it for professional reasons—it's always a good idea to check out what colleagues are doing. But the top reason I go to museums is that they are unparalleled as spaces in which to appreciate objects.

Though I may be a bit prejudiced, I would argue that museums are the most accessible settings of all in which the public can learn from encounters with things. True, one can see art and artifacts in many other places—in a church, for example, or used as props in a movie. But in those cases, if we are in the right spirit anyway, we will not experience the objects primarily for their own material qualities. Even the greatest painting in a cathedral, a Caravaggio, for example, is there not to be admired for its own sake but to encourage spiritual

uplift. Similarly, a painting that appears in a film is there because it helps to build character and shape the narrative. In fact, paintings in churches and paintings in films may well be totally fake—if they look convincing enough, they still do the job perfectly well. A painting in a museum, however, must be genuine. It must merit the attention that the public brings to it, and this can only work when the public has trust in the object.

Once put on display, a painting can be considered from a number of different and mutually compatible perspectives, potentially as varied as the visitors themselves. An artist might want to sketch the work (or, more likely these days, photograph it) so they can later use it as inspiration for their own creative endeavors. An art historian might see it as one example within a series of related pictures. Other visitors may appreciate the painting as a demonstration of skilled technique. All of these responses are equally valid, for any painting is an embodied moment of truth—and the same can be said for any museum object. Visitors can and should respond how they like, bringing their own interpretations. But the artifact itself will not change. It is a witness, an ongoing presence of the near or distant past.

Museums revolve around objects, these still centers of attention, in ways that are perhaps not very well understood. For starters, our museums are more than just collections. They provide spectacle and entertainment. They represent group identity, both through their telling of historical narratives and by providing a public space where people can congregate freely. They are even popular places for dating couples. This mixed usage suggests a certain neutrality, a sense that the curatorial voice of the museum is less significant than its role as a backdrop

for individual encounters with things. It is interesting to note that, while the public perception of trustworthiness has declined precipitously for almost every other type of institution in America—the government, the church, the police, universities, the media—museums still rank extremely high. This is because, at least in theory, they stand apart from contingent interests.[1] Museums preserve the past, in the present, out of altruism toward the future—so that those who come after us will be able to make their own determinations.

There are gaps in this system, of course. Arguably the most important arises from the fact that museums are not as neutral as they might seem. They are made up of carefully constructed narratives, not just objects. Partly this is because of the nature of the material things that anchor the operation. Museums often pretend to be a comprehensive and stable record of the past; their "permanent collections" constitute the foundation for interpretation. But of course, very little of the past is totally stable. Many ephemeral phenomena could never have been preserved in the first place: sounds prior to the advent of recording; the sensations of smell, touch, and taste; gestures and other bodily movement; emotions. These cultural intangibles, one might say, are an unexplored territory for the museum, and the stories that can be told will necessarily be very partial.[2]

Furthermore, artifacts decompose in ways that we cannot prevent, and are often lost through neglect or active destruction. Museums try to minimize this loss with the help of conservation science, which involves many of the same procedures as those Ian Hutchings uses in his work. For example, conservators often adopt the same "acceleration" method that he does, subjecting a material to intense UV light and measuring the

results as a way of estimating how it will respond to various light levels over a longer period of time. But even the best conservators are doomed to fight a losing campaign against entropy.

Museums, then, cannot do everything. But they do certain things very well. For reasons both financial and ethical, most are obliged to attract as broad a public as possible, and they are incredibly important as places where commonality is forged. As the historian Tony Bennett once pointed out, one of the main things that people look at in exhibitions is one another; a museum is one of few places where the general public encounters itself in a nonprescribed, egalitarian manner.[3] The objects on display function as a sort of pretext for this communal experience.

The twenty-first century has been a good time for the museum sector so far. Attendances are up, and the diversity of art on show is much wider than it used to be. But for museums to fully realize their unifying potential, there are some hurdles to overcome. First and foremost, we are not reaching enough people, and there is cultural bias built into the demographics. A 2014 poll found that only 23 percent of American conservatives felt it was important to live near cultural institutions; among liberals, the figure was nearly three in four.[4] This disparity derives partly, I think, from the perception that while museums may be trustworthy, they are also elitist. The escalating cost of attendance is one reason for this (in countries like the UK, museums receive government support, making free admission possible, so the presumption of elitism is much lessened). But the real barricade is the nature of much museum content, which presumes extensive previous knowledge and often foregrounds narratives of only remote relevance to the average visitor.

I would be the last person to argue that esoteric details of art history should never find space in our galleries—I absolutely love that kind of thing. But on the whole, less emphasis on conceptual and theoretical considerations, and more emphasis on materiality, could help museums to reach a wider audience. Some curators might be suspicious of this idea, for fear of slipping into a simpleminded, "how to" didacticism. But that hardly need be the case. One of the most affecting experiences I have had with artifacts was a visit to the Musical Instruments Museum in Brussels. This institution has a few advantages, starting with the fact that it is located in a beautiful art nouveau building, formerly a department store—even the elevator ride is memorable. The museum is also dedicated to the idea of hands-on learning; in 2015 they went so far as to open a full-time violin-making workshop on the premises.

The really special thing about the place, though, is that the museum's instrument displays are interpreted by a proximity-sensor audio tour. On arrival you are given a pair of headphones, and as you walk through the galleries, you hear period-appropriate music played on each instrument as soon as you walk up to it. Bach sounds when you look at a harpsichord. Percussive rhythms can be heard when you approach a set of Zande drums from the Congo, beautifully wrapped in cord. And you can follow the successive innovations of local hero Adolphe Sax, the nineteenth-century Belgian who invented the saxophone. The effect is that of navigating the displays with your ears as well as your eyes.

The Musical Instruments Museum is a great example of objects brought to life through technology. A similar effect of

revelation can be achieved through much less complicated means, however. There is a beautiful story about the artist Wassily Kandinsky entering his own studio late at night, turning on the lights, and seeing a painting he did not recognize. He was transfixed: The image seemed to him alien and powerful, possessed of "extraordinary beauty, glowing with inner radiance."[5] After a long, awestruck moment, he realized that it was one of his own paintings . . . sitting on its easel upside down. In that serendipitous moment, Kandinsky had been given an unexpected gift: that of experiencing his own work much as a stranger might first experience it. Such moments of encounter have tremendous transformative potential. In Kandinsky's case, the experience encouraged him to believe that a completely abstract painting might be possible. From then on he devoted himself to the exploration of an entirely imagined pictorial world.

That an artist could have stumbled across one of the greatest innovations of twentieth-century art in this way is almost too good to be true. That it did indeed happen is a reminder of how powerful a direct material encounter can be when it is unencumbered by interpretive narrative. That is exactly what happens in the Musical Instruments Museum in Brussels, through sound, but it can also be done through many other curatorial maneuvers, some very simple and inexpensive. In fact, one of them is to do exactly what happened in Kandinsky's studio: Turn the objects upside down. This is not usually done with paintings or sculpture—though maybe it should be—but it is a common enough technique for displaying ceramics, furniture, and other decorative artworks.

Inverting an object is enlightening, because makers often look at objects upside down and backward while they are at work. A bowl is typically turned over on a potter's wheel while it is being thrown, and the bowl of a handmade spoon is placed against an anvil and struck from the back. Cloth is held in reverse over the embroiderer's knee, a chair placed with feet pointing upward on the joiner's workbench. In the museum, it can be quite useful to do the same—to turn a thing over, or look at it backward or inside out. This is the first step in helping the audience to "reverse engineer" the object, working like a detective to determine its story on the basis of the traces it contains. As a display tactic, one couldn't get much easier or simpler, but it can be a powerful reorientation. Consider the difference between showing a full suit of parade armor facing forward and showing it from behind so that all its internal hardware, straps, and fittings are seen. In one case, you are presented with an image of power, authority, and implied violence; in the other, the skilled workmanship of an anonymous tradesman. It is like walking out of a theater, down a side alley, in through the stage door, and watching the performance from the wings.

I once had an epiphany that was somewhat like this, or even a little like Kandinsky's, if not quite as consequential for the history of art. I was nineteen years old at the time. Enrolled for one year at Harvard University as an exchange student, I wanted to take as many courses as possible. So I scheduled my week carefully. Along with classes about French painting and modern architecture, I ended up taking one called "The History of Chinese Ceramics." This sounded wildly esoteric to me, but it fit neatly into my last available slot, so there I was,

sitting dutifully in the back storeroom of Harvard's Asian art museum. It was much like any other classroom seminar I had attended, but with a crucial added ingredient: We were going to have a "handling session" with artifacts from the collection. We would be allowed to hold ancient pots and turn them over in our hands.

The professor who taught the course, Bob Mowry, is possessed of great knowledge, bright blue eyes behind gold-rimmed glasses, and a glorious snowy-white mustache. He passed around the first object, which I don't really remember. I guess it made no impression on me. Then he handed around a second, a dish from the Tang dynasty (A.D. 618–907). This was a flourishing period for China, when the country was relatively peaceful and flooded regularly with imported goods and travelers from other parts of the world. The dish, Professor Mowry informed us, reflected this influx of new ideas. It was decorated in a palette called *sancai* (Chinese for "three-color"): a grassy green, a rich brown, and a deep blue. These tints were achieved using lead-based glazes, with crushed minerals as colorants. They used copper for green, iron for brown, expensive imported cobalt for blue. The decorative pattern was inspired by metalwork from the west, possibly modern-day India, or even further afield in Persia. But the design had a characteristic Chinese twist, with curling cloud forms toward the edges, a motif that also appears in silk paintings of the era.

I still have my notes from the class and see that I took down all this information dutifully, probably thinking not so much about medieval Chinese trade and technology as how different it was to learn about ceramics instead of paintings. I'd never been told which minerals were crushed to make the colors in

a Caravaggio. So it was all reasonably interesting. But then I turned the dish over, and *pow!* Everything changed for me. On the underside of the object were the fingerprints of the potter who had made it all those centuries ago. I could put my own fingers in the same spots, almost feel the pressure that had been applied into the wet clay so long ago. I had that electric charge you get when you feel a true emotional connection with a person. Suddenly, this historically remote thing felt alive. I wanted to know all about the unknown maker of that beautiful bowl, just as much as you might want to know all about the author of an anonymous letter addressed to you.

From that day on, I looked forward to Professor Mowry's class more than any other. I took his follow-up course on the history of Korean ceramics the next semester. I took on an internship in the university museum. And so began my interest in material things, and especially in craftsmanship. I went on to volunteer at other museums: first the Everson in Syracuse, New York, which has a terrific ceramics collection thanks to funding provided by the local china industry over the years, and subsequently the American Craft Museum in New York. This paved the way for my career; in fact, I later returned to the American Craft Museum, which had changed its name to the Museum of Arts and Design in the intervening years, as its director. Had I not had the chance to turn that Chinese pot upside down, I'm sure I would have done something else entirely.

In the course of my career in museums I have had the chance to do a lot of my own teaching with objects. In these sessions I have always tried to reproduce the "Eureka!" moment for students that I had been lucky enough to experience myself.

I generally ask the students to sit around a large table, assigning an object to each one in order to give them a sense of personal encounter. Then I provide them with a set of instructions: Hold your object over the table, not over your lap. Keep it at a low height; if it falls, at least it won't go far. Keep the objects far apart from one another, lest they collide. Always use two hands. And here is a curious rule: This may be a handling session, but you should never pick up a cup or a teapot or anything else by its handle. "Yes," I'll say, "I know that is what they were designed for, but the join in an old handle may be fragile."

Once the rules are established, I'll ask the students to attend to the object as closely as possible. Turn it over in your hands, examining its every detail. Try to piece together how it was made. Ask questions about who might have made it and used it over the course of its life. Ask questions about the object as a form of evidence: Is it in its original condition? If it has been repaired or otherwise altered, what might that suggest? As these questions imply, what happens in a handling session is quite different from what happens in other encounters with objects. When I ask a group of students to study the signs of manufacture on the bottom of a teapot, I am putting them in an unusual position—a position of heightened attention, right in the contact zone. Most people simply use a teapot to pour tea. I want the students to try and crack its code instead.

As it happens, there are many examples of museums allowing visitors to handle or otherwise use the objects in their collections. A project called "Please Be Seated," pioneered by curator Jonathan Fairbanks at the Museum of Fine Arts, Boston beginning in 1975, involved the commissioning of benches and chairs from prominent contemporary craft makers. According

to Fairbanks, his colleagues at the MFA were initially skeptical about this idea, fearing that it would seem an open invitation to visitors to physically interact with everything else in the museum, too, with disastrous consequences in terms of object conservation. In fact, the opposite occurred. Not only were the commissioned seats undamaged, but as if an itch to touch had been scratched, the overall incidence of visitor-induced damage actually decreased.

"Please Be Seated" was such a success that it has been widely imitated at other decorative arts museums in America and Europe, with equally positive results. Also increasingly common are instances in which artists or members of the public are permitted to handle collection objects as part of an installation or performance. The Museum of London, one of many archaeological and historical institutions that have such extensive holdings that they can only present a fraction of their collections, allows visitors to touch runner-up objects that did not make the cut for permanent display. Because of the richness of the institution's holdings, even these second-class artifacts can be very special—a broken figurine from Londinium, the Roman settlement that preceded today's city; a copper earring covered with an iridescent green patina from centuries of burial; an ancient perforated hairbrush made of bone.[6]

Other museums, like the Art Institute of Chicago, have implemented special tours for blind visitors. They are encouraged to touch the surfaces of sculptures or decorative art objects under supervision, much as Helen Keller recalled doing as a child at the Chicago World's Fair. There is also a program, again at the MFA in Boston, in which a curator stages concerts

using the historic instruments under his care so that audiences, sighted or not, can hear them—a live version of the technological interface in Brussels.[7] Interestingly, according to the curators at the MFA, this is actually a good way to care for some of the wooden stringed instruments in the collection. They are more difficult to preserve when they are *not* used, because they were designed to be held constantly at a certain tension, and if left unplayed for decades at a time, they tend to warp out of shape.

A friend of mine who was once a student interpreter at Winterthur, the great repository of early American decorative arts near Wilmington, Delaware, told me about an experience she'd had there while leading a group of visitors through a gallery devoted to the seventeenth century. My friend had launched into a practiced explanation about the objects on display. She happened to be facing away from her audience for a few moments as she spoke about something on the wall in front of them. She then turned around in order to point out an unusual survival within the collection: a joined bench made of oak, probably dating to the 1630s. She had been on the point of telling her visitors that this was a unique (and therefore extremely precious) survival, the only American example of its era known to exist today. Imagine her surprise when she saw that the members of her tour group were already sitting on it like a row of ducklings, listening politely to her explanation. Of course she asked them to stand up and *never to touch*. Which prompts the question: Who was using the bench properly, them or her?

Chapter 27

ANCHOR POINTS

O NE OF MY FAVORITE FILMS is called *Jiro Dreams of Sushi*. It tells the story of a Tokyo chef, now in his nineties, who has dedicated his life to making the best possible sushi he can. Every detail is considered: the selection of the fish, the method of cooking the rice, the serving dishes, the sequence of the meal. In Jiro's restaurant, octopus is extensively massaged by hand before it's sliced and served. The film is a tribute to a life of slow and patient improvement, within a time-honored set of traditions. I absolutely loved it. And I streamed it on Netflix.

This is just one example of the fact that the digital realm does not need to diminish our appreciation for the material one. There are many other ways in which new technology aids, rather than hinders, the cause of material intelligence. If you want to see a traditional craft village in Japan, it's quite likely you will go online to book a ticket on the Shinkansen (high-speed train) before you go. Likewise, if you want to learn how to make sushi from scratch, there are plenty of YouTube videos that will show you how. One could argue that the Internet has reinvigorated the whole museum sector by enhancing public

access to institutional collections. By the end of the twentieth century, the problem of scale had come to seem insoluble. My own former institution, the Victoria and Albert Museum, has over a million artworks in its care, not to mention books and extensive archival holdings. All of these artifacts are held in the public trust, and the museum has a moral obligation to make them available for study.

Before the advent of online access, this was impossible to achieve, and certainly not for lack of trying. The museum had always undertaken temporary exhibitions, periodic gallery redisplays, publications, study rooms, and even an "opinions service" in which members of the public could bring in their own artifacts to have them evaluated by curators and directly compared to objects in the collection. Even taken together, however, these mechanisms could only provide access to a tiny percentage of the V&A's massive holdings. Online access has been the solution. Today, anyone anywhere, so long as they have Internet access, can search the museum's full collection. Not all the objects in the collection have been photographed, but over half have, and more are added all the time. It is an incredibly powerful engine for knowledge and discovery.

Once it is placed online, a museum object can become a gateway into a rich and beguiling (if thoroughly mediated) experience of history. One reason this is such a promising direction is that objects—being visual and material rather than linguistic in nature—can cross cultural barriers. They may require interpretation, but not translation. Interestingly, this is only the latest spin on a millennia-old dynamic. From the days of the Silk Road, the overland trading route by which textiles and other goods traveled between the Mediterranean

and the Far East, to the glory days of the China trade in the seventeenth and eighteenth centuries, when porcelains from Asia flooded into Europe, to today's online web browsers, objects are ideal global emissaries.

Needless to say, there is a big difference between handling an object and seeing a picture of it on-screen. Yet there is already tremendous value in the V&A's online provision and that of other institutions. And as massive as these recent efforts have been, there can be little doubt that they are only a first step. As we know from the example of *Wikipedia*, crowdsourcing can be highly effective when it comes to making knowledge available to the public. One can easily imagine a time soon when museums will adopt moderated "wiki" structures that will allow online readers to add content to catalog records. Already, institutions are exploring collaborative partnerships in which aggregated and hyperlinked search engines can connect collections to one another, raising the possibility of universal object databases for research and discovery.[1]

In the future, these and other currently unimaginable initiatives will certainly be put in place. One implication of such developments is that they will have the effect of changing the nature of curatorial expertise. Until recently, the role of the curator was still much the same as it was back in the nineteenth century, when the modern museum was invented. For all that time, the job description has remained more or less constant: to become the expert about the objects under the museum's care and make them physically available to the public within an interpretive framework. Now, after two centuries, the job description is changing quickly. When anyone at all can look up the date, attribution, and provenance of any one of 1.2 million

artifacts, it no longer really makes sense for curators to memorize all those data points. As information becomes more widely available, museum expertise consists less and less of knowing basic facts, and more and more of thinking about the larger shapes of history. In years to come, even that aspect of the museum's privileged relationship to the original artifacts under its care—the right to say why an object matters and how it should be understood—may well evaporate in turn. It has gotten to the point that leaders in the museum field like Nicholas Thomas, director of the Museum of Archaeology and Anthropology in Cambridge, England, have felt moved to point out what one would have thought obvious: that collections do indeed need to remain at the center of museums, otherwise they will lose their role as cultural anchors.[2]

This shift in the nature of curating is a special case within a more general phenomenon. One can make comparisons to the rise of bloggers, who have challenged traditional newspaper journalists; or the decline of major labels' influence in the music industry. The material basis of curatorial expertise, however, makes the case of museums somewhat different. Because an object is a material moment of truth, it would not be right for curators to regard their collections only as a set of props. (The V&A is occasionally approached by fashion editors who want to borrow historic garments and accessories to appear in magazine shoots. The answer is always no.) As collections become increasingly available online, however, one thing is for sure: The museum's obligation to create compelling narratives, stories that give shape to the basic facts rather than ignoring them, is all the more important.

Chapter 28

THE VIEW FROM TUCUMCARI

MUSEUMS COME IN ALL SHAPES AND SIZES, and very few are of the scale of the Victoria and Albert Museum. In the summer of 2016, my partner Nicola and I had a chance to take a drive across America, something we had long wanted to do. We hadn't planned the trip in advance, as we were more interested in improvising. And because we were not in a rush, whenever we saw anything of interest, we took a detour to check it out. The experience more than lived up to expectations. We covered about eight thousand miles, along the way seeing some of the country's most awe-inspiring sights, like Yellowstone and the Grand Canyon. We visited lots of museums, including great treasure houses like the Nelson-Atkins in Kansas City, with its unrivaled collection of Chinese art, and the Saint Louis Art Museum, which has a definitive collection of work by Max Beckmann (one of Nicola's favorite artists). But to me, the most fascinating museum we saw on the trip was one that we found completely by chance.

About 125 miles west of Amarillo, we abruptly turned off Route 66 to see the tiny town of Tucumcari, New Mexico.

We had seen a modest sign for a local historical society. There I found a very interesting spot, quite literally: a black splotch of ink on the floor of the second-story gallery. A didactic label mounted on the wall nearby bears the following explanation:

> You will notice a dark spot on the center of the floor. In 1972, Herman and Lucille Fitzner were caretakers of the museum. At that time, their five-year-old grandson used to come and roam the museum while they were working. As kids will do, he got a bottle of ink out of the school area and then spilt it on the floor. Mr. Sanchez said he remembered his grandpa getting really, really mad. But this is just a reminder that kids are all alike. Doesn't matter the year. Plus, it goes to show us that ink was a pretty potent item that year. This stain is now some 30 plus years old and has had numerous moppings over the years. On the occasions when Mr. Sanchez comes back to visit, he always looks for his ink stain. Hopefully, it will continue to be there for a long time to come as it brings back fond memories of his youth.

There are so many things I love about this short piece of writing that I almost don't know where to begin. First, there is the affable and accessible tone. Starting off with direct address to the visitor, the label immediately puts you (whoever "you" might be) on terms of intimacy with the museum—its caretakers, its internal workings, its frequent moppings. The label is also attentive to materiality and its

implications. Ink back then was "a pretty potent item." Subtly, with a slight southwestern twang, the text insists on continuity between the moment of 1972 and the present: "Doesn't matter the year." Kids may not fool around with ink bottles anymore, true, but the visitor is encouraged to see that little five-year-old as a familiar, even universal figure.

Then there is the remarkable fact that the museum decided to make the ink stain into an exhibit. It's safe to say that few institutions would make such a choice. If a child were to spill black ink on the floor of the grand and beautiful Saint Louis Art Museum, I doubt it would stay there for more than an hour. In Tucumcari, though, the expectations are quite different. So much is clear from a further look around the Historical Museum, which one could perhaps compare to a Renaissance cabinet of curiosities, but might better be described simply as a big collection of seemingly random stuff. Every wall and horizontal surface is packed with objects: postcards, cowboy boots, glass bottles of every color and description, "appliances of yesteryear," saddles, bedpans, crutches, sewing machines, strange photos (one bearing the legend WARTS ON CATTLE). One display presents various types of barbed wire. Another corner is filled with World War II memorabilia, including a captured Japanese imperial flag. The top of every wall is painted with a frieze of mysterious markings, like a secret code, which turn out to be cattle brands local to the area. A large yellow sign of uncertain date hangs in the main stair hall: WE DO NOT DISCUSS POLITICS, RELIGION, OR THE CIVIL WAR. Behind the main museum building are a series of stables with antique vehicles— carriages, homesteaders' wagons, and farm equipment. There

is also a reproduction tepee, an old outhouse, and, sitting in one field, a derelict fighter plane.

Where did all these things come from? The answer can be found in a small annex building. There one encounters a display about Mr. Herman "Corney" Moncus, the longtime proprietor of Elk Drug Store in Tucumcari and founder of the museum's collection. He was born in Texas in 1901 and came to New Mexico the following year, in a covered wagon. After getting his pharmacist's license via a correspondence school, Moncus took over the local drugstore in 1948 and began turning it into a center for local history, which had been a passion since his childhood. Gradually, he set about filling the walls and ceiling of Elk Drug, to the growing fascination of the local kids who came to sit at the soda fountain in the front. Moncus had a touch of the showman about him. He painted the exterior of Elk Drug with cattle brand insignia, similar to those on the walls of the Historical Museum today, broadcast a daily radio program on local matters, and wrote two books, one of which had the unimprovable title *Prairie Schooner Pirates*.

When Moncus retired as a pharmacist in 1968, he attempted to auction off the contents of the drugstore collection. The sale results proved so disappointing that he instead struck a deal with the local government to give the collection to the town. And so he became a museum director. The site chosen for the new Tucumcari Historical Museum was a former central school building, which had also seen service over the years as a soup kitchen, hospital, and (during the Second World War) glider school. Today, Moncus is gone—he died in 1980. But others continue his vision. After visitors pass a sign that reads THIS IS

NOT A TOURIST TRAP, they fall easily into conversation with the current caretaker and whatever neighbors happen to have dropped by.

As a big-city curator, I have to admit that I was a little surprised to be so enraptured by my experience in Tucumcari. Normally, I tend to be most impressed by museums that create beautiful settings for their displays and weave artful narratives around their artifacts. I am keenly attuned to the quality of objects, like Beckmann's paintings in St. Louis or the Chinese Buddhist sculptures at the Nelson-Atkins, that exemplify historical importance, depth of understanding, and artistic skill. By comparison, the various oddments in Tucumcari's ramshackle galleries exert little claim on aesthetic sensibility. Yet, taken as a totality, Moncus's vision seems to me worth studying and celebrating.

This has much to do with his attitude to materiality. That ink spot on the floorboards of the second-floor gallery dates back to a moment when the museum itself was only a few years old. Moncus's determination was a perfect example of the collecting impulse as described by Susan Stewart in her book *On Longing.* In preserving this accidental mark, inconsequential in itself, he and his successors signaled that their real concern was to be true to the past, in its entirety, unedited. Logically, this is an impossibility. (As the comic Steven Wright once said, "You can't have everything. Where would you put it?") After driving hundreds of miles through the barren scrubland of Oklahoma, Texas, and New Mexico, however, one can begin to appreciate the dimensions of Moncus's achievement. He saw that just because something doesn't seem all that special

doesn't mean you shouldn't be curious about the stories it might tell, and anyway, what counts as special is very much a matter of opinion.

The idea that "flyover country" (as many on the coasts unkindly call states in the Central and Mountain time zones) is devoid of culture is a persistent but pernicious myth. Over his fourteen years of collecting, in the 1950s and '60s, Moncus managed to prove the opposite, hunting down every fragment of rural southwestern culture that he could, reputedly covering 120,000 miles in the process (which makes my own eight-thousand-mile trip, guided by GPS, look pretty paltry). By gathering all this material in one place and making it available to the public, Moncus not only assembled a material portrait of the region, he also laid down a nonjudgmental and generous idea about what a museum could be. For him, things were worthwhile simply because they came from nearby. From this perspective, the ink spot left by a rambunctious five-year-old, which at first seems so trivial, is actually a perfect emblem for the whole enterprise.

In a country as divided as America is today, it would be a good thing if urbanites could take an interest in things like cattle brands and barbed wire, and in places like Tucumcari. Even if you don't stay at the Historical Museum long enough to learn about ranching practices in depth, the abstract glyphs of the brands and the distinctive twists of the fencing immediately impress upon a visitor the complex structure and specific know-how of this part of the world. I don't think it's idealistic to suggest that an encounter like this can offer opportunities for us to cross barriers of opinion, or at least

establish the possibility of shared respect and understanding. Like indelible ink, the Tucumcari Historical Museum tenaciously holds its ground. Humble though it may be (and all the better for it), no institution could surpass its power to evoke collective memory, the feeling that we have things in common with those around us.

Chapter 29

THINKING INSIDE THE BOX

Most curators tend to value only those artifacts that exemplify the best, or rarest, or most precious. Corney Moncus was unusual precisely because he was interested in the usual—the everyday, the typical. He was determined to preserve evidence of regional life despite its seeming normalcy. Sure enough, with the passage of years, the objects he gathered from near and far are, in fact, coming to seem extraordinary. Even professional ranchers don't tend to know much about regional variations in the style of barbed wire anymore, and how many people today have seen a Japanese imperial flag claimed as a war trophy? Even so, the real intent of the Tucumcari Historical Museum is not to present esoteric rarities but to record a whole way of life.

Professional archivists, as a breed, are a lot like Moncus. They often value the quantitative as much as the qualitative; it is collecting en masse that makes for a reliable register of past events and people. I came to a better understanding of this comprehensive approach by talking to Mimi Bowling, who is now retired but for many years worked as a collections manager

at the New York Public Library. We immediately fell into a discussion about the biggest recent change in her profession, the question of digitization. As archives are primarily intended to keep evidence safe and make it accessible, some argue that it is better to create digital copies of documents, which can be easily stored and remotely searched, and discard the originals. Certainly it is less costly to do so. Yet Bowling, who describes herself as "an old-fashioned, inside-the-box archivist," feels that in most cases, this would be a mistake: "The jury is still way out on how long digital surrogates will last. I believe they are much more imperiled than the physical original."[1]

This is currently the consensus view among archivists and librarians, and it makes sense to me. A moment's reflection is enough to realize that rapid technological obsolescence is a major threat to preservation. Would you be able to access your very first year of e-mails now? How about the call register on your first mobile phone? Indeed, some archivists fear that despite the overwhelming volume of the digital information we are currently producing, historians of the future may come to view our era as a black hole because of the ephemerality of the media we use to store it.

Bowling also points to another, more subtle reason to care about the objects within an archive: "There is that hard-to-describe importance. If you have the physical thing in your hand, people tend to accept it as genuine much more than a digital copy." One thinks here of the aura that certain extraordinary documents possess, like the Magna Carta or the Emancipation Proclamation, for example. I once had the privilege of visiting the laboratory of another archivist, Fenella

France, who is chief of preservation research at the Library of Congress. She and her team use powerful new technology to examine and conserve the documents under their care. A particularly stunning discovery occurred when France was studying a manuscript draft of the Declaration of Independence, in Thomas Jefferson's own hand. Using a spectral imaging machine, which is able to detect mineral traces invisible to the naked eye, she was able to see that in a crucial passage Jefferson had struck out the word "subjects" and replaced it with the word "citizens." She felt as if she had discovered the birthplace of democracy right there.

That is an exceptional example, of course, but it does point to another important feature of physical documents: They capture the original conditions of writing and reading. This is true of any handwritten text, not just famous and important ones, and it is a quality that is extremely important to hold on to in an age of digital search. As anyone who has ever conducted research with primary documents can attest, it is painstaking work. Puzzling out period scripts, finding the relevant passage in a thick tome without the aid of word search, shaking the coal dust off Victorian paperwork—all these slow down the acquisition of knowledge to human speed, which is the right speed to aim for. They also reinforce the importance of context. There is a counterintuitive tendency for the availability of mass data to promote misunderstanding, because people can zoom in on a single piece of evidence, even a few words, and immediately draw conclusions on that basis. Even genuine passages of text, when stripped of their original setting, are perilously close to not being facts at all.

During her career at the New York Public Library, one of Bowling's most significant projects was a groundbreaking exhibition on the history of gay culture in New York City. Along with her colleagues, she collected early newsletters and flyers of activists, photographs and documents of the Stonewall uprising, T-shirts printed with slogans, and personal diaries that recorded the horror of the AIDS epidemic. For her, every one of these archival holdings acted as an anchor of moral concern. Given the underground nature of gay life for most of New York's history, they constituted more than just evidence. They were the physical traces of a whole community's identity. The fact that the documents would technically be classified as "ephemera," flimsy and transient bits of paper, was itself a moving indication of the way that gay men and women had to lead their lives. Anything more public, more permanent, would have constituted a legal and perhaps physical risk.

One of the documents that Bowling most wanted to find in her research was a copy of the first *New York Times* report on the emergence of AIDS—which, incidentally, was not a banner-headlined article in large type above the fold on the front page, but a small piece buried inside the paper. Of course, it was available to her in reproduced form, on microfilm. But that didn't seem enough somehow. "For reasons that were hard to articulate, it was so important to get a copy of that paper from that date," she recalls. "In the end we actually did find several copies of that physical clipping. A lot of people had written on them—just exclamation marks, or 'Oh my god, that's me.' I don't think we ever found a clean one." Ultimately, perhaps, this accumulation of private notations spoke more movingly

than a pristine document ever could. Certainly they spoke more powerfully than microfilm could.

The unexpected similarity between Moncus and Bowling prompts a thought: Just as it would be great if city people could get interested in places like Tucumcari, it would be good if people from rural areas could get interested in the history of urban gay culture. As pronounced as such cultural divides may be, there are ways to cross them, and artifacts are among the best bridge-building materials. The things found in both Tucumcari and in New York City are inherently relatable. When confronted with an opinion you don't agree with, the tendency is to dig in your heels. When confronted with an object you don't at first understand, however, the tendency is more often to become curious. In time, this may turn into curiosity not just about things themselves but the people who make and use them.

Consider one last example of an archive: two rusted milk cans that were dug up in Warsaw, Poland, in December 1950, along with a few tin boxes buried nearby. It turned out that these containers held the deposited record of the city's Jewish ghetto. The materials had been assembled under the direction of a professional social historian named Emanuel Ringelblum. With the rise of the Nazis to power, he had first been harassed and then, like the other Jewish residents of the city, encircled within the ghetto district and forbidden to leave. Eventually he was incarcerated in a concentration camp and murdered. But he took action while he could. Realizing that his community was threatened, not just the people themselves but their whole history and culture, he decided to make a secret archive.

The name that Ringelblum gave to his collected materials was *Oneg Shabbat*, meaning "Sabbath Joy." Working with others in the neighborhood, he collected thirty-five thousand documents in all over a period of two and a half years. As the historian Peter Miller recounts, the collection was very diverse and heartbreaking in its quotidian detail: "tram tickets, programs to school plays, restaurant menus, maps of the complex doorbell schemes needed to accommodate the reality of 30 percent of a city's population forced into less than 3 percent of its space." Some inhabitants contributed essays and economic analyses of life in the ghetto, with titles like "Processes of the Adaptation of the Jewish Artisan to Wartime Conditions" and "On Jewish Barbers."[2]

When Ringelblum buried these records to evade discovery by the Nazis, he no doubt hoped he might be able to return to them himself, but probably also feared that they might never be recovered. In fact, though only a few years passed before the archive was found, his worst fears had been realized. Warsaw's Jewish population was all but wiped out, and with them, their collective memory, apart from the contents of these precious vessels. As Miller puts it, had the archive not been assembled and preserved, "then no one would believe that such a place had existed; not on the moon, but right here, in the center of the earth's most sophisticated continent." Most objects from the past, thank goodness, are not so tragic. But the story of the Warsaw ghetto, the condensation of all that life as it was lived, amply attests to the potency of material evidence.

Chapter 30

MATERIAL HISTORIES

THIS BRINGS ME BACK to the Victoria and Albert Museum, an institution whose collection is explicitly divided between different materials. This vast ark of culture could be considered an archive of a different kind, in which objects rather than documents are the primary concern. There are departments of textiles, ceramics and glass, metalwork, painting, and photography. Not everything fits into the scheme; for example, there is an Asian department, which is defined by geography rather than material, because of the demands of language and area-based expertise. There is also a sculpture department, which incorporates many different materials and (like the painting and photography departments) tends to focus on narratives that are specific to fine art. For the most part, though, the V&A is conceptually organized around materiality, pure and simple.

This has always struck me as an ideal way to go about things. If a few milk cans and tin boxes can carry the freighted history of a whole community, what human stories does a museum of this enormous size contain—what sorrows, fears, hopes, and

joys? Certainly, there are pragmatic reasons behind the V&A's way of organizing its collection. Textiles, which are especially challenging to store and maintain, can all be kept under one department's care, for example; ceramics, which are unusually robust, can be displayed in galleries with high light levels and fluctuating temperature conditions. The real value of the museum's material-based organization, however, is that it helps to bring out the continuities between different artistic cultures. At the V&A, staff and visitors alike naturally follow trajectories of technique. They come to understand the artifacts in the collection as a diverse set of responses to what materials can do, their constraints and possibilities.

The furniture gallery, for example, is organized not according to stylistic progression—baroque, rococo, neoclassical—but along the much more interesting lines of process. Carving, veneering, and joinery all have sections devoted to them, as does molding, which is particularly wide ranging, as it includes everything from early nineteenth-century papier-mâché to recent injection-molded plastics. In an ingenious application of this logic, my former colleague Christopher Wilk, who led the curatorial team for the V&A's furniture gallery project, has recently completed an exhibition at the museum on the subject of plywood. Most people think of this as a modern, twentieth-century material, and perhaps associate it with the work of designers Ray and Charles Eames. The oft-repeated story is that they invented a new means of shaping plywood under heat and pressure, using a pneumatic press they called the Kazam! machine. The Eameses first developed the press for military products during the Second World War,

like leg splints and stretchers for wounded soldiers, and then used it to create their iconic chair designs of the succeeding decade.

In fact, as Wilk explains, just about everything Charles and Ray Eames did had precedents going way back into the nineteenth century, when plywood and related molding technologies were first developed. The attractions of the material are its strength, resistance to moisture, and relative cheapness. By sandwiching together a stack of thin-cut wood sheets, each one turned at a ninety-degree angle to the next, manufacturers could construct a kind of wonder material. It can be shaped into compound curves by gluing the wood layers together in a mold and then pressing them as they dry, so that they hold the shape (that is what the Kazam! machine was for). Already by 1900, plywood had been used extensively in products as diverse as furniture, shipping crates, and sewing machine cases. In one particularly ambitious episode from the 1860s, a New York City developer named Alfred Beach tried to build an aboveground, pneumatically powered public transport system sheathed entirely in plywood. As Wilk writes, a 107-foot-long section of the proposed system was actually built for an exposition: "Powerful, engine-driven fans were said to create a vacuum within the tube, propelling and then sucking back the 12 person passenger car from one end to the other, to the delight of the more than 75,000 riders said to have 'enjoyed the atmospheric ride.'"[1]

Despite its numerous advantages, plywood was often disdained as cheap and shoddy. Wilk notes the early appearance of "veneer"—a thin surface sheet of figured wood, often glued

over plywood to make it look more presentable—as a metaphor for all that was superficial in modern culture. In his 1865 novel *Our Mutual Friend*, for example, Charles Dickens bestowed the name of "Mr. and Mrs. Veneering" on an unattractively caricatured couple, whose every possession was brand new. "From the hall-chairs with the new coat of arms, to the grand pianoforte with the new action, and upstairs again to the new fire-escape, all things were in a state of high varnish and polish," Dickens wrote. "And what was observable in the furniture, was observable in the Veneerings—the surface smelt a little too much of the workshop and was a trifle sticky."

From this reputational nadir in the nineteenth century, Wilk traced the onward trajectory of plywood. He showed how its use in aircraft and housing helped to shift ideas about its qualities. In the present day, it is simultaneously being celebrated anew as a wonder material—because timber is more sustainable than most other architectural construction materials—but also swept up into public health controversies, because the glues used in plywood and most other board products emit dangerously high levels of formaldehyde. (The same type of emissions wrecked the Martian simulator described by Constance Adams in chapter 21.) A material that had been an index of bad taste in the nineteenth century has reemerged as an ethical quandary in the twenty-first. Wilk's work shows how a material-based history can interweave narratives about technology, class, aesthetics, and environmental protection—a set of connections that would otherwise be missed.

It is also helpful for the historian to look laterally across different materials and notice how certain patterns recur. The

story of plywood turns out to be typical of a common phenomenon in which a material rises into fashion, falls out of fashion, then rises again. It goes like this: When a material is first invented, there is often a rush of curiosity, interest, and enthusiasm. Sometimes people don't quite know what to do with it.[2] Eventually, as manufacturers find applications for a new material, it becomes increasingly popular, sometimes earning a reputation as a magical solution to existing problems. Often it is used to imitate established materials, typically more expensive ones. As it proliferates, however, the material gradually becomes overfamiliar and cheaper, thanks to improvements in manufacture and economies of scale. It loses the appeal it had when new. Eventually, the material is rediscovered and valued for its cheapness, precisely the reason it was once disdained.

There is a long list of materials that have undergone exactly this rise, fall, and rise. Aluminum and vulcanized rubber, both developed in the mid-nineteenth century, were initially so precious and difficult to work that they were used mainly to make jewelry and delicate objets d'art. They soon lost that luster, but over time significant industrial applications were found for them; today only historians recall their previous elite status.[3] Linoleum—which is not exactly a material but more of a composite product, made by coating jute or cotton cloth with a linseed-oil-based amalgam—was invented in the mid-nineteenth century by a man named Frederick Walton from Manchester, England. With the addition of a layer of ground cork, it served as an ideal flooring material, cheap, comfortable to walk on, and easy to clean. The linoleum business boomed

alongside housing construction through the 1870s. Decorated with colorful patterns using copper and type-metal blocks, linoleum became a staple in late Victorian decor.[4] Once it became commonplace, it lost its "wonder material" status and drifted to the lower registers of cultural cachet, becoming the very emblem of cheap suburbia in postwar America.

Chapter 31

THE ITINERARY OF PLASTIC

O F THE MATERIALS TO UNDERGO THE RISE, fall, and rise pattern, the most significant is undoubtedly plastic.[1] In 1957, fifty years after Leo Baekeland developed the first commercially viable plastic polymers, the French theorist Roland Barthes wrote that the material exemplified the dream of "infinite transformation." In a short essay, published in his widely read book on popular culture *Mythologies*, he described a scene he had witnessed at an industrial exposition:

> At the entrance of the stand, the public waits in a long queue in order to witness the accomplishment of the magical operation par excellence: the transmutation of matter. An ideally-shaped machine . . . effortlessly draws, out of a heap of greenish crystals, shiny and fluted dressing-room tidies. At one end, raw, telluric matter, at the other, the finished, human object; and between these two extremes, nothing; nothing but a transit.[2]

Despite the amazing alchemy of this process, Barthes saw that plastic was well on its way to becoming a "disgraced material,"

though he also postulated that its very pervasiveness might eventually result in the abolition of the hierarchy of materials altogether. He imagined a world in which almost every object would be made of plastic—"it can become buckets as well as jewels"—so the idea of equating materials with status would disappear entirely.

As we now know, only part of this prediction has come to pass. Barthes was right to predict a near-total dominion of plastic across the planet. Our landfills and seas are straining to contain the volume that we produce, and because most of it is nonbiodegradable, the plastics that we are making now will still be pollutants hundreds of years in the future. Financially and functionally, plastic has been a tremendous success story. Materially, it is a plague upon the landscape. Yet today, plastic is again recapturing the imagination of designers, engineers, and the public, because of the new application of 3-D printing. This promises yet another type of "infinite transformation" and a further reshaping of industry.

With the advent of 3-D printing, it is worth recalling another perceptive observation Barthes made in his short essay, pointing to the psychological implications of this wonder material. What he called the pervasive "itinerary of plastic" gives people "the euphoria of a prestigious free-wheeling through Nature." His point was that plastic's potential for infinite transformation can prompt ill-founded feelings of invincibility. This misplaced confidence was parodied in a well-known scene in *The Graduate* (1967), in which an uncertain young man played by Dustin Hoffman is told by a successful businessman that the future can be summarized in "just one word." That word, of course, is

"plastics." The material is used as a dramatic device to indicate the disjunction between generations and the growing sense that postwar prosperity has produced a hollow culture.

Barthes noted that the primary characteristic of plastic was "*resistance*, a state which merely means an absence of yielding." Precisely because they are so changeable, plastics can seem most important as alternatives to other materials, rather than materials in their own right. It is also particularly difficult for nonspecialists to understand plastic, because it is the product of a laboratory rather than a natural substance. Even in our days of declining general material intelligence, most people have at least some idea of what a woodworker or a blacksmith or a weaver does, and what their tools look like. Few have any mental picture whatsoever of industrial injection molding, which is how much of our environment is shaped. Plastic is the material equivalent of a "black box" electronic device, functional and serviceable, but opaque to the understanding.

For the record, the way such injection-molded plastic objects are made these days runs something like this. First, a digital model is created using rendering software. It seems slightly inaccurate to call this virtual 3 D object an "original," since it is not a physical thing. Yet it does perform the same role as a traditional prototype, in that it guides the subsequent stages of production. The next step is to create a die in two or more parts, usually out of steel or aluminum. (Often the die metal is porous, which helps to vent the gases released from the molten plastic.) Fabrication of the die can most easily be done by a CNC router or other mechanized cutter, resulting in an exact physical negative of the digital design. The die is assembled and then the

plastic is injected through a nozzle into the cavity—picture a high-pressure spray gun being fired into the hollow of the die. The plastic accumulates on the interior walls, building up to the desired thickness and solidifying as it cools. Depending on the formula being used, the plastic itself may be made of two or more compounds, which are introduced to the mold simultaneously.

Once the plastic sets, the product is done and ready to sell—unless precision is required. Look at any inexpensive plastic object in your house and you'll notice that it has visible seam marks and "sprues" from the injection point, leftover from the forming process. In this respect molded plastic is just like cast metal or ceramic. If the remnants of the process are not acceptable, they must be cleaned off by hand, a skilled and time-consuming undertaking. At a high-precision plastic manufactory that makes products for medical or military use, the artisanal work of finishing constitutes nearly all the day-to-day labor.

The most famous designer in America (or at any rate, the designer whose work is best known) is probably Jonathan Ive, who oversees the styling and interface of current Apple products. But there has also been a strong tradition of expressive and individualistic work in plastic. Thomas Thwaites's celebrated *Toaster Project* is one recent example. It was inspired by an episode in Douglas Adams's popular *Hitchhiker's Guide to the Galaxy* novels, in which the protagonist, Arthur Dent, is marooned on an alien planet. He soon realizes, to his horror, that "left to his own devices he couldn't build a toaster. He could just about make a sandwich and that was it."[3] Inspired to

try it for himself, Thwaites set about months of research in order to make a toaster entirely by hand, in a completely self-taught and self-sufficient manner. Perhaps unsurprisingly, the result is sad-looking and nonfunctional, more an abject sculpture than a real appliance. Yet the object provides poignant testimony about the limits of personal capability.

In a TED talk that has been viewed by more than one million people, Thwaites explained that he had not really been interested in achieving self-sufficiency, but rather in tracing the process by which "rocks and sludge buried in the ground in various places in the world" turn into our finished consumer products.[4] It is sobering to consider that a cheap toaster of the type he tried (and failed) to make would cost only about four British pounds to purchase at a store. How can a single maker compete with those odds—particularly when every available source of information on processing the materials involved (not just plastic, but also steel, mica, copper, nickel, and other materials) presumes enormous economy of scale, rather than the limited resources of an individual?

Chapter 32

A BOOK OF SECRETS

INTRIGUINGLY, ONE OF THE MEANS by which
Thwaites did manage to make progress with his quixotic
toaster project was by turning to publications hundreds of
years old. Because these sources predated the rise of modern
mass industry and assumed the constraints of an individual
maker, they had more useful information for him than any
contemporary text. "The smaller the scale you want to
work on," he noted, "the further back in time you have to
go." Thwaites may not have been aware of the connection,
but this has become an increasingly common research
strategy among historians in recent years, as academics have
woken up to the importance of "embodied" knowledge. It
is a genuinely innovative direction: The goal is to understand
the subjectivity embedded in physical processes. While
apprentices have always imitated their masters as a way of
learning a trade, it is a different matter for a scholar to
re-create a historic technique. The question being asked is
not just how a period artisan worked in the way that they
did, but why.

The leader in this field is the scholar Pamela Smith, who teaches in the history department at Columbia University. She is a specialist in the scientific revolution of the sixteenth and seventeenth centuries, who, earlier in her career, relied on the standard textual sources that most historians use. But while writing a book called *The Body of the Artisan*, which is about the techniques and philosophies of Renaissance workshop practice, she got increasingly interested in matters that could not be inferred from documents. How different, really, was the supposedly "magical" approach of the alchemists from the rigorous scientific method that displaced it? Smith concluded that the conventional opposition between "the supposedly rote and unscientific approach of craftsmen and the 'experimental method' of the new experimental philosophers or 'scientists'" was incorrect.[1] In fact, the research methods long used by craftspeople were foundational to the professional bodies of modern science that emerged in the seventeenth century, such as the Royal Society in England and the Académie Royale des Sciences in France.

In her research, Smith often found it necessary to ask questions about practice that were not easy to answer on the basis of surviving documents. What was it actually like for an artisan in the laboratory? How difficult were the processes involved? What was the sensory aspect of the experience of research like—the way it looked, felt, and smelled? What equipment was required?

"Lacking written documents about this tacit knowledge," Smith asks, "how then do we go about building up a picture of artisanal knowledge and theorizing?"[2] She decided there was

only one way to proceed: She would actually re-create the experience of the alchemists.

Smith chose a particularly informative manuscript, a French "book of secrets" that probably dates from the sixteenth century. The anonymous author of the text recorded not only his recipes, but also his impressions of what he was doing as he worked. It is filled with fascinating detail—for example, at one point the author mentions that he was given to reciting the Lord's Prayer during experiments as a means of timekeeping, a way of counting out seconds in the absence of a clock. As Smith puts it, the book has an "immediacy, self-reflexivity, and process-oriented character" that is highly unusual. It also covers a wide range of crafts, from the making of imitation gemstones to the casting of cannons to the creation of taxidermy "monsters" that combine the body parts of multiple animals.

To fully exploit the opportunities afforded by this extraordinary source, Smith has reconstructed some of the processes it described. In order to do this, she took over an old laboratory on the Columbia University campus and apprenticed herself to a range of skilled craftsmen, learning how to do things like making molds, casting metal, and mixing pigments. By testing contemporary techniques against the descriptions provided in the manuscript, she and her students are gradually working backward toward the experimental methods of artisans who died five hundred years ago. Smith says that she has gained many insights in this fashion. Some are straightforward; for example, remaking a historical artifact will show its original color and surface texture, unaltered by the passage of time.

On another occasion, Smith got interested in the process of casting reptiles, beetles, insects, and even spiderwebs in silver

or bronze. For a Renaissance artisan, this was an expedient technique: Rather than carving in wood or some other material, he could take a mold directly from the specimen, achieving a level of accuracy and detail that would be very difficult to equal by hand. Smith and her collaborator, an Amsterdam-based silversmith, found that in order to cast a dead lizard, it was necessary to pin its body down at several points—otherwise it would float away from the mold during the pouring of the molten metal. Sure enough, the next time she had a chance to examine a Renaissance silver object that incorporated such a cast reptile, she found tiny holes in its feet where the pins had been driven through.

While it was certainly thrilling to find such material confirmation of her own experiments, what Smith has really been after is the more complex question of the historical maker's mind set and worldview. For example, the manuscript that she works from is very repetitive, looping back over similar territory again and again. This had initially been simply confusing, as fragmentary and contradictory evidence prevented easy understanding of the processes involved. But when Smith and her collaborators actually undertook the experiments themselves, they realized that such repetitive trials, each with slight variations on preceding experiments, were essential to learning a technique. "Materials are something to explore," as Smith puts it, "and their resistances impelled us to seek out their characteristics in different situations."[3]

Reconstruction of techniques also helped to focus her attention in the right places—and not just the feet of lizards. For example, when we look at a cast object from long ago, we might well assume that getting the composition of the metal

right would be the most important technical challenge. In working from the manuscript, Smith has discovered that this is incorrect. Actually, the challenge is to work out the best molding material, which will have the right characteristics of plasticity and fineness of detail. She has come to appreciate many of the fine details of Renaissance casting technique, which prevented any mold marks being left on the surface of the object (unlike the cheap plastic objects in our homes today). These were things meant to be examined as marvels of artisanal prowess. Unlike museum visitors today, who view the same artifacts through a glass case, the original owners would have held them in the hand, turning them over and inspecting them up close.

In the Renaissance, apprentices typically imitated their masters in the workshop, rather than following detailed written instructions. Thus there are few fully explanatory texts left to us. When artisans did write about their crafts, they almost always emphasized that book learning was never enough. Smith likes to quote the Renaissance potter Bernard Palissy, who wrote in his *Admirable Discourses* of 1580:

> Even if I used a thousand reams of paper to write down all the accidents that have happened to me in learning this art, you must be assured that, however good a brain you may have, you will still make a thousand mistakes, which cannot be learned from writings, and even if you had them in writing, you would not believe them until practice has given you a thousand afflictions.[4]

Rather than ignoring such a comment, as most text-based historians would probably be inclined to do, Smith's research

follows in its spirit. In the process, she and her team have demonstrated that the best way to learn about an object is often to copy it directly. This principle would have been unsurprising to a guild-trained artisan in the Renaissance. As apprentices graduated to journeyman status and then finally to the title of master, they would first execute specific processes and then whole objects based entirely on models set before them. Only at the point of professional mastery would an artisan consider inventing a new form. In more recent years, as artistic and technical cultures alike have shifted their focus more to originality and innovation, the idea of spending years making copies has become deeply unfashionable. Yet as Smith's experience shows, it is still probably the best way to come to an understanding about material things and their making—an understanding that is both bodily and conceptual.

This principle also has pride of place in the work of another, very different specialist: Catherine Willems, a Belgian design researcher who is trying to (in her words) "combine ancient wisdom with new technologies" in order to solve certain problems in the footwear industry.[5] Shoes are among the many things contemporary society produces badly—not in the sense that they are technologically unsophisticated (Nike, Adidas, and other brands spend a fortune on R&D) but in the sense that they are disastrous for the planet. Willems notes that the average consumer in Europe and America buys two or three pairs of shoes a year; billions are produced annually worldwide. Most of these end up in landfills. Footwear is not generally recycled, because of cultural predisposition against reuse and the complex combination of materials involved, which makes it difficult to separate and process shoes. Many shoe designs

are outright impractical, too. High heels are the most infamous example of restrictive footwear. Wearing them regularly produces severe orthopedic problems, but even low-heeled shoes can be damaging to feet if they are fashionably narrow or otherwise ill fitting.

As a way of addressing these problems, Willems has gone back to the fundamentals of footwear. She has extensively studied the physiological effects of walking and running, both barefoot and with different types of footwear, measuring biomechanical variables like ankle joint rotation, muscle activity patterns, and "peak acceleration at foot strike impact."[6] The science involved in assessing this interplay of factors is complex, yet she likes to say that she does her most important research sitting on the ground—studying sandals that are handmade by communities in India and Africa. She considers this traditional footwear, which has been tried and tested over many generations, to be a fascinating source of ideas for sustainable footwear. With all the advanced technology of modern shoe companies, Willems feels we still have a lot to learn from indigenous peoples.

In India, Willems has worked in Karnataka, and Rajasthan, where sandals are made using vegetable-tanned buffalo hide. In Finland, she has collaborated with the Sami, who make boots out of reindeer skin. And in the Kalahari plains of Namibia, she has worked with the Ju/'hoansi, who make hunting sandals out of the skin of elands, a type of antelope. In each of these cases, Willems has been interested not only in the craft techniques used to prepare and assemble the materials, but also in the gait that the footwear encourages. Though each

of the handmade solutions she studies is distinct, all achieve an effect that approximates the experience of walking barefoot, while also providing a layer of protection (and, in the case of the Sami's fur boots, warmth). From a health perspective this is clearly a superior design to many shoes on the market today.

Over the course of her research, Willems has realized that there are many unexpected connections between 3-D-printed shoes and handmade local footwear. Most striking is the scale of the production. Both approaches concern the making of customized single products or small batches to order, at minimal cost, usually in just one material. Her shoe designs, developed in conjunction with the London-based company Vivobarefoot, are based on continuous engagement with artisans. She is trying to avoid the "hit-and-run" tactics often adopted by Western designers when they parachute into craft cultures, extract ideas and feel-good symbolism, and then move on. Willems therefore insists that the indigenous communities with whom she works retain intellectual property over their contributions; once her designs enter the mainstream market, profits will be shared with them. In her practice, we see how learning about materials can serve as a powerful means of cross cultural motion, even if only one step at a time.

Chapter 33

FACTS, NOT OPINIONS

P AMELA SMITH AND CATHERINE WILLEMS work in a similar way for very different reasons. One is trying to understand history, while the other is trying to gain insights into the future of her chosen field. Yet they share the important premise that materiality is its own special kind of truth, and studying it is a way to extract the human intelligence it contains. Both use reproduction as their chosen method, but there are, of course, many other ways to achieve the same end. Another is to test materials according to quantitative measures. This is a discipline that goes back a long way, to the heart of the industrial revolution. If every object is a fact out in the world, then precision testing is one of the best ways to understand it in depth.

Mention of the industrial revolution should remind us that the rise of machine manufacture is often seen as a disaster for craftsmanship. The shift from the artisan's workshop to the industrialist's factory was a tremendous economic success story that often resulted in equally tremendous human suffering. The division of labor, the imposition of long workdays, and the

lowering of wages under the pressure of competition all contributed to a massive exploitation of the labor force. As the social reformer Robert Owen put it in 1813:

Since the general introduction of inanimate mechanism into British manufactories, man, with few exceptions, has been treated as a secondary and inferior machine; and far more attention has been given to perfect the raw materials of wood and metal than those of body and mind.[1]

At the same time, the industrial revolution could not have happened without the contributions of artisans. The design and construction of machines was itself a highly skilled trade. So too was the fabrication of prototypes that could then be duplicated through mass production processes. Like today's digital revolution, the industrial revolution of the eighteenth and nineteenth centuries represented an undermining of some aspects of material intelligence and a drastic increase in others.[2]

Materials testing was one of the most dynamic areas of new knowledge occasioned by industry. Innovators like David Kirkaldy, a Scottish engineer who began his career working with wrought iron, realized that manufacturing was being held back by the absence of any precise understanding of what a material could do. He designed a series of testing machines, focusing particularly on cast iron, in order to establish its exact properties under the crushing forces of compression and the stretching forces of tension. His ambitiously named Universal Testing Machine (patented in 1863 and built in Leeds by the firm Greenwood & Batley) measures nearly fifty feet in length

and can apply up to a million pounds of hydraulic pressure to metal, in fifty-pound increments. The machine is now held in the Kirkaldy Testing Museum in Southwark, London, not far from where I used to live. The building bears the legend FACTS NOT OPINIONS above the door, and even today it strikes the casual visitor as a temple to uncompromising rigor. This is a place for establishing what, exactly, is what.

The novelist A. L. Kennedy has described Kirkaldy's institution as "a museum of craftsmanship, safety and truth," and as a place out of step with our times:

> It makes me smile whenever I pass, because I live in a world so much in love with opinions not facts, a world stuck in denial, never moving to adult responsibility . . . Experts are to be avoided. [But] there is a terrible truth in a girder that won't hold your weight. You can fiddle the statistics to say it should, produce paperwork to say that you built it to a standard you never achieved, but nature cannot be fooled.[3]

Of course, material testing did not begin or end with Kirkaldy, and his motto could just as easily be set above the door of many laboratories today, both in universities and in the private sector. A particularly interesting example is the Forest Products Laboratory in Madison, Wisconsin, a division of the U.S. Forest Service. This is America's leading institute for the study of wood, and it conducts many types of tests, both evaluative and experimental.

Wood is a particularly difficult material to test, because it is so variable. Assuming a foundry has access to pure metals, cast

iron of a certain formula will be relatively consistent over many batches. Test one sample made to that formula, and you'll have a pretty good sense of how another sample will perform. But even one species of wood is highly inconsistent in its properties, depending on many biological factors. For example, a yellow pine beam may have more or less strength depending on how knotty it is, and also where a given knot is located (if it's near the edge, the wood is much more likely to split and fail). Because timber is used so widely, often in highly regulated industries like architectural building and mass-produced furniture, understanding the range of properties of a given species is vital, but it is also a challenge.

To get an insight into how the Forest Products Laboratory addresses these problems, I spoke to Dr. Alex Wiedenhoeft, a botanist who leads the Center for Wood Anatomy Research there and teaches at the University of Wisconsin–Madison.[4] He does not do the sort of mechanical testing that Kirkaldy undertook (though elsewhere in the FPL, there are machines that do pull wood apart or compress it, to spectacular effect). Rather, his work falls into three other areas. First, he does what he describes as "nerdy wood stuff," in which samples are tested at micro scale to determine their characteristics. This might include, for example, taking tiny measurements of a wood's cellular structures through which water flows. This helps him to understand how the wood dries, or how a timber will absorb preservatives, for example. A second area is biocentric wood science. Wiedenhoeft describes this as looking at wood "from the tree's point of view," that is, understanding it from the perspective of biological growth. He tells a story about

speaking to an older wood engineering specialist when he was first starting out, who lamented the fact that trees didn't just come out of the ground perfectly rectangular—it would make things so much easier! For Wiedenhoeft, though, the irregularities and the reasons behind them are the fascination of the material: "The more you learn about trees, the more they make sense."

A third area of Wiedenhoeft's work is forensic analysis, in the same sense that a technician in a crime lab does forensics. Mostly this is a matter of identification—what type of wood is a given sample, and where is it likely to have come from? Unfortunately, much of the call for this aspect of his work does indeed have to do with illegal activity. Cutting down valuable protected species, logging in areas that are protected from commercial exploitation, and smuggling timber are all huge problems. Though Wiedenhoeft is oriented to issues of legality rather than sustainability—he focuses on trees, not forests— his forensic work clearly has ecological implications.

Wood identification is an example of the way that material intelligence can be improved, not weakened, by new digital technology. Traditionally, it has been done with a hand magnifier or microscope, through comparison to existing reference samples. If what you see through the lens looks like the reference specimen, you can be relatively confident that you have the same wood—and if it's illegal to log that wood, then the anatomist's report can be entered into evidence by law enforcement. This sounds easy, but it definitely is not. I tried to learn once, as part of my work on historic furniture (you can often tell where an antique chair or cabinet is from, and sometimes its likely date of manufacture, based on the woods

used in its construction), and I can attest that learning the features that mark out a species and recognizing them reliably is a challenge.

Having taught many people the skills involved in wood identification, Wiedenhoeft has concluded that some folks have aptitude for it and some do not, rather like musical ability. The level of difficulty involved obviously limits the ability of authorities to do their work protecting the forests— "excruciatingly slow, compared to the scale of illegal logging," Wiedenhoeft says. So the introduction of new techniques like DNA analysis, spectroscopy, and what he calls a "machine-vision-based ID" system for use in the field have all improved reliability and consistency. Using the whole range of techniques now available, forensic wood science helps not only to crack down on illicit logging, but also to settle product claims in furniture, solid wood products, even paper and cardboard, all up and down the supply chain.

Wiedenhoeft spends enough time doing wood analysis and identification that he jokes about being "a glorified microscope attachment." But his material intelligence opens up whole vistas of understanding; he even sees world history from a wood specialist's point of view. It so happens that in the last ice age, all the red oaks in Europe were wiped out, while white oaks survived. This was just an accident of geography, but it would have significant long-term impact. Though superficially similar, the two species have quite different properties. Red oak is extremely porous. If you take a small piece of it and put one end into a glass of water, you can actually blow bubbles with it. White oak, by contrast, plugs its internal channels with

cellular ingrowths. This, in combination with its large size and prolific growth rate, makes it an ideal timber for making ships. Had the Europeans only had red oak to work with, it would have been much more difficult for them to develop naval power and intercontinental trade. By the same token, American red oak would prove essential for the expansion of railroads in the nineteenth century. Because of its porosity, it can be pumped full of creosote, which preserves the wood from rot—perfect for making sleepers, the thick wooden supports for steel track.

From Wiedenhoeft's point of view, European prowess in exploration and warfare is a story about timber, and so too is the expansion of the American frontier. Of course, many other forces were in play, but if you take these particular materials out of the equation, things might have turned out quite differently. Kirkaldy's motto, "facts not opinions," works for history, too. Materials are the objective foundation to all our endeavors. Still today, oak is our most popular flooring material. This is not necessarily because it is the best choice of all available woods, but because our culture has so much experience in using it. A newly laid living room floor preserves in it the memory of a ship's hull, the happenstance connections between geological change, patterns of forestation, and centuries' worth of economic activity. Along with all the other materials we have, it is a stage against which our drama has unfolded.

Chapter 34

TWO CASTES, ONE PEOPLE?

WIEDENHOEFT IS NOT JUST a consultant and scientist, but also an educator—and a father of five. So he has done a lot of thinking about how to impart knowledge. He realizes the next generation will need different skills from his own (and he's only forty years old). All the same, he has been struck by the fact that his students at the University of Wisconsin typically arrive to his laboratory without much knowledge of wood's materiality. Midwesterners like my grandfather Arthur used to grow up using timber of all kinds. He worked with whatever grew on the farm or could be secured nearby; it's no wonder he took up wood carving as a hobby later in life. These days, though, the spectrum of woods that people experience is comparatively restricted. Only varieties that grow prolifically and can be managed easily tend to see much commercial use. Many products are made of plywood or fiberboard, which are cheaper and more predictable as building materials.

A further problem is that most people have no experience whatsoever of wood manufacture. Unless they've been lucky

enough to land in a wood shop in school, they will never have been attuned to the textures, colors, smells, and qualities of even a single species, much less the wondrous diversity of the world's forests. Beyond this question of affinity to wood as a particular material, Wiedenhoeft also finds it alarming that many people don't have an instinctive respect for manual skills. They are likely to take for granted the know-how of a car mechanic, for example, even though a professional mechanic knows a lot more about automotive engineering than a typical undergraduate knows about anything. He wonders, "Are we going down a path where we have two castes—people who interact with stuff, and people who interact with the ether?"

Based on his experience in the classroom, he offers an answer to his own question: "I do have some hope, because I've seen how in one session with a group of students, you can create a sense of discovery and wonder about materials. When people find out what is actually happening in the real world, they usually tend to respect it."

That seems right to me, too, but there is no doubt that the opportunity that Wiedenhoeft is able to offer his students is available to only a few. So his concern about "two castes"—one anchored in materiality, the other digitally oriented—is justified. It relates to a broader set of worries about class distinction: concerns about how, and whether, our citizens are really interested in one another's perspectives.

There is a lot of strong opinion around these days, often fueled by misinformation. Like many suddenly urgent political considerations, this one has resulted in a bloom of catchphrases: Journalists speak of the need to "fact-check," to combat the

rise of "fake news," to forestall the onset of "post-truth" times. My brother Peter, the philosopher, has contributed some helpful wisdom to this debate, going so far as to suspend his weekly podcast for the first time in order to broadcast a special episode about the current crisis of truth. He argues that the problem we are facing is not so much a spate of outright lying, which he calls a "first-order" problem, or even that people are lying knowingly, or buying into things that they should know aren't true—which are "second-order" problems. Rather, the problem is that as a society, we seem to be losing track of how to establish truth in the first place. This is a "third-order" problem. We no longer know how to know what we want to know. Maybe it's a twin thing, but I find this very persuasive. If it is indeed the case that we are, collectively, confused about what constitutes a valid fact, then probably we need to stop arguing about first-order problems and instead reestablish some basic principles. In this process, it helps to look to objects, because we can all agree on their reality.[1]

This brings me back to the main point of this book. Everyone can't just go and study tree anatomy, indigenous footwear, or Renaissance alchemy. But we could do a lot of good for our society simply by changing our collective attitude toward material intelligence of all kinds. We need to remember that working with one's hands is an education, too, and can be a proud lifelong pursuit. It's a simple point, really: Everyone deserves respect for their knowledge and their experience. This is the most important reason to find value in things and take the time to learn about the materials from which they are made. Even more important than scientific and practical applications

of such knowledge, understanding things also encourages us to understand other people who are daily in touch with them.

Professor Ned Cooke, who mentored me at Yale University when I was in graduate school and has been a valued colleague ever since, has taught me many things about craft and materiality in general. He has often emphasized the concept of material literacy in his teaching, encouraging us to learn about our objects of study from the ground up. Perhaps the most important lesson that he imparted to me is about respect. When it comes to materiality, no one way of understanding it is inherently superior. The important thing is simply that we all do it, and do it as well as we can. I made this point in the introduction to this book, but it bears repeating: An object cannot be good all on its own; it can only be good for someone. Getting to a better world of things is a group enterprise. We cannot be guided by any one set of rules. We are all on our own pathways of capability and conviction. It's just like Ned taught me: When faced with a person who makes something differently from you, or lives with something you wouldn't, it's best to be curious rather than dismissive. You can learn a lot that way.

Epilogue

THE VIRTUES OF THINGS

W HEN I BEGAN THIS BOOK with a recollection of my childhood teddy bears, I did not mention that one of them, Phil, was prone to bursting at the seams. Often he would spring a leak and, when hugged, would release a little cloud of sawdust. Whenever this happened, my mother would step in and sew him up, which she did adroitly enough, as she was a doctor. In fact, she had decided on a career in medicine when she was a child herself. At the age of four, she was given a toy first aid kit—a little stethoscope, reflex hammer, and other miniature tools—and fell in love with it. She enlisted her own teddy bear as a patient, along with all the other dolls in her possession. If one of them had a broken leg, she would refuse to throw it out, instead setting the wound using two tongue depressors and some tape. She jokes that she first realized that she wanted to be a doctor when she saw the grateful look on her teddy bear's face.

My mother followed through on her childhood ambition, despite the fact that women doctors were few in those days. This would have been in the late 1960s, when many medical schools simply didn't accept female students. She was rejected

by several colleges because of her gender, and even at the school she did attend, Boston University, as a woman she was very much in the minority. That remained the case throughout her career. She was among the first female physicians to work at her hospital in Winchester, Massachusetts, and when she rose to become chief of medicine there, she was the first woman to do so and one of the few in the country to hold that position.

Her gender did not necessarily affect her approach to medicine, but it is nonetheless the fact that she did give her patients lots of hugs. That is probably very unusual now, and it certainly was then. When I asked her whether she felt that her work as a doctor involved much in the way of material intelligence, the hugs are what she talked about. Like scientists, some doctors have what are called "good hands." They excel at procedures like diagnosing pneumonia by tapping on the patient's back to see if there are hollow-feeling spots, or detecting the onset of liver disease on the basis of a swollen

abdomen. This was not my mother's strength. She says she wasn't so good at diagnosing by feel; she was "glad she practiced in the age of X-rays." But hugging she could do.

Many of her patients benefited from the attention. She tells the story of one extremely formal lady, very cool and distant, who was quite ill. My mother always asked for permission before hugging her patients, and in this case she felt some trepidation—surely this lady would feel uncomfortable? But instead, the patient's face lit up in surprise. "Would you?" she cried, and they embraced. My mother sometimes felt that it was the most important aspect of the care that she provided. "I did something for this lady that I could never have done as a doctor," she said. "But as a human being, I could."

Unfortunately, my mother has had a great many health problems of her own. In our family we jokingly compare her to a cat, which famously has nine lives. By that calculation she still has six to go: She has faced potentially fatal breast cancer, a brain tumor, and cerebral meningitis. The last of these, which she contracted about fifteen years ago, left her in a coma for several months. When she came to, she was entirely deaf, and she has been confined to a wheelchair ever since. She went from being someone who lived energetically and enthusiastically—working fifty or sixty hours a week, going on far-flung vacations, being a social leader of the community—to having a very restricted existence. Since the meningitis, my father has been caring for her full-time. Even getting out of the house is something of a project, so they do it together only once or twice a week. Travel beyond the immediate vicinity is essentially impossible.

It is very sad that my mother, who spent so much of her life healing others, should have had such terrible luck. She faces it all with admirable fortitude, though, bringing to her reduced circumstances the same determination that she once brought to being a doctor. And the situation has had its positive aspects. Once, when she was fighting cancer but still practicing as a physician, she was amazed that one of her own patients offered to hug *her*—turning the tables after many years. "I felt so moved by this expression of solidarity," she recalls. "He was the only person that ever hugged me, and not the other way around." Similarly, her disability has given my father, who had retired a few years before my mother's meningitis, a tremendous sense of purpose. My dad helps my mom with every one of the repetitive, material processes of daily life—the cycle of eating, sleeping, and going to the bathroom that most of us take for granted. Sure, my mother would love to be able to walk and hear, and my father would love to have more daily freedom to pursue his own interests. But out of necessity has come an incredibly deep and lasting bond.

It is strange, in some ways, that my life has led to me writing a book about the virtues of things, for my family is not notably attuned to the topic. True, my farm-raised engineer grandfather was an extraordinary repository of material intelligence. But that has not necessarily been passed on. My twin brother, Peter, is a philosopher, a profession whose practitioners are often teased for having their heads in the clouds. My mother, as I just mentioned, was not all that adept at the more hands-on aspect of her work. And as for my math genius father, he was once asked whether he knew much about fixing cars and

replied, "Oh, no. I have only a very tenuous relationship with physical reality." Speaking for myself, I have abundant respect and fascination for craft but don't consider myself to be particularly talented in that direction; I'm not what you call handy. When asked by artists and makers whether I am one myself, I usually mumble something about "those who can't do, teach."

Be that as it may, my parents' situation speaks to the importance of materiality to quality of life, even for those who have not mastered it. The physical traces of my mother's illness have been hard to miss. Eventually the carpets in my parents' home were worn flatter where her wheelchair passed, and there were deep grooves in the walls from numerous minor collisions of its wheels against the paint. On the other hand, their daily routine is organized with near-military precision. (A favorite example: My mother drinks her juice from a particular favorite glass, which has horizontal stripes, and my father always pours her exactly six stripes' worth.) They know exactly where to position her wheelchair when transferring her to the couch so that she can watch the Red Sox game. Though they would not use the word "design" to describe the solutions they have devised, that is exactly what is happening: an ongoing act of arrangement aimed at making their own daily lives as livable as possible, despite the limitations of my mother's condition.

Last year, my parents moved from their home of forty-five years to a retirement community. They had to transplant all their well-practiced daily patterns as best they could, come to grips with the new material circumstances that presented themselves, and reinvent their lives as necessary. When they

moved, I helped them go through all the steps that anyone in such a situation would. Every object had to be classified: "keep," "give away," or "junk." Furniture, appliances, and clothes that had been used exactly in the same way every day for years, over and over again, suddenly became trash. Conversely, other things that had no practical function turned out to be extremely important to them and were duly preserved. Fine gradations of sentimental attachment were measured in the process.

I have tried to find a few lessons in my parents' experience. One thing I've noticed is that, as their needs and their range of activities have narrowed, they have become very particular about the objects in their environment. My dad jokes that they are "consumption impaired"—they don't want to buy much or otherwise add anything to their home. Finding them birthday presents is a real challenge. Their circumstances have freed them from the seemingly endless wants that many others have. Gradually, this has come to seem the foundation of a healthy life. A second lesson is equally simple: My parents faced the challenge of my mother's illness together and thereby became closer to each other—closer than they ever were before she became disabled, and probably closer than most people ever get to another person. The reason this happened was not just affection, or even mutual dependency, but an almost total sharing of their environment.

I believe that we can derive the same sense of togetherness from a shared concern for our material world, even when we are distracted by a superfast, globalized, technologically advanced economy. That is true whether we are contending with physical challenges (as my mother and father do every day)

or enjoying our pleasures (which they do, too, of course). What we need to do is, in some ways, analogous to what they have had to do since my mother woke up from her coma: stop adding things to our lives unless the things really matter, attend to the things that are already there, and above all, find meaningful ways to connect to each other.

This brings me, at last, to the big question: How can we encourage people to value the things in their lives more than they do today? It won't be easy. We'll need to rethink the way we approach education, medicine, technology, art, public policy, and many other areas of our culture. Fortunately, in this effort, we have great allies in things themselves. Objects may not speak up on their own behalf, but almost anyone can get interested in them—and in the slow, sustaining truths of our material environment. And the things in our lives do have incredible staying power. In our homes and our museums, in every kind of human landscape, they sit, obdurate, free from the domain of opinion, ever ready for interpretation and connection. Things can function as powerful exemplars and guides. Like rocks in a swift current, even when they sit perfectly still, they shape the course of our experience.

ACKNOWLEDGMENTS

I'm a person who feels most at home when thinking and writing. But making is what I like to think and write about best. What's often called "tacit knowledge," which I prefer to call "material intelligence," has a profound appeal for me. Many others feel the same, I know. Yet this fundamental human faculty does not get enough respect. This is partly because it is difficult to grasp making from the outside. If you haven't done something yourself, then the depth involved may well remain lost on you.

My greatest debts in writing this book, accordingly, are to those who helped me to understand their own branch of material intelligence: Alan Miller, Alex Wiedenhoeft, Catherine Willems, Chris Pellettieri, Christopher Wilk, Constance Adams, Ellen Freund, Fenella France, Ian Hutchings, Jerry Walsh, Katharine Hibbert, Luke Beckerdite, Mimi Bowling, Pamela Smith, Scott Bodenner, and Susan Tunick. I have been fortunate to learn from these knowledgeable people, who are "hands on" in all kinds of ways.

The interviews and other exchanges I have had with them are the heart and soul of this book.

My next thanks go to the team at Bloomsbury, who have handled the manuscript with a care equal to that observed on a workshop floor. I would like to thank former publisher George Gibson; editors Kathryn Earle, Nancy Miller, and Ben Hyman; production editor Carrie Hsieh; copy editor Greg Villepique; illustrator Polly Becker; art director Patti Ratchford; production controller Natasha Qureshi; and especially Jacqueline Johnson, who retired from her long and successful editorial career just as *Fewer, Better Things* was going to press. She was the first reader of the book, and I was one of the last authors to benefit from her wise counsel.

Speaking of wisdom, I would also like to thank my academic and curatorial colleagues, and my current and former students. When I began studying the topic of craft, there were comparatively few people with an active interest in the field. Now there are many—far too many to list here, but all valued peers. At an early stage of my own career I was lucky to find Ned Cooke, at Yale University, as a mentor; and soon after, forged a deep friendship and intellectual partnership with Tanya Harrod. Together we three co-founded the *Journal of Modern Craft*, a vehicle for scholarship in the field and a major influence on my own thinking. I acknowledge here the other current co-editors at the journal—Elissa Auther, Jenni Sorkin, Joseph McBrinn, Namita Wiggers, and Stephen Knott—as well as the many other contributors to the publication over the years, and others writing groundbreaking studies of making.

Over the past few years, I have also worked collaboratively on many curatorial and publishing projects that have informed this book. Thank you, comrades: Andrew Perchuk, Daniel Charny, Eleanor Watson, Jane Pavitt, Julia Bryan-Wilson, Giorgio Riello, Marc Benda, Martina Droth, Sarah Archer, Sarah Teasley, Simon Olding, and Victoria Kelley.

While writing *Fewer, Better Things*, I was welcomed as a senior scholar at the Yale Center for British Art. My sincerest thanks go to that fine institution, and particularly to its director, Amy Meyers, for her unstinting support. Likewise I would like to thank colleagues at the Chipstone Foundation in Milwaukee (Jonathan Prown, Sarah Carter, and Natalie Wright) and at Harvard University (Ethan Lasser and Jennifer Roberts) for important ongoing conversations about materiality and making.

Finally, I'd like to recognize my own family. They have been the foundation of my life and work, and it's been a pleasure to give a few of them center stage in these pages: my grandfather Arthur, the farm boy turned engineer; my parents, who taught me by example what it was to care about people; and Peter, my extraordinary and indefatigable twin brother, who has dedicated himself to illuminating past wisdom for the present day. My love also goes out to Peter's family—Ursula, Sophia, and Johanna—to my aunt Judy (a proficient maker in her own right), uncle Fred, and all the AJs; and to David and Caroline and the whole Probert family.

This book is dedicated to my partner, Nicola, whose intelligence (material, emotional, and otherwise) is my most constant inspiration.

NOTES

Introduction: ENGAGING WITH THE
OBJECTS AROUND US

1 Andy Tope, "The Children of Technology, a New
 Species," *Fox Gazette* (November 22, 2011).
2 William Morris, "Art and the Beauty of the Earth," 1881.

Chapter 2: A FEW WORDS ON CRAFT

1 On the question of craft's presumed inferiority from the
 perspective of fine art, see Glenn Adamson, *Thinking
 Through Craft* (Oxford: Berg, 2008), and Glenn Adamson
 and Julia Bryan-Wilson, *Art in the Making: Artists and Their
 Materials from the Studio to Crowdsourcing* (New York:
 Thames and Hudson, 2016).
2 Hugh Aldersey-Williams, *Periodic Tales* (New York:
 Viking, 2011), p. 12.
3 Thomas Heatherwick and Maisie Rowe, *Thomas
 Heatherwick: Making* (London: Monacelli, 2015).

4 Andrew O'Hagan, "Imaginary Spaces: Es Devlin and the Psychology of the Stage," *New Yorker* (March 28, 2016).

5 Andrew Bolton, ed., *Alexander McQueen: Savage Beauty* (New York: Metropolitan Museum of Art, 2011).

Chapter 3: THE PAPER CHALLENGE

1 Doris Lessing, "Out of the Fountain," in *The Story of a Non-Marrying Man and Other Stories* (London: Penguin, 1975), p. 13.

2 David Esterly, *The Lost Carving: A Journey to the Heart of Making* (New York: Penguin, 2012), p. 67.

3 Esterly, p. 109.

Chapter 4: BEING "HANDS ON"

1 Martin Heidegger, *Being and Time*, 1927.

Chapter 5: TRICKS OF THE TRADE

1 Richard Sennett, *The Craftsman* (New Haven: Yale University Press, 2008), p. 175.

Chapter 6: TOOLING UP

1 Quotes from Scott Bodenner are taken from an interview held on April 15, 2016.

2 Twill is fabric in which either warp or weft passes over a small number of threads, usually two, then under one, then over two again, producing a smooth surface. The

Bauhaus-trained designer Anni Albers's book *On Weaving* (Middletown, CT: Wesleyan University Press, 1965) remains a helpful source for learning about weave structure.

Chapter 7: LEARNING BY DOING

1 Quotes from Chris Pellettieri are taken from an interview held on April 13, 2016.

2 Wayne Koestenbaum, "The Inner Life of the Palette Knife" (2011), in *My 1980s and Other Essays* (New York: Farrar, Straus and Giroux, 2013), p. 251.

Chapter 8: PROTOTYPING

1 Larry Pelowski, quoted in "Designing with Tape at Ford," *Car Body Design* (website), February 13, 2014.

2 The earliest extant steam-driven drop hammer is in the collection of the Science Museum in London. Almost eight feet tall and made of iron, it dates to around 1850 and was made by the engineer James Nasmyth. It is supposedly so sensitive that it can crack the shell of an egg sitting on an inverted wineglass without breaking the glass.

Chapter 9: ONE THING FOR ANOTHER

1 Martin Gardner makes this argument in *The Ambidextrous Universe: Mirror Asymmetry and Time-Reversed Worlds* (New York: Basic Books, 1964).

2 David Pye, *The Nature and Art of Workmanship* (Cambridge, UK: Cambridge University Press, 1968), p. 7.

3 Luke Beckerdite and Alan Miller, "Furniture Fakes from the Chipstone Collection," *American Furniture* (Milwaukee: Chipstone Foundation, 2002).

4 See Manuel Charpy, "Patina and Bourgeoisie: Appearances of the Past in Nineteenth-Century Paris," in Victoria Kelley and Glenn Adamson, eds., *Surface Tensions* (Manchester, UK: Manchester University Press, 2013).

5 See Guy Keulemans, "The Geo-Cultural Conditions of *Kintsugi*," *Journal of Modern Craft* 9, no. 1 (March 2016).

Chapter 10: FACE TO FACE

1 Christopher Breward, "The Evolution of Men's Suits," *Observer* (March 27, 2016). See also Breward, *The Suit: Form, Function and Style* (London: Reaktion, 2016); Glenn Adamson, "Tailoring and Craft," in Sonnet Stanfill, ed., *The Glamour of Italian Fashion* (London: V&A Publications, 2014).

2 Kristina Dziedzic Wright, "Cleverest of the Clever: Coconut Craftsmen in Lamu, Kenya," *Journal of Modern Craft* 1, no. 3 (November 2008).

3 Brian Moeran, "Materials, Skills and Cultural Resources: Onta Folk Art Pottery Revisited," *Journal of Modern Craft* 1, no. 1 (March 2008). See also Moeran, *Lost Innocence: Folk Craft Potters of Onta, Japan* (Berkeley: University of California Press, 1984).

4 John L. Jackson Jr., "Ethnography Is, Ethnography Ain't," *Cultural Anthropology* 27, no. 3 (August 2012). My thanks to Chandan Bose for this reference.

Chapter 13: THE CONTACT ZONE

1 "Architectural Terra Cotta a Big Factor in New Building," *New York Times* (May 14, 1911). See also Susan Tunick's fine book *Terra-Cotta Skyline: New York's Architectural Ornament* (Princeton: Princeton Architectural Press, 2007).

2 For more on fabricators like Milgo/Bufkin, see Glenn Adamson and Julia Bryan-Wilson, *Art in the Making: Artists and Their Materials from the Studio to Crowdsourcing* (London: Thames and Hudson, 2016).

3 One report suggests that over five million dollars' worth of American flags are imported from China every year, along with over 90 percent of fireworks used in the United States. See "The Fourth of July, Made in China," *Vox* (July 3, 2017).

4 A. C. Grayling, *The Meaning of Things: Applying Philosophy to Life* (London: Weidenfeld and Nicolson, 2001), p. 184.

Chapter 14: THE PARADISE OF TOUCH

1 Helen Keller, *The Story of My Life* (New York: Modern Library, 2003; orig. pub. 1903), p. 60.

2 Keller, *The Story of My Life*, p. 20.

3 Keller, *The Story of My Life*, p. 26.

4 Helen Keller, *The World I Live In* (New York: New York Review Books, 2003; orig. pub. 1908), p. 9.

5 Keller, *The World I Live In*, p. 9.

6 Keller, *The World I Live In*, p. 29.

7 Keller, *The World I Live In*, p. 42.

8 "Contact zone" is a common term in anthropology, where it denotes one culture meeting another—often, situations where anthropologists themselves (who tend to be Euro-American) encounter indigenous populations. I employ the phrase here in a more literal sense; however, anthropologists do often focus on material culture as the basis of cross-cultural inquiry.

9 Bacon and Vasari quoted in Geraldine A. Johnson, "The Art of Touch in Early Modern Italy," in Francesca Bacci, *Art and the Senses* (Oxford: Oxford University Press, 2009), p. 62. See also Constance Classen, ed., *The Book of Touch* (London: Berg Publishers, 2005).

10 "Sensuous Healing: The Sensory Practice of Medicine," in David Howes and Constance Classen, *Ways of Sensing: Understanding the Senses in Society* (London: Routledge, 2014). See also Tim Dornan and Debra Nestel, "Talking, Touching, and Cutting: The Craft of Medicine," *Journal of Modern Craft* 6, no. 1 (March 2013).

11 Adam Gopnik, "Feel Me," *New Yorker* (May 16, 2016), p. 66.

Chapter 15: The View from the Hardware Store

1 This passage and direct quotes are based on time spent in Mayday Hardware with Jerry Walsh on September 26, 2016. Jerry is also working on an autobiography based on his experiences in Prospect Heights, so keep an eye out for that.

Chapter 16: Time to Pay Attention

1 Andrew Sullivan, "I Used to Be a Human Being," *New York* (September 19, 2016), p. 34.

2 Sullivan, p. 9.

3 Sullivan, p. 103.

4 The survey referred to was conducted by the consultancy group LaPlaca Cohen as part of their annual Culture Track survey, in 2014. See also Tom Vanderbilt, *You May Also Like* (New York: Knopf, 2016).

5 Brian Droitcour and William S. Smith, "The Digitized Museum," *Art in America* (October 2016), p. 80.

6 Zadie Smith, *NW* (New York: Penguin, 2012), p. 328.

Chapter 17: The Myth of the Dumb Object

1 Neal Gershenfeld, *Fab: The Coming Revolution on Your Desktop—from Personal Computers to Personal Fabrication* (New York: Basic Books, 2005).

2 Deyan Sudjic interviewed in *Domus* magazine (March 7, 2016).

3 For a summary of smartphone production and distribution, see David Barboza, "An iPhone's Journey, From the Factory Floor to the Retail Store," *New York Times* (December 29, 2016).

4 Pamela H. Smith, "Making as Knowing: Craft as Natural Philosophy," in Smith, Amy Meyers, and Harold Cook, eds., *Ways of Making and Knowing: The Material Culture of Empirical Knowledge* (Ann Arbor: University of Michigan Press, 2014), p. 20. I further discuss Smith's work as a practicing historian in chapter 32.

Chapter 18: GOING DEEP

1 Sherry Turkle, "Connected, but Alone?" TED talk, February 2012. See also Turkle's book *Alone Together: Why We Expect More from Technology and Less from Each Other* (New York: Basic Books, 2012).

2 Art Buchwald, "Art and Museum Fail to Maintain Worthy Attention," *Daily News* (September 18, 1990), p. 4.

3 Maggie Jackson, *Distracted: The Erosion of Attention and the Coming Dark Age* (Amherst, NY: Prometheus Books, 2009), p. 22. See also Matthew Crawford, *The World Beyond Your Head: How to Flourish in an Age of Distraction* (New York: Viking, 2015).

4 Sally Andrews, David A. Ellis, Heather Shaw, and Lukasz Piwek, "Beyond Self-Report: Tools to Compare

Estimated and Real-World Smartphone Use," *PLOS* 10, no. 10 (October 2015). This study is summarized in Teddy Wayne, "The End of Reflection," *New York Times* (June 12, 2016).

5 Jan Morris, *Trieste and the Meaning of Nowhere* (London: Faber and Faber, 2001), p. 21.

Chapter 19: THE WAY OF TEA

1 Christine M. E. Guth, *Art, Tea and Industry: Masuda Takashi and the Mitsui Circle* (Princeton: Princeton University Press, 1993).

2 Kakuzo Okakura, *The Book of Tea* (London: Penguin, 2010; orig. pub. 1906), p. 3.

3 Allen S. Weiss, *The Grain of the Clay: Reflections on Ceramics and the Art of Collecting* (London: Reaktion, 2016), p. 67.

4 Bernard Leach, *A Potter's Book* (London: Faber and Faber, 1940), p. 23.

5 Weiss, *The Grain of the Clay*, p. 92.

Chapter 20: ALL THAT IS LEFT

1 I am indebted for this observation to my colleague Natalie Wright of the Chipstone Foundation, Milwaukee. See also Marita Sturken, "The Aesthetics of Absence: Rebuilding Ground Zero," *American Ethnologist* 31, no. 3 (August 2004).

2 Susan Stewart, *On Longing* (Durham: Duke University Press, 1993; orig. pub. 1984), p. 135

Chapter 21: SMALL WORLDS

1 Stewart, *On Longing*, p. 61.

2 Alexandre Dumas, *The Count of Monte Cristo* (London: Chapman and Hall, 1846). My thanks to Stephen Knott for pointing out this reference.

3 Louis Zamperini and David Rensin, *Devil at My Heels* (New York: HarperCollins, 2014).

4 Mark Murphy, "Eighty-Three Days" (1943), in *The New Yorker Book of War Pieces* (New York: Reynal and Hitchcock, 1947).

5 Pat Kirkham, "Keeping Up Home Front Morale: 'Beauty and Duty' in Wartime Britain," in Jacqueline M. Atkins, ed., *Wearing Propaganda: Textiles on the Home Front in Japan, Britain, and the United States* (New York: Bard Graduate Center/Yale University Press, 2005), pp. 214–15.

6 Julie Jackson, "Subversive Finds: Hidden Cross-Stitched Messages from a Nazi POW," *Make:* (December 21, 2011). Casdagli's sampler was displayed in the exhibition *Power of Making* at the Victoria and Albert Museum in 2011.

7 The best-known such experiment is Biosphere 2, constructed in Arizona between 1987 and 1991. For a recent fictional account of life inside such a facility, see T. C. Boyle, *The Terranauts* (New York: Ecco/HarperCollins, 2016).

8 This passage and direct quotes are drawn from an interview with Constance Adams conducted on September 2, 2016.

9 See Constance Adams, "Techne and Logos at the Edge
 of Space," in Louise Valentine, ed., *Prototype: Design
 and Craft in the 21st Century* (London: Bloomsbury,
 2013).

Chapter 22: FEWER, BETTER THINGS

1 Katharine Hibbert, *Free: Adventures on the Margins of a
 Wasteful Society* (London: Ebury Press, 2010).
2 Lewis Hyde, *The Gift: Imagination and the Erotic Life of
 Property* (New York: Vintage, 1979), p. 56.
3 Philip Drucker, *Indians on the Northwest Coast* (New York:
 McGraw-Hill, 1955).

Chapter 23: TO HAVE AND TO HOLD

1 Susan Falls, *Clarity, Cut, and Culture: The Many Meanings of
 Diamonds* (New York: New York University Press, 2014).
2 Susan Falls, "The Many Meanings of Diamonds" lecture
 at the Los Angeles County Museum of Art, October 1,
 2016.
3 In the Middle Ages, as Jacques Attali has pointed out, the
 only paved floors a peasant was ever likely to experience
 were those in the local church; the echo of footsteps on
 that surface would have immediately differentiated it
 from other places. Attali, *Noise: The Political Economy of
 Music* (Minneapolis: University of Minnesota Press, 1985;
 orig. pub. 1977).

Chapter 24: THINKING THINGS THROUGH

1 The podcast can be found at historyofphilosophy.net. Peter has also published a related series of books for Cambridge University Press.

Chapter 25: MATERIAL SCIENCE

1 Quotations from Ian Hutchings are taken from an interview conducted on June 29, 2016.

Chapter 26: HANDLE . . . WITH CARE

1 See James Cuno, ed., *Whose Muse? Art Museums and the Public Trust* (Princeton: Princeton University Press, 2006).

2 For further thoughts on this point, see my essay "Curating the Ephemeral," in Joanna Marschner, David Bindman, and Lisa L. Ford, eds., *Enlightened Princesses: Caroline, Augusta, Charlotte, and the Shaping of the Modern World* (New Haven: Yale Center for British Art, 2017).

3 Tony Bennett, "The Exhibitionary Complex," *New Formations* 4 (Spring 1988).

4 Dan Balz, "Pew Poll: In Polarized United States, We Live as We Vote," *Washington Post* (June 12, 2014). This statistic includes theaters and other arts institutions, as well as museums.

5 Quoted in Laura Cumming, "What Drove Kandinsky to Abstraction?," *The Guardian* (June 25, 2006).

6 Adam Corsini, "Delivering the Past: Touch, Don't Look,"
 Museum of London (website), September 8, 2016.
7 The Art Institute of Chicago is unusual in having a
 permanent gallery dedicated to tactile exploration for
 the blind, the Elizabeth Morse Touch Gallery; the
 "performing" musical instrument curator at the Museum
 of Fine Arts, Boston is Darcy Kuronen.

Chapter 27: ANCHOR POINTS

1 The most promising such initiative at the moment, as far
 as I know, is ResearchSpace. Funded by the Andrew W.
 Mellon Foundation, it seeks to integrate institutional
 databases, which is challenging because each is organized
 according to its own protocols. This can be done through
 a "semantic recognition model," which extracts data and
 integrates it into a single searchable set. The Yale Center
 for British Art and the British Museum are serving as
 early entrants into the system.
2 Nicholas Thomas, *The Return of Curiosity: What Museums
 Are Good For in the 21st Century* (London: Reaktion,
 2016).

Chapter 29: THINKING INSIDE THE BOX

1 Quotations from Mimi Bowling are taken from an
 interview conducted on September 2, 2016.
2 Peter Miller, "How Objects Speak," *Chronicle of Higher
 Education* (August 11, 2014).

Chapter 30: MATERIAL HISTORIES

1 Christopher Wilk, *Plywood: A Material Story* (London: Thames and Hudson, 2017), chapter 1.

2 This is the case currently with a material called Aerogel, for example, which has gained attention as the least-dense and lowest-weight solid known. Unfortunately, no one has yet devised a use for it, though there has been one ingenious proposal to use it as a filter in giant screens mounted on satellites, in order to catch microscopic space debris for future study.

3 Sarah Nichols, Elisabeth Agro, and Elizabeth Teller, eds., *Aluminum by Design* (Pittsburgh: Carnegie/Harry N. Abrams, 2000); Stephen L. Harp, *A World History of Rubber: Empire, Industry, and the Everyday* (Chichester: John Wiley, 2015).

4 Philip J. Gooderson, *Lord Linoleum* (Keele, UK: Keele University Press, 1996).

Chapter 31: THE ITINERARY OF PLASTIC

1 Jeffrey Meikle, *American Plastic* (New Brunswick: Rutgers University Press, 1997).

2 Quotes from Roland Barthes are taken from *Mythologies* (1957), trans. Annette Lavers (New York: Vintage, 2000), pp. 97–99.

3 Douglas Adams, *Mostly Harmless* (London: Pan Books, 2009; orig. pub. 1992), p. 92. My thanks to Catharine Rossi, who has recently published an article showing how Thwaites and other designers subscribe to a model

of self-imposed limitation that ultimately descends from Daniel Defoe's 1719 novel *Robinson Crusoe*. Rossi also makes the important point that such situations are very rarely truly self-sufficient. Like Crusoe, who relied on the supplies from his wrecked ship, they almost always require externally produced resources. Rossi, "The Crusoe Condition: Making Within Limits and the Critical Possibilities of Fiction," *Journal of Modern Craft* 10, no. 1 (March 2017).

4 Quotes from Thomas Thwaites are taken from "How I Built a Toaster—from Scratch," TED talk, November 2010.

Chapter 32: A BOOK OF SECRETS

1 From an interview with Pamela Smith, November 23, 2016.

2 Pamela H. Smith, "Making as Knowing: Craft as Natural Philosophy," in Smith, Amy Meyers, and Harold Cook, eds., *Ways of Making and Knowing. The Material Culture of Empirical Knowledge* (Ann Arbor: University of Michigan Press, 2014), p. 19.

3 Pamela Smith, "Snakes, Lizards, and Manuscripts: Humanists in the Laboratory," unpublished lecture, Columbia University, December 2, 2013.

4 Bernard Palissy, *Admirable Discourses* (1580). Quoted in Pamela H. Smith and the Making and Knowing Project, "Historians in the Laboratory: Reconstruction of Renaissance Art and Technology in the Making and Knowing Project," *Art History* 39, no. 2 (April 2016).

5 Quotes from Catherine Willems are taken from a public
 lecture and ensuing conversation in Ghent, Belgium, on
 November 18, 2016.

6 Catherine Willems, et al, "Biomechanical Implications of
 Walking with Indigenous Footwear," *American Journal of
 Physical Anthropology* 162, no. 4 (April 2017). My thanks to
 Willems for sharing this manuscript with me prior to its
 publication.

Chapter 33: FACTS, NOT OPINIONS

1 Robert Owen, "To the Superintendents of Manu-
 factories," in *A New View of Society* (London: Cadell and
 Davies, 1813), p. 64.

2 On these issues see Glenn Adamson, *The Invention of Craft*
 (London: Bloomsbury, 2013).

3 A. L. Kennedy, "A Point of View: Facts Not Opinions,"
 broadcast, July 17, 2016, BBC Radio 4.

4 Quotations from Alex Wiedenhoeft are taken from a
 phone conversation conducted on December 22, 2016.

Chapter 34: TWO CASTES, ONE PEOPLE?

1 Actually, some philosophers have contested our
 epistemological access to any external reality and insist
 that there is no way to prove that the objects of our
 perception have any true existence outside of our minds.
 But I'll leave that one to my brother.

INDEX

A NOTE ON THE AUTHOR

Glenn Adamson is a senior scholar at the Yale Center for British Art and works across the fields of design, craft, and contemporary art. A former director of the Museum of Arts and Design in New York, Glenn also has been head of research at the Victoria and Albert Museum in London and curator at the Chipstone Foundation in Milwaukee. His books include *Art in the Making* (coauthored with Julia Bryan-Wilson) and *Thinking Through Craft*, among others. He lives in Brooklyn, New York.